GUCC.

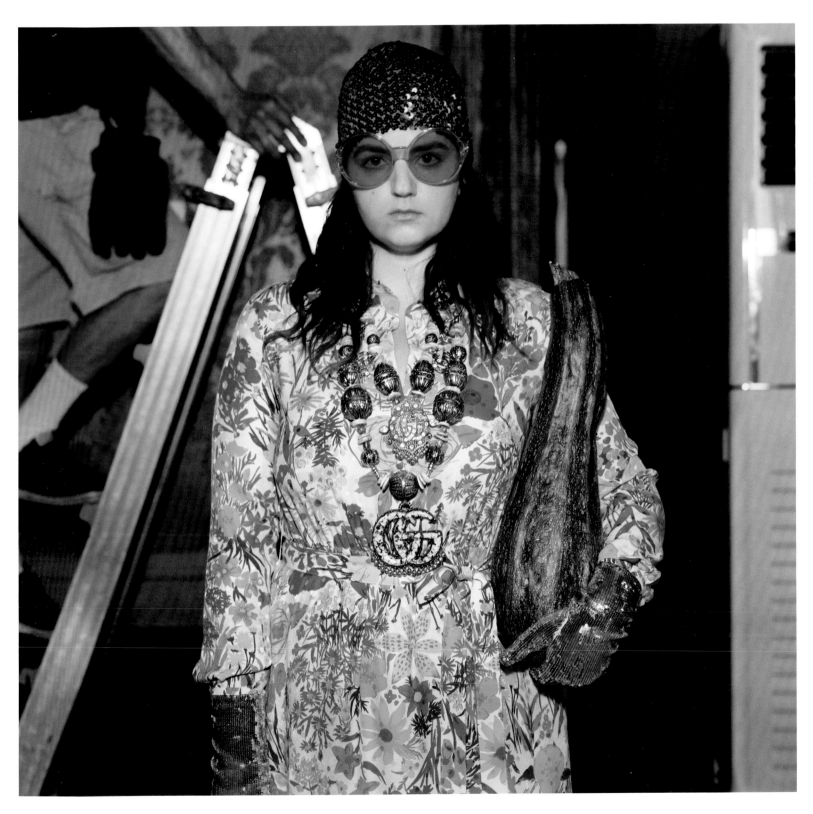

#GucciEpilogue

Spring 2021
New York

Words & Pictures

Front

Back

Front cover:
**Roe Ethridge, *Apple
and Black Glove*, 2020,
from the series *Fugitive
Sunset*, for *Aperture***
Courtesy the artist and
Andrew Kreps Gallery,
New York
(See page 154)

Opposite:
**Zoe Leonard, *Downtown
(for Douglas)*, 2016**
Courtesy the artist; Galerie
Capitain, Cologne; and
Hauser & Wirth, New York

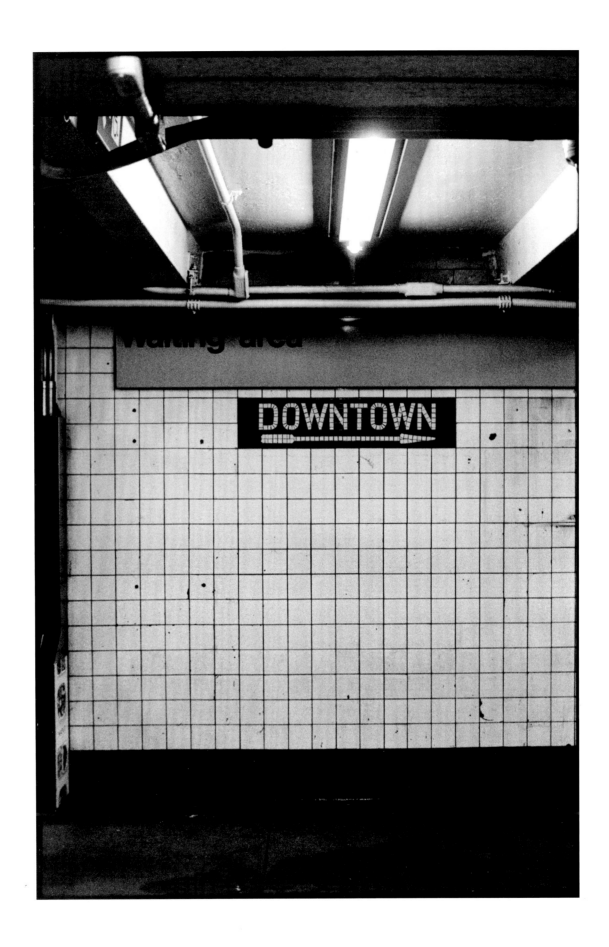

Aperture, a not-for-profit foundation, connects the photo community and its audiences with the most inspiring work, the sharpest ideas, and with each other—in print, in person, and online.

Aperture (ISSN 0003-6420) is published quarterly, in spring, summer, fall, and winter, at 548 West 28th Street, 4th Floor, New York, N.Y. 10001. In the United States, a one-year subscription (four issues) is $75; a two-year subscription (eight issues) is $124. In Canada, a one-year subscription is $95. All other international subscriptions are $105 per year. Visit aperture.org to subscribe. Single copies may be purchased at $24.95 for most issues. Subscribe to the Aperture Digital Archive at aperture.org/archive. Periodicals postage paid at New York and additional offices. Postmaster: Send address changes to Aperture, P.O. Box 3000, Denville, N.J. 07834. Address queries regarding subscriptions, renewals, or gifts to: Aperture Subscription Service, 866-457-4603 (U.S. and Canada), or email custsvc_aperture@fulcoinc.com.

Newsstand distribution in the U.S. is handled by CMG. For international distribution, contact Central Books, centralbooks.com. Other inquiries, email orders@aperture.org or call 212-505-5555.

Become a Member of Aperture to take your interest in and knowledge of photography further. With an annual tax-deductible gift of $250, membership includes a complimentary subscription to Aperture magazine, discounts on Aperture's award-winning publications and photography workshops, a special limited-edition gift, and more. To join, visit aperture.org/join, or contact membership@aperture.org.

Library of Congress Catalog Card No: 58-30845.

ISBN 978-1-59711-503-2

Printed in Turkey by Ofset Yapimevi

OFSET
YAPIMEVİ

Significant support of Aperture magazine is provided by The Kanakia Foundation and by Jon Stryker and Slobodan Randjelović. Aperture gratefully acknowledges Judy and Leonard Lauder for their lead support of the "New York" issue, and Laumont Editions, for support of additional editorial content. Further generous support is provided in part by the New York City Department of Cultural Affairs in partnership with the City Council.

Aperture Foundation's programs are made possible in part by the New York State Council on the Arts with the support of Governor Andrew M. Cuomo and the New York State Legislature.

Statement of Ownership, Management, and Circulation (Required by 39 U.S.C. 3685). 1. Publication Title: Aperture; 2. Publication no.: 0003-6420; 3. Filing Date: October 1, 2020 4. Issue Frequency: Quarterly; 5. No. of Issues Published Annually: 4; 6. Annual Subscription Price: $75.00; 7. Complete Mailing Address of Known Office of Publication: Aperture Foundation, 548 West 28th Street, 4th Floor, New York, NY 10001-5511; Contact Person: Dana Triwush; Telephone: 212-946-7116; 8. Complete Mailing Address of Headquarters or General Business Office of Publisher: Aperture Foundation, 548 West 28th Street, 4th Floor, New York, NY 10001-5511; 9. Full Names and Complete Mailing Addresses of Publisher, Editor, and Managing Editor: Publisher: Dana Triwush, Aperture Foundation, 548 West 28th Street, 4th Floor, New York, NY 10001-5511; Editor: Michael Famighetti, Aperture Foundation, 548 West 28th Street, 4th Floor, New York, NY 10001-5511; Managing Editor: Brendan Embser, Aperture Foundation, 548 West 28th Street, 4th Floor, New York, NY 10001-5511; 10. Owner: Aperture Foundation, Inc., 548 West 28th Street, 4th Fl., New York, NY 10001; 11. Known Bondholders, Mortgagees, and Other Security Holders Owning or Holding 1 Percent or More of Total Amount of Bonds, Mortgages, or Other Securities: None; 12. Tax Status: The purpose, function, and nonprofit status of this organization and the exempt status for federal income tax purposes: Has Not Changed During Preceding 12 Months; 13. Publication Title: Aperture; 14. Issue Date for Circulation Data Below: Summer 2020 #239; 15. Extent and Nature of Circulation (Average No. Copies Each Issue During Preceding 12 Months; No. Copies of Single Issue Published Nearest to Filing Date): a. Total Number of Copies (Net press run): 14,524; 16,118; b. Paid Circulation; (1) Mailed Outside-County Paid Subscriptions Stated on PS Form 3541: 5,456; 5,377; (2) Mailed In-County Paid Subscriptions Stated on PS Form 3541: 3; 3; (3) Paid Distribution Outside the Mails Including Sales Through Dealers and Carriers, Street Vendors, Counter Sales, and Other Paid Distribution Outside USPS: 4,171; 4,791; (4) Paid Distribution by Other Classes of Mail Through the USPS: 20; 20; c. Total Paid Distribution: 9,649; 10,191; d. Free or Nominal Rate Distribution: (1) Free or Nominal Rate Outside-County Copies included on PS Form 3541: 340; 335; (2) Free or Nominal Rate In-County Copies Included on PS From 3541: 0; 0; (3) Free or Nominal Rate Copies Mailed at Other Classes Through the USPS: 106; 120; (4) Free or Nominal Rate Distribution Outside the Mail: 413; 250; e. Total Free or Nominal Rate Distribution: 858; 705; f. Total Distribution: 10,507; 10,896; g. Copies not Distributed: 4,017; 5,222; h. Total: 14,524; 16,118; i. Percent Paid 91.8%; 93.5%; 16. Electronic Copy Circulation, a. Paid Electronic Copies: 1,033; 1,083; b. Total Paid Print Copies + Paid Electronic Copies: 10,682; 11,274; c. Total Print Distribution + Paid Electronic Copies: 11,540; 11,979; d. Percent Paid (Both Print & Electronic Copies): 92.6%; 94.1%; I certify that 50% of all my distributed copies (Electronic & Print) are paid above a nominal price. 17. Publication of Statement of Ownership: Will be printed in the Spring 2021 issue of this publication. 18. I certify that all information furnished on this form is true and complete. I understand that anyone who furnishes false or misleading information on this form or who omits material or information requested on the form may be subject to criminal sanctions (including fines and imprisonment) and/or civil sanctions (including civil penalties). Signature and Title of Editor, Publisher, Business Manager, or Owner: Dana Triwush, Publisher, October 1, 2020

aperture

The Magazine of Photography and Ideas

Editor
Michael Famighetti

Senior Managing Editor
Brendan Embser

Assistant Editor
Nicole Acheampong

Copy Editors
Olivia Casa, Donna Ghelerter

Senior Production Manager
True Sims

Production Manager
Andrea Chlad

Art Direction, Design & Typefaces
A2/SW/HK, London

Chief Operating Officer
Dana Triwush
magazine@aperture.org

Director of Brand Partnerships
Isabelle Friedrich McTwigan
212-946-7118
imctwigan@aperture.org

Advertising
Elizabeth Morina
917-691-2608
emorina@aperture.org

Executive Director,
Aperture Foundation
Chris Boot

Minor White, Editor (1952–1974)

Michael E. Hoffman, Publisher and Executive Director (1964–2001)

aperture.org

FUJIFILM
X | GFX

BUILD YOUR LEGACY™
WITH FUJIFILM X-S10

| X-TRANS 26.1 MEGAPIXEL BSI CMOS 4 SENSOR | X-PROCESSOR 4 QUAD-CORE IMAGING ENGINE | ISO 160-12,800 SENSITIVITY RANGE | UNPARALLELED 5-AXIS IMAGE STABILIZATION | PROFESSIONAL 4K VIDEO AT 30 FPS |

MOYRA
DAVEY

THE
SHAPELESS
OF DEATH

PETER
HUJAR

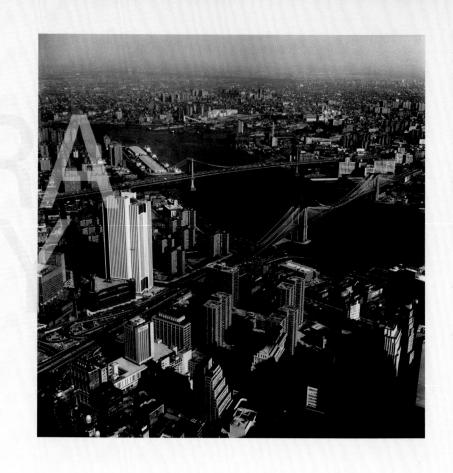

Agenda
Exhibitions to See

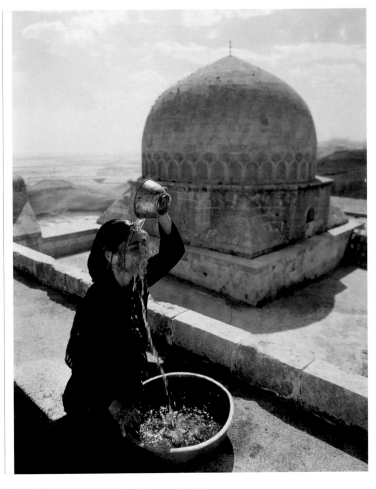

Shirin Neshat

In 1975, the artist Shirin Neshat left her home of Iran to attend school in California. She didn't return to her birthplace for another fifteen years. During her time away, the Islamic Revolution and then the Iran-Iraq War shifted the country's face past Neshat's recognition. That cultural dislocation is the thematic heart of an exhibition of three decades of Neshat's photography and video at the Modern Art Museum of Fort Worth, in Texas. *Shirin Neshat: I Will Greet the Sun Again*—featuring more than two hundred of her works from her iconic early projects such as *Women of Allah* (1993–97) to her recent series *Land of Dreams* (2019)—considers themes of immigration and exile. "Her work is so important for what it says about gender and ideology and the complications of living between two cultures," says Andrea Karnes, a senior curator at the museum. "Although the exhibition strikes a very serious tone, it's also incredibly poetic."

Shirin Neshat, *Soliloquy Series*, 2000
© the artist and courtesy Gladstone Gallery, New York and Brussels

Julio Agostinelli, *Circus (Circense)*, 1951
© Estate of Julio Agostinelli and courtesy the Museum of Modern Art, New York

Fotoclubismo

"Why are we so dismissive of amateur work?" asks Sarah Meister, a curator at the Museum of Modern Art in New York. In *Fotoclubismo: Brazilian Modernist Photography, 1946–1964*, Meister reexamines the status of the amateur via São Paulo's Foto Cine Clube Bandeirante, a collective of photographers, many of whom have yet to receive their due of accolades outside of Brazil. Most of the club's members held day jobs; photography was not their profession. Yet while these artists were amateurs, their craft was highly cultivated, with members hosting one-person photography exhibitions at the city's major museums, in an energetic, local art culture. *Fotoclubismo* includes works from artists such as Geraldo de Barros, Thomaz Farkas, and Gertrudes Altschul, and is united by an attentiveness to the balance of human and architectural forms and to the texture and tenor of urban life.

The New Woman

Pioneers of modernism are at the center of *The New Woman Behind the Camera*, an extensive survey of over 120 women photographers from the 1920s to the 1950s, which will be presented this year at the National Gallery of Art, in Washington, D.C., and travel to the Metropolitan Museum of Art, in New York. The curator Andrea Nelson was inspired by Ilse Bing, the German photographer who worked for *Le Monde Illustré* and *Harper's Bazaar* before the onset of World War II and was known as "Queen of the Leica." Although Bing, Claude Cahun, Florence Henri, and Germaine Krull are canonical figures today, mostly due to the revisionist work of feminist curators, Nelson looks globally at the phenomenon of the "new woman," as both icon and operator, and highlights lesser-known practitioners. In the 1940s, Esther Bubley, for example, worked for the Office of War Information in Washington, D.C., where she made a pensive photograph of her sister at a boardinghouse. Nelson notes the "dynamic sense of space" and the social record Bubley provides of independent, working women fashioning new ways of living.

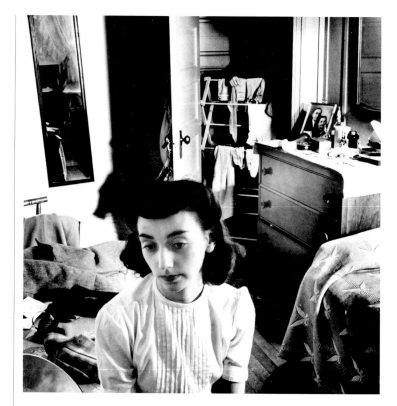

Esther Bubley, *Young woman in the doorway of her room at a boardinghouse, Washington, DC,* **1943**
Courtesy the National Gallery of Art, Washington, D.C.

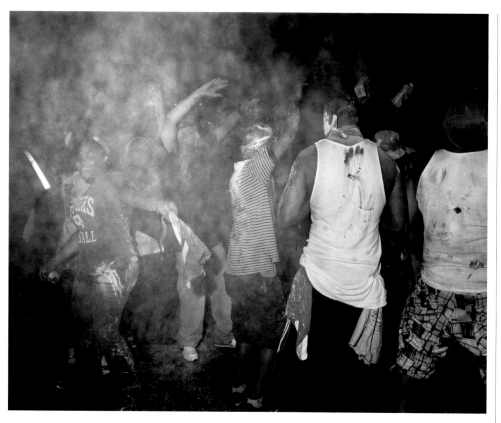

Deana Lawson, *Jouvert,* **2013**
© the artist and courtesy Sikkema Jenkins & Co., New York

Grief and Grievance

Okwui Enwezor originally imagined *Grief and Grievance: Art and Mourning in America*, a trenchant examination of Black mourning and white nationalism in the United States, would open at the New Museum, in New York, in fall 2020. The exhibition, with works in photography, video, and other media by artists such as LaToya Ruby Frazier, Carrie Mae Weems, Deana Lawson, and Arthur Jafa, was intended to consider parallels between the civil rights movement and Black Lives Matter—and would have seemed custom-built for addressing the past year. Yet Enwezor died in 2019. And while he didn't witness the collective national trauma wrought by the pandemic and the murder of George Floyd, there's "nothing prophetic" about his vision, says the New Museum artistic director Massimiliano Gioni, who, together with a team of advisers, presents *Grief and Grievance* this spring. With "clear-eyed realism," Enwezor selected works whose meanings would reverberate. "He could look at the present from a different perspective," Gioni says of Enwezor, "and act on the present, to create a different future."

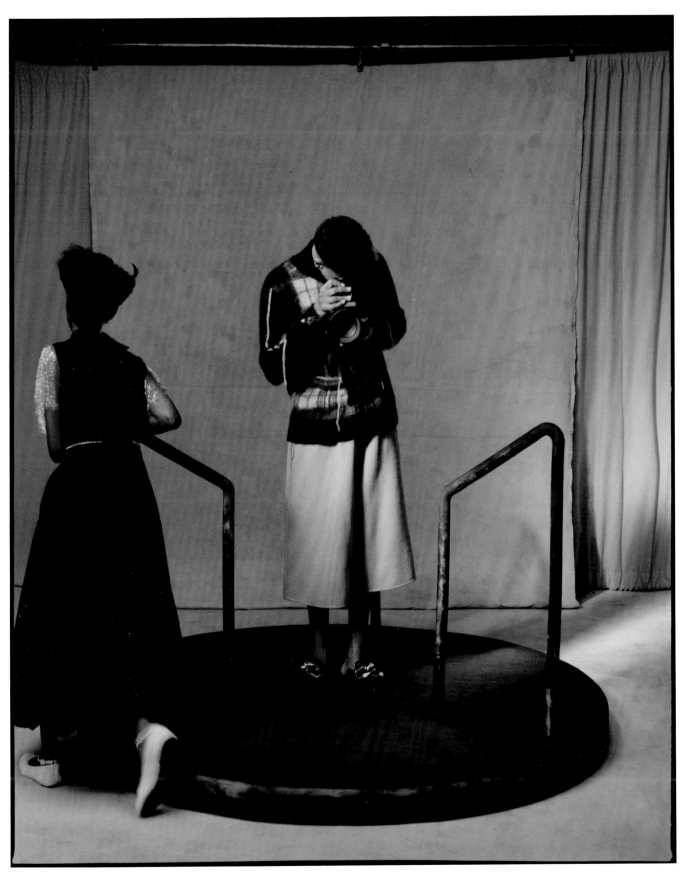

PHOTOGRAPHS
April 10 | Live & Online

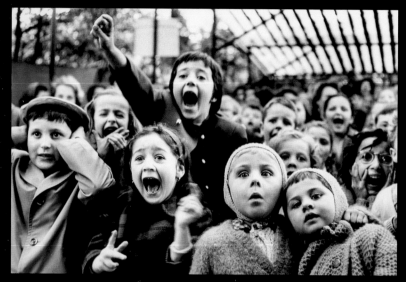

Alfred Eisenstaedt
Children at a Puppet Theatre, Paris, 1963
Estimate $20,000-30,000

Robert Mapplethorpe
Portrait of Roger, 1983
Estimate $6,000-$8,000

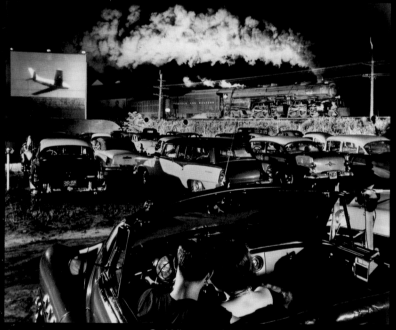

O. Winston Link
Hot Shot Eastbound, Iaeger Drive-in,
Iaeger, West Virginia, 1956
Estimate $6,000-8,000

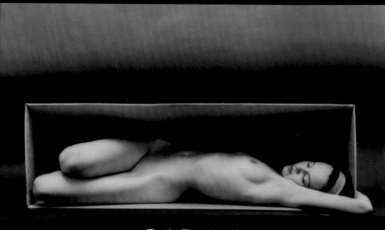

Ruth Bernhard
In the Box-Horizontal, 1962

**View Online Catalog and
Bid at HA.com/8041**

**Inquiries
Nigel Russell**
212.486.3659 | NigelR@HA.com

Day Jobs

In the 1970s, Jim Goldberg collaborated with children on a series of mind-expanding photograms.
Rebecca Bengal

Last fall, from his studio in Northern California, where the skies were orange with wildfires, Jim Goldberg rattled off a photographer's résumé: "Oh, I worked at Burger King. I drove a laundry truck. I was a tree planter in a forest collective. A housepainter. I worked in a Clairol factory making curlers. I worked as a cook. I was a camp counselor. I worked a lot of jobs, like everybody. Never a waiter though."

A work-study gig in the early 1970s at a university-run children's day care was the job that took hold. Goldberg had dropped out of theology studies at Hofstra University and moved cross-country, joining a friend in Bellingham, Washington, where he transferred to Fairhaven College of Interdisciplinary Studies at Western Washington University

("a real hippie, Ken Kesey kind of school"). Secretly, he wanted to become a photographer. "I thought I could use the camera as a way to draw out what it was that I was thinking, or what I wanted to ask the people in my photographs," he told me.

The fact that Fairhaven offered no photography major simply meant that Goldberg had the darkroom mostly to himself. He bought odd-sized, expired photographic papers on sale. And for two years, he taught at the day care. He read stories and sang the children songs in a language they invented together. Eventually, he invited them into the darkroom.

The children were three, four, five years of age. With Goldberg, they made photograms using objects collected from home or on nature walks. "They'd draw

something on the photographs and say, 'That's a frog,' or whatever it was to them." Bones, potatoes, lemons, a monster. "I was using their direction as the cue as to how to see," he said.

In the more abstract photograms, amorphous forms resist being reduced to anything explainable, retaining the inherently inscrutable essence of the imagination. One particularly crowded brain resembles an X-ray of strange swallowed objects—"plane crash, gun, store, sea dragon, blood, house (brown), me (as baby) inside my mom's belly, brain"—the contents of a child's absorbed consciousness.

After graduation, the photograms stayed packed up, moving with Goldberg from place to place over the years. In 1976, he went to San Francisco, joined a "collective household in the Mission," and enrolled in his first "real" photography course, at the Lone Mountain College, with Larry Sultan, who would become a profound influence.

The desire to know what was inside other people's heads resurfaced when Goldberg began to meet strangers on the street, follow them to the homes and hotels where they lived, and make photographs. He invited them to inscribe their thoughts and feelings in the margins of the frame. "I didn't feel *I* could say who they were, but I thought if they could, then they would be more themselves," he says. "The work would be more collaborative." For his final project in Sultan's class, Goldberg made a little book of these images overlaid with the handwritten inscriptions. "I just wanted something that's real. Something that's honest, that gives a portal into this other life."

For eight more years, Goldberg continued making annotated pictures, an approach that would form his landmark 1985 book, *Rich and Poor*, and become a way of working that, like the day care photograms now pinned to his studio walls, has remained with him in projects and books such as *Nursing Home* (1988) and *Raised by Wolves* (1995). It is its own made-up language, a mingling of others' words and his pictures—an ongoing attempt to collectively show and tell the secrets and mysteries lurking inside our heads.

Jim Goldberg, *Untitled Photogram #3*, 1974
Courtesy the artist and Casemore Kirkeby, San Francisco

Rebecca Bengal is a writer based in New York.

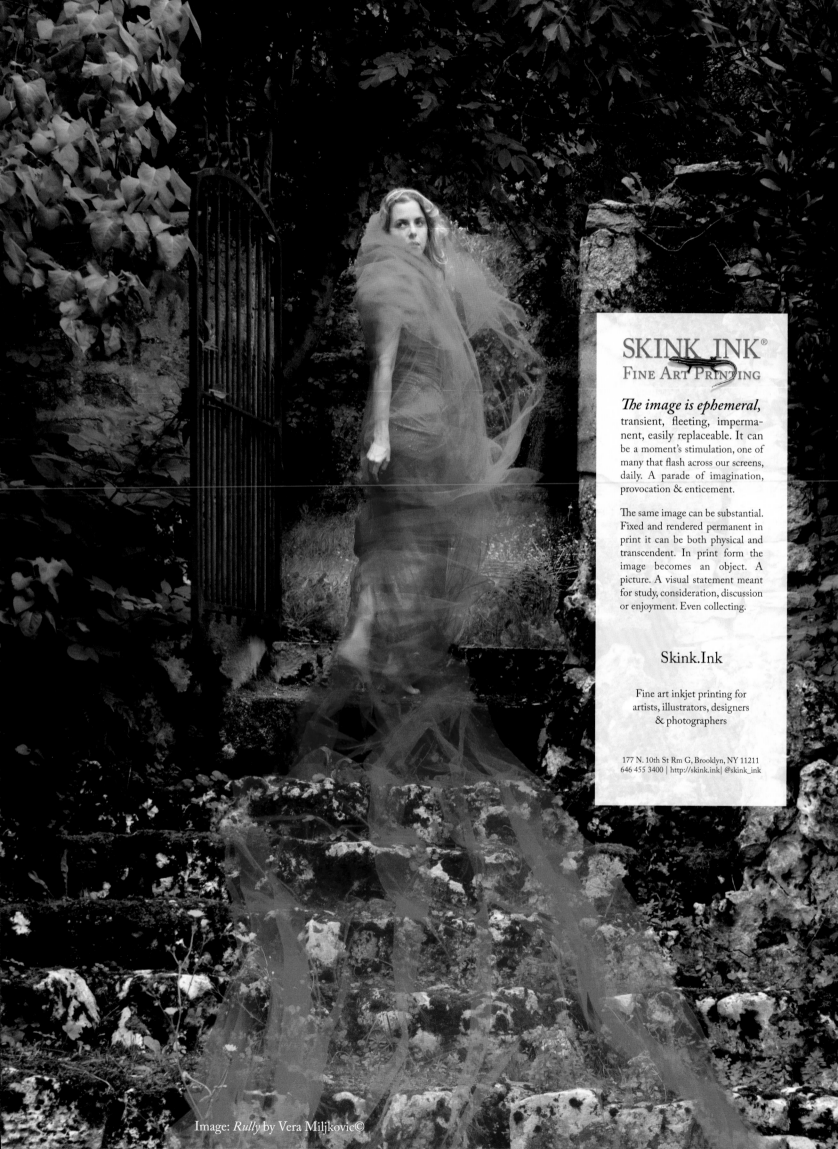

Image: *Rully* by Vera Miljkovic©

Backstory

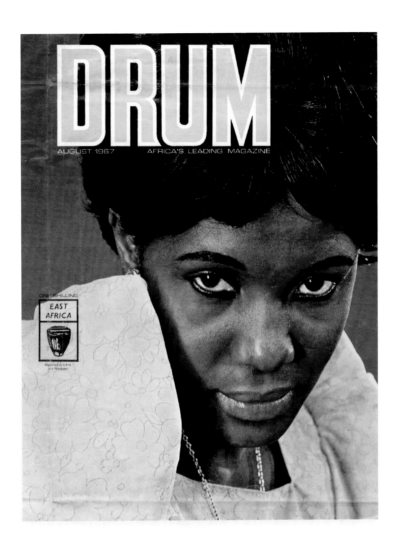

A solo exhibition celebrates six decades of James Barnor's photography in Ghana and the United Kingdom.

Rianna Jade Parker

James Barnor's deeply personal artistic practice has traversed cities, continents, and genres over six decades, all in reverence of the African diaspora. Barnor is a newsman, studio photographer, and fashion image maker. But the too common neglect of Black artists in the art world means his genteel images have been presented only on a handful of grandstand stages, beginning with exhibitions in London, in 2010, and Ghana, in 2012. Now, art history is finally catching up. Barnor, who was born in Ghana in 1929, was pronounced a 2020 recipient of the Royal Photographic Society Awards, and his work will be the subject of a solo exhibition at the Serpentine Galleries this year.

The result of cataloging tens of thousands of photographs, the eponymous exhibition *James Barnor* will be the most comprehensive survey of Barnor's work. Originally scheduled to open in June 2020 on the event of his ninety-first birthday, the exhibition was delayed until 2021 due to the COVID-19 pandemic. A second national lockdown in the U.K. last autumn meant that I could only speak with Barnor by phone. Barnor is forthcoming and earnest despite not being able to travel home to Ghana for the burial of his sister Ivy Barnor, who modeled for him, or his close friend Jerry John Rawlings, Ghana's former president, both of whom passed away in quick succession in November 2020. Rawlings once said, "I'm just an ordinary, hungry, screaming Ghanaian who wants to realize his creative potential. Who wants to contribute." Barnor began making his own contributions in 1950, as the first appointed photojournalist for Accra's *Daily Graphic*, a state-owned newspaper. Self-motivated and eager, Barnor captured a nation remaking itself. Twenty-eight years after Barnor's birth, Ghana would gain independence from Britain in 1957.

Whispered news spread that Ghana was planning to introduce color television, and it was impressed on Barnor how invaluable it would be for him to travel and learn new imaging techniques to bring back home to Ghana. Taking heed, Barnor left behind his first, and successful, portrait studio, Ever Young, in Jamestown, a neighborhood of Accra, frequented

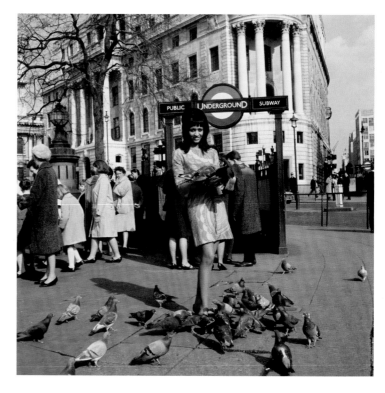

Black women became symbolic repositories of glamour, style, and Black social life in Barnor's photography.

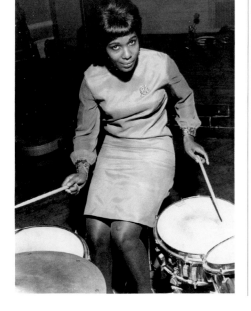

by young couples, artists, and government officials, and arrived in London on December 1, 1959. Looking at a 1952 self-portrait with Kwame Nkrumah, who would become the first prime minister and president of Ghana, it's easy to imagine the kind-eyed young man who arrived in the London metropolis curiously enchanted, unaware of the literal and figurative cold challenges ahead.

In the 1960s, Black photographers were not actively employed in the United Kingdom, and only on occasion would some be assigned to jobs in darkrooms, out of sight. In his first years in London, Barnor worked multiple jobs to generate enough income. He attended Medway College of Art, in Kent, for two years (despite not having a general certificate of education), learning how to take photographs, process film, and print in color. He also worked at the Colour Processing Laboratory, where he was eventually promoted to an assistant technician.

During this time, when fashion was limited to very specific European ideals of beauty, Black women would become symbolic repositories of glamour, style, and Black social life in Barnor's photography. Erlin Ibreck and the Jamaican-born Rosemary "Funflower" Thompson frequented his editorials for *Drum*, the anti-apartheid South African lifestyle and politics magazine, which had offices and editions in various African cities and was distributed internationally. *Drum*'s London office on Fleet Street became

a personal and professional safe home for Barnor. His sitters were aspiring models, passersby, and, in one case, a London bus driver, but all were effortlessly alluring and a much-needed counterimage to the esteemed British swinging '60s model Twiggy. On a trip to London, the Ugandan musician and singer Constance Mulondo was photographed for the August 1967 *Drum* cover. Her oval eyes are framed with thick black eyeliner and her chin is angled downward, nestled into the powder-blue collar of her dress.

Barnor returned to Ghana in 1969, as a representative for Agfa-Gevaert, to introduce color-processing facilities in Accra; soon after, he established a new portrait studio, Studio X23, which ran from 1973 to 1992. But in 1994, Barnor chose to adopt London as his permanent home. There, he developed a brotherhood with the younger Black British photographers Neil Kenlock and Charlie Phillips that continues through the pandemic. That sense of community has been visible in Barnor's work all along. "What unites all the images is Barnor's extraordinary ability to make visible his personal connection to his sitters," says Lizzie Carey-Thomas, the chief curator of the Serpentine Galleries. "As he has stated: 'People are more important than places.'"

Rianna Jade Parker is
a writer, curator, and
researcher based in South
London and a contributing
editor of *Frieze*.

Curriculum
By Rinko Kawauchi

With her poetic meditations on the textures of daily life, Rinko Kawauchi has for two decades honed and evolved a startlingly fresh way of seeing the world. Her first photobooks, with their methodical sequencing, harmonize cycles of life and nature's formal beauty, proving that small miracles of vision can be found in unexpected places and objects—an illuminated spoonful of fish roe, a hole carved into a sandy beach, a cracked watermelon. Shifting light, an encroaching shadow, or a sudden gust of wind often transform what is before her lens. "Whenever I'm taking pictures," Kawauchi says, "I need to discover something. I want an impression from the object."

Leiko Ikemura

The first time I met Leiko Ikemura was at her atelier in Cologne. I had been commissioned to photograph the artist as she worked. Once Ikemura started, the entire atmosphere of the place changed, as if we'd been transported to a completely different space and time. The phrase "to concentrate is to empty the mind" came to me as I watched, and I felt compelled to dive with her into this world beyond language. Ikemura faced away from me while she sculpted, and as I observed her complete absorption, it was as though I were watching a scene of prayer. Even now, that image of her working pops into my head from time to time and always encourages me.

Sally Mann, *Immediate Family*, 1992

Immediate Family contains photographs the artist Sally Mann took, using a large-format, 8-by-10-inch camera, of her three children amid the natural beauty of the Virginia countryside. When I picked this book up for the first time, I'd just begun my own career as a photographer. As soon as I opened the pages, I was overcome by the desire to possess it. This was the first photobook to affect me in that way. *Immediate Family* has a special place in my heart because of that reaction.

Rei Naito

Rei Naito creates spaces that make me nervous to enter, as if the figures I encounter there might break just by being breathed on. Yet this is precisely her power, to have you perceive the presence of these delicate, fragile forms with such intensity. By the same token, with Naito's art I feel like I myself am accepted in these spaces—they produce a soft fluttering deep in my chest. Experiencing her work evokes the quiet wish that I could engage this way with the world at large.

Han Kang, *The White Book*, 2016

The White Book, Han Kang's reflections on loss and mortality, contains words that usher me into a hushed, silent space. As I read, it's as though I'm watching snowflakes fall one by one, melting into an endless field of snow. The book design is beautiful too—layer after layer of different shades of white paper.

James Turrell

On the Japanese island of Naoshima there are opportunities to experience the works of James Turrell, whether at the Minamidera (a building that is part of the island's Art House Project), where you can gradually sense faint illumination while wrapped in the darkness of the installation *Backside of the Moon* (1999), or at the nearby Chichu Art Museum, where you can be swallowed entirely by the light of his pieces. I feel that his work creates entirely new sensations that are also, paradoxically, strangely nostalgic, as if I were experiencing my own origins. Turrell inspires me to conjure a similar response in my art.

Jiddu Krishnamurti, *Krishnamurti to Himself: His Last Journal*, 1987

I have a habit of picking up the book *Krishnamurti to Himself* and reading a few pages from it whenever I have a pause in my work. As I flip through, peace returns to my scattered, noisy heart, and I'm able to find my center again. Reading Jiddu Krishnamurti always leaves me feeling as though I've just meditated, and so I keep it close at hand.

Rachel Carson, *The Sense of Wonder*, 1965

The Sense of Wonder reminds me of how I related to the world as a child, the bond that existed between me and nature. It makes me remember the importance of looking, of harmony, and helps me regain the initial sense of purpose in my photography.

Seiichi Furuya

Seiichi Furuya was born in Japan but has lived in Europe since the 1970s. Being in a foreign country for so long and continuing to make art, even through the suicide of his wife and the grief that followed, must take immeasurable mental fortitude. Looking back over Furuya's photographs, I feel confronted by the harsh, exacting demands involved in facing the photographic subject. Furuya's images give me strength—as if I were standing a little taller—to contemplate them.

Translated from the Japanese by Brian Bergstrom.

Opposite, clockwise from top left: Seiichi Furuya, *East Berlin*, 1985; Alfred Eisenstaedt, *Rachel Carson*, 1962; Leiko Ikemura, *Shadow-Hair*, Berlin, 1992/2018; Rei Naito, *Matrix*, 2010; Cover of Jiddu Krishnamurti, *Krishnamurti to Himself: His Last Journal*, 1987; Sally Mann, *Torn Jeans*, 1990

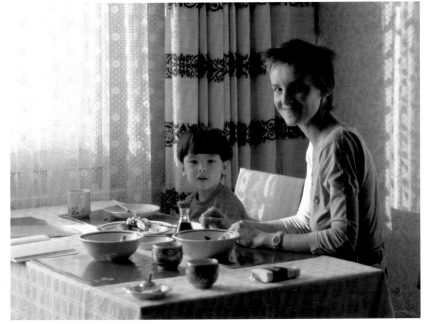

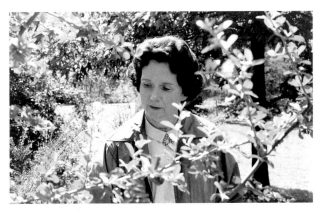

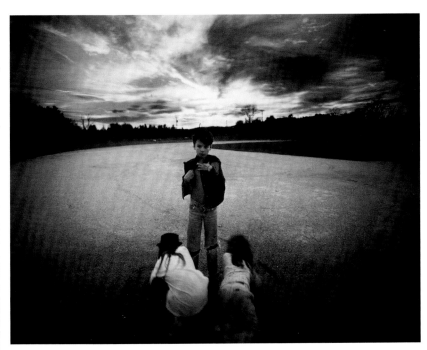

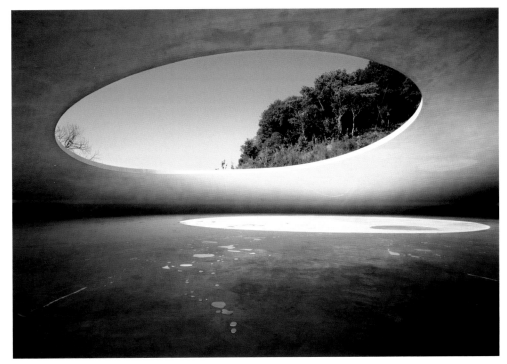

New York

The urbanist Jane Jacobs, who famously made the case for the life of New York's sidewalks, believed that New Yorkers are foot people. That may be why photographers, the ultimate foot people, thrive here, finding endless visual pleasure and contradiction in the city's frenzied theater of the everyday, whether along crammed sidewalks or down below in the aging, often-delayed subway that everyone loves, and loves to loathe. New York is a town of improvisers—and there has been no shortage of creative solutions to adapting and to weathering the trauma and challenges of the pandemic. Photographers who would usually be on the street making pictures have instead been busy organizing their archives, finding new meanings in indelible images. As they rediscover previous versions of the city, their efforts underscore that the one constant here is change. Others venture into the city's streets to bear witness to dramatic inflection points—the protests in defense of Black lives, the plight of health-care workers and first responders. Sidewalks also lead to boundless surprises, to indispensable urban idylls. A subway ride can end at a surfing spot on a wide, sandy stretch of the Atlantic. Our lives and our city have been transformed over the past year, yet the artists and writers in this issue remind us of how much there is to discover, and relish, when New York comes roaring back.

—**The Editors**

ROSALIND FOX SOLOMON'S NEW YORK

Lynne Tillman

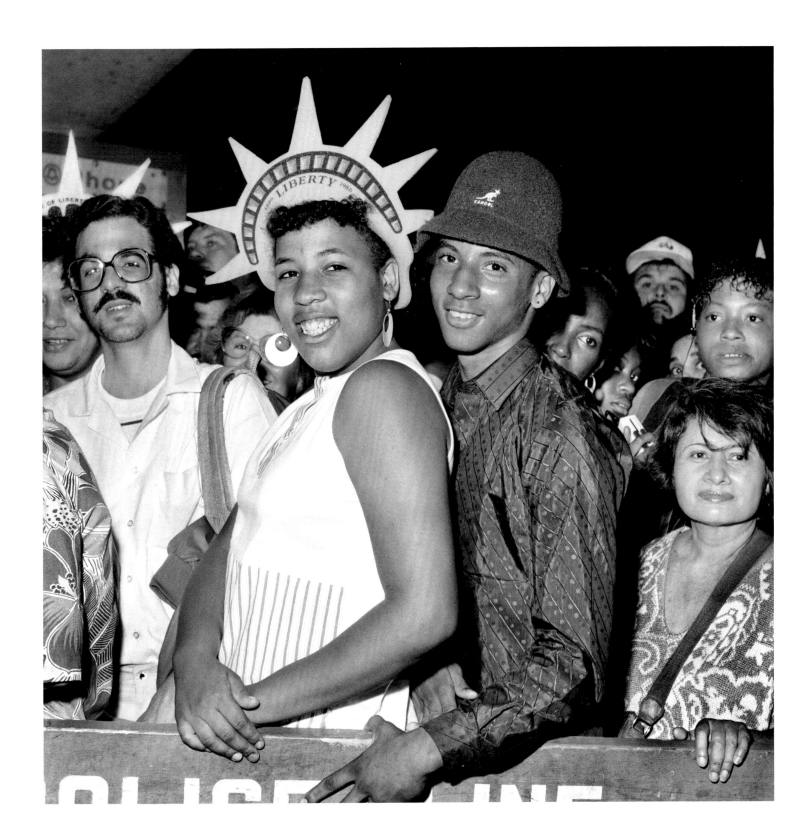

Rosalind Fox Solomon found her calling, photography, in her late thirties. Solomon's teacher, Lisette Model, encouraged her daring and self-confidence. With a camera, Solomon could view life from her own angle, her distinctive vision.

Solomon has traveled widely, photographing in Peru, the American South, Israel, and the West Bank, to name a few places. But, she tells me, "I did not find myself shooting in New York City in a different way. I made portraits of people and imagined their concerns. As I shoot, there is always inner tension, a trance-like state that contrasts with a nice-girl smile. That's how I work everywhere."

Over the last five decades, Solomon has pictured New York through its events, inhabitants, and objects. Her commitment to social justice animates her choice of subjects, and her pictures often show those who are troubled, suffering, or in crisis.

A young man with AIDS looks solemnly at the camera. He appears resolute, an implacable expression on his face. "It was wrenching shooting people with AIDS," Solomon tells me. "I met and photographed them, and some died soon after." Her exhibition *Portraits in the Time of AIDS* at New York University's Grey Art Gallery in 1988, in the midst of the epidemic, insisted on the public's awareness of the suffering of so-called ordinary people.

People in wheelchairs on the Staten Island Ferry, people standing, all with their backs to the viewer, are looking at the water or the skyline, or inwardly. What they are thinking about, how they feel, is unknowable; but imaginations are spurred to wonder.

After 9/11, handmade posters of the missing showed up on walls all over Lower Manhattan. "From a poster, I learned about the death of a friend, the artist Michael Richards," Solomon says. The attack on the Twin Towers was political, but the effects were instantly personal, each poster a death. Solomon's photograph of the desperate pleas of families and friends, and not the city's physical devastation, emphasized her concern with wrecked lives, not buildings.

A Macy's Thanksgiving Day Parade balloon, lying on a street, is a template for interpretation. This poetic image could register a tragic reality: Americans celebrate a family holiday, which elides North America's first families, almost entirely wiped out by the U.S. government. Or, it might represent the melancholy that comes after the fun ends, or how temporary pleasure is. There are many ways to see it.

People can see so differently from each other, so idiosyncratically. Eyewitnesses have different eyes. There may sometimes be a consensus about a photograph—this is a good picture—but judgments about its meanings vary. Photographs don't reveal themselves, don't investigate, don't tell us how to see them. Reactions to any picture depend on a viewer's subjectivity, psychology, sympathies, sensibility, and more. An understanding of that dissonance inheres in Solomon's imagery. These photographs are gentle, also tough and unsentimental, sometimes tender yet unsettling.

Solomon's New York photographs look at the past and augment public and private histories. They are impressions of what compelled her, or disturbed her, about how people lived and what shaped their lives. Her photographs intend an intimacy, a connection and closeness to this place.

Looking at this work now, Solomon says, "I am struck by the fact that my themes and interests are consistent—people, their differences and similarities; relationships; and issues such as race relations, politics, women's roles, illness."

Lynne Tillman is the author, most recently, of the novel *Men and Apparitions* (2018).

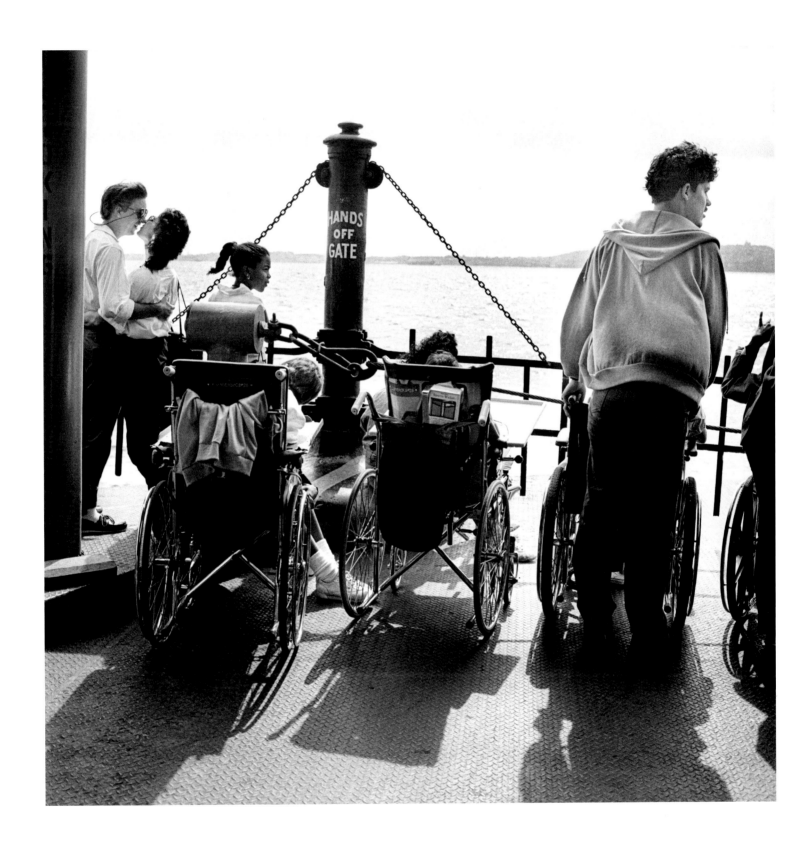

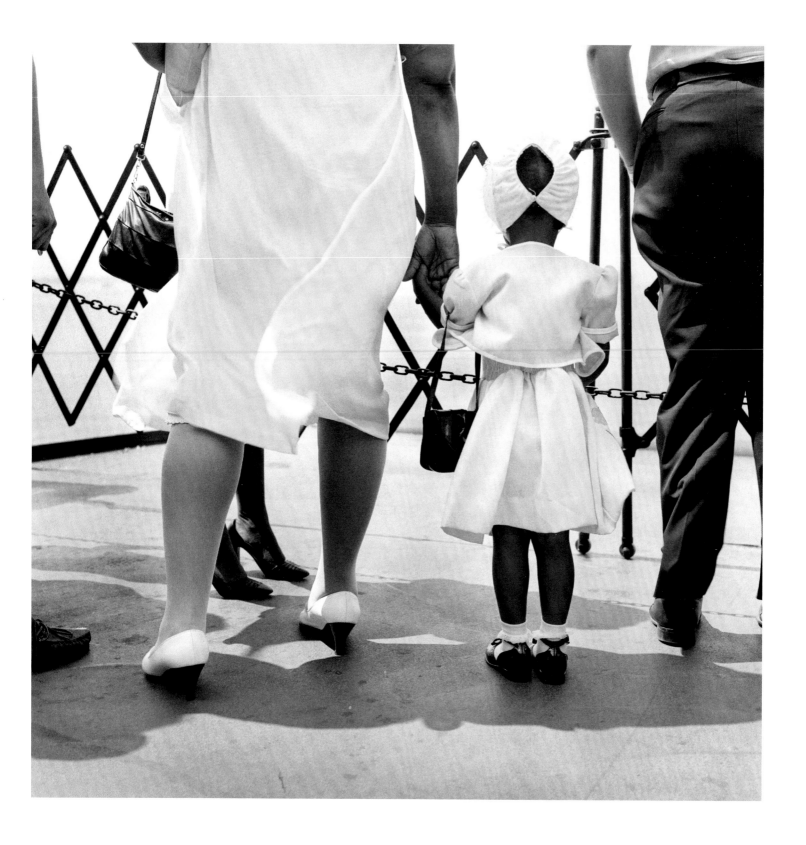

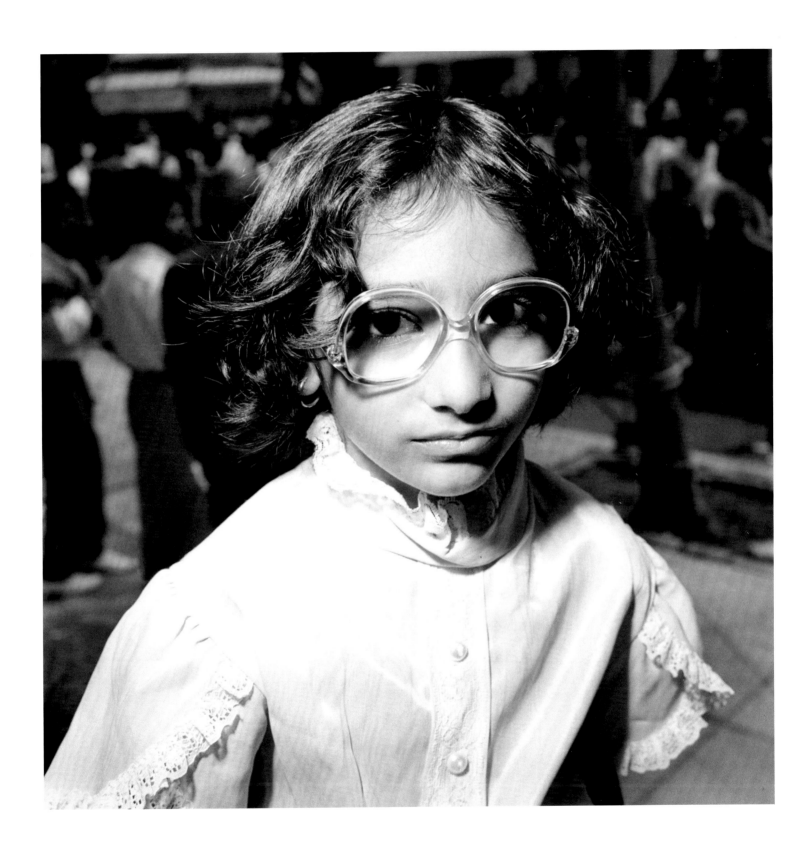

The Artist's Wife, Meta
Cohen Bolotowsky, 1978

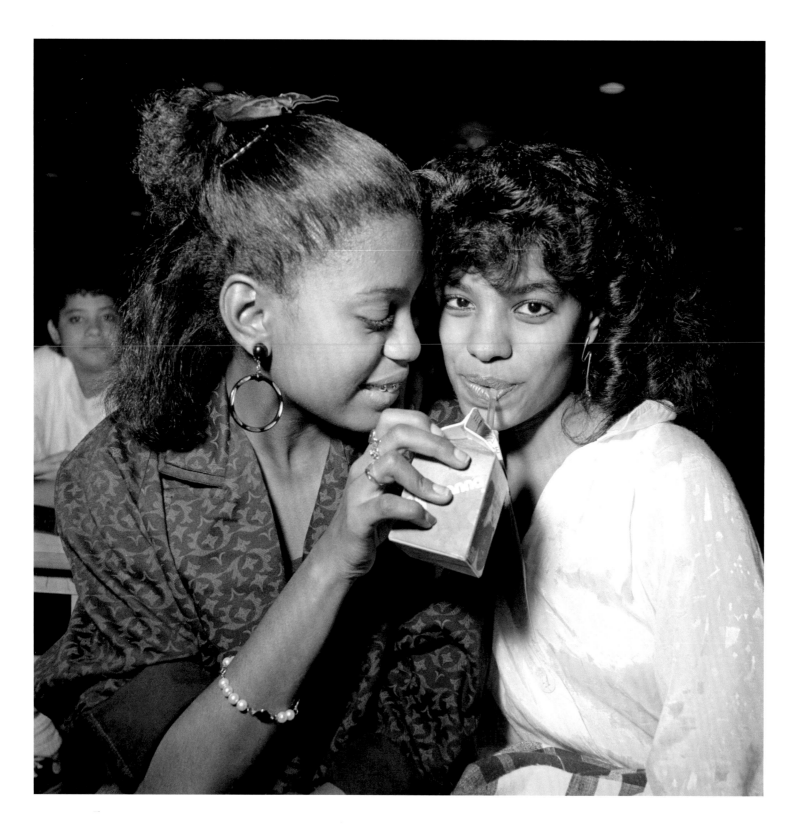

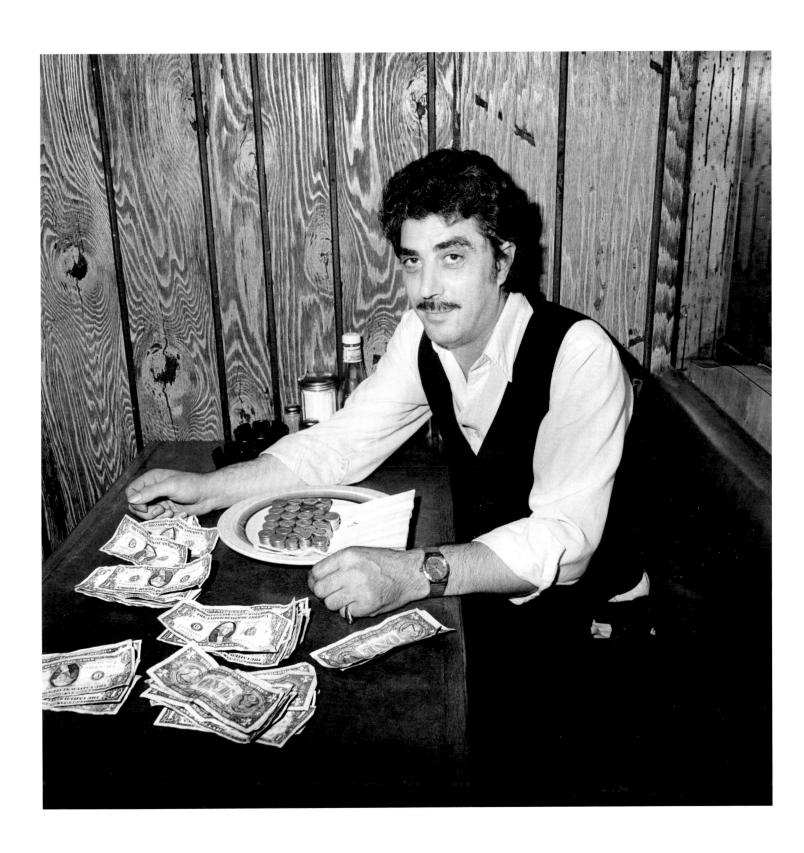

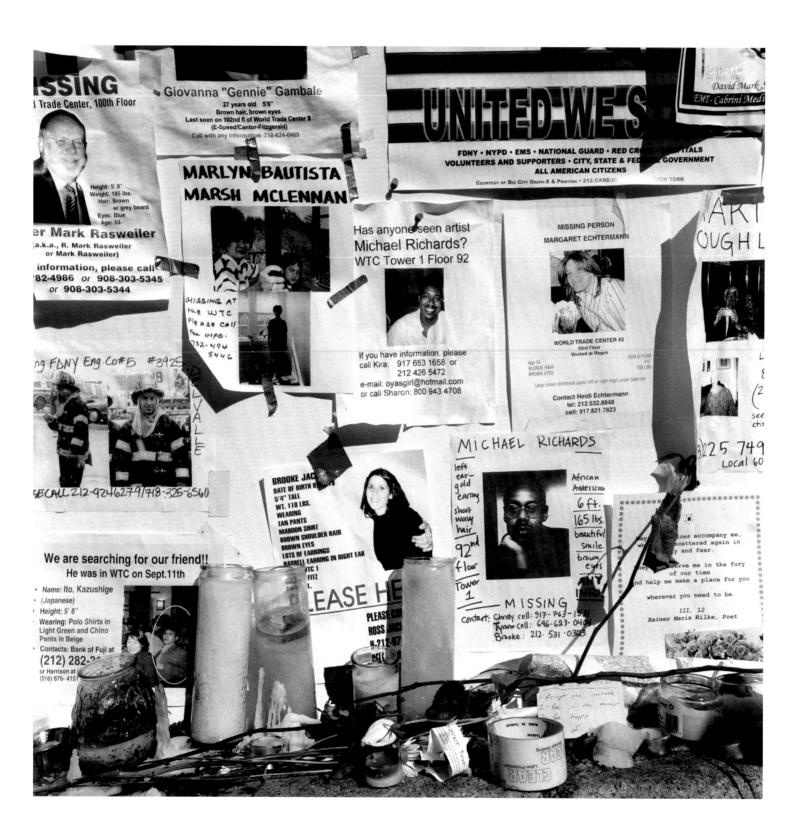

Singing Revival, Washington Square Park, 1986
All photographs courtesy the artist

Julian Rose
Taking Flight

Like many of Berenice Abbott's iconic photographs of 1930s New York, *Downtown Skyport* (1936) offers a glimpse into a lost world. The gleaming biplane moored in the foreground now looks as quaint as the relics of the vanishing Gilded Age metropolis visible in some of Abbott's other photographs—horse-drawn peddlers' carts, rickety el stations—must have once appeared to her. This cycle of reverberating nostalgia was preordained by the title Abbott chose for the seminal collection of these images she published in 1939: *Changing New York*. What was then new is now old; what was then old is now gone. Change is inexorable, Abbott seemed to be saying, and her mission was to preserve a moment in the city before it passed into the slipstream of history.

Abbott's iconic photographs of 1930s New York offer a glimpse into a lost world.

This, at least, is how the book has most often been understood. Abbott's work was underwritten by the Federal Art Project and is often compared with the famous documentary projects by Walker Evans and Dorothea Lange that emerged from similar New Deal programs. Yet Abbott's original proposal was substantially edited to maximize its sentimental appeal to visitors descending on the city for the 1939 world's fair, the very theme of which—"Building the World of Tomorrow"—expressed a triumphalist faith in the forward march of progress. The full extent of these revisions was long unknown until the recent publication of *Documentary in Dispute: The Original Manuscript of "Changing New York" by Berenice Abbott and Elizabeth McCausland* (2020), in which the scholar Sarah M. Miller painstakingly reconstructed the project, which included lengthy captions by McCausland, Abbott's partner and a well-known art critic. This new volume suggests that Abbott was less concerned with the disappearance of history than with its uncanny persistence. Her goal was to reveal the paradoxical ways in which material residues from different times could overlap within the same urban space—what she described as "the past jostling the present."

True to form, *Downtown Skyport* does not mark a single point on the timeline of New York's development; it takes a synchronic slice through three distinct, if interpenetrating, temporalities. The five- and six-story brick buildings in the middle distance are hanging on from the nineteenth century, when they were established as the downtown urban fabric, even as they are squeezed from beside and behind by the vast grids of the new steel-frame, stone-clad skyscrapers that were proliferating downtown as Abbott took her photographs. The Skyport, meanwhile, with its state-of-the-art seaplanes, suggests a fantastic future that is already arriving: an era of air taxis, zeppelins, and other as-yet unimagined technologies.

By emphasizing the uneven nature of change in New York, Abbott also called attention to the painfully contradictory social realities of urban flux. The 1930s skyscrapers in this image are now beloved for their multitiered Art Deco look, but back then they were recognized for what they were: a new building typology that emerged directly from the drive to maximize profits. Their ziggurat forms were, in fact, developed as a clever response to New York's zoning ordinances, enabling architects to provide the absolute maximum floor area within the allowable building envelope. Though built by the city (at a cost of five hundred dollars, with WPA labor), the Skyport was hardly a public amenity—it was used primarily to bring the offices of Wall Street executives within commuting distance of their Long Island estates. As McCausland put it in a particularly caustic passage, unsurprisingly excised from the published book, "these things represent power in brutally quantitative terms."

Look again at *Downtown Skyport*, and Abbott's city appears remarkably familiar today. Those specific low-rise buildings have been demolished, but the style of their brick arches and wrought-iron fire escapes is still ineffably New York. Both of the skyscrapers pictured remain standing, though they are now flanked by glass prisms erected in the intervening decades. The one in the background, 70 Pine Street, housed the world headquarters of AIG until the firm was bailed out by the Federal Reserve in 2008, and in 2016 it was converted into luxury apartments, suggesting that even at almost a century old such buildings are reliable bellwethers of the political and economic forces shaping the city.

But it is the Skyport that resonates—and rankles—most of all. The helicopter may have replaced the biplane, but the idea that wealth entitles some residents to enjoy the best of New York and avoid the worst—to be in the city but not of it—remains unchanged. Indeed, aerial access is now de rigueur for both luxury residential and high-end office buildings; as the website for one new development puts it, "the helipad ensures the ultimate in luxury and convenience." And in the midst of a pandemic—when avoiding congestion is a matter not just of luxury and convenience but of life and death—helicopter commuting is at a record high.

Adherents of documentary photography have long touted its ability to demystify and unmask, to reveal things as they really are. But in this moment when grim realities are glaringly, terrifyingly visible, we might look to Abbott's work less to help us see what is hidden than to teach us to look in a new way. To be alive to the contradictions moving within our city is not only to recognize things as they are but to begin to imagine things as they might be. Perhaps her images, in other words, show not only how the past jostles the present but how the present can jostle the future.

Julian Rose is an architect and critic based in New York.

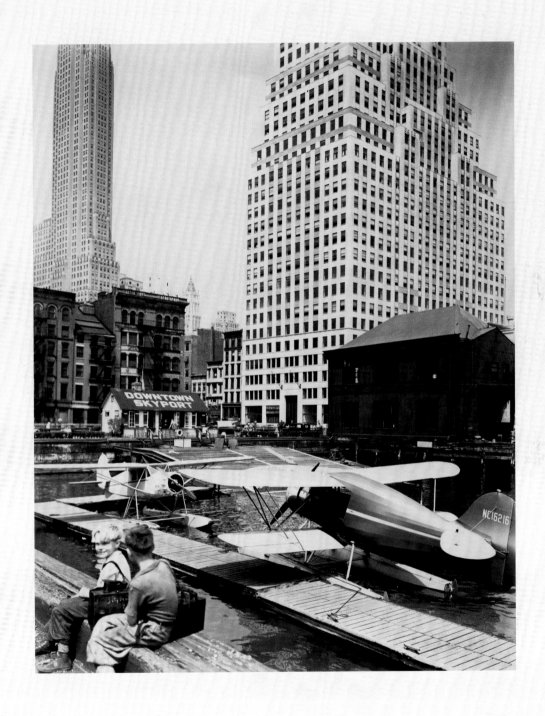

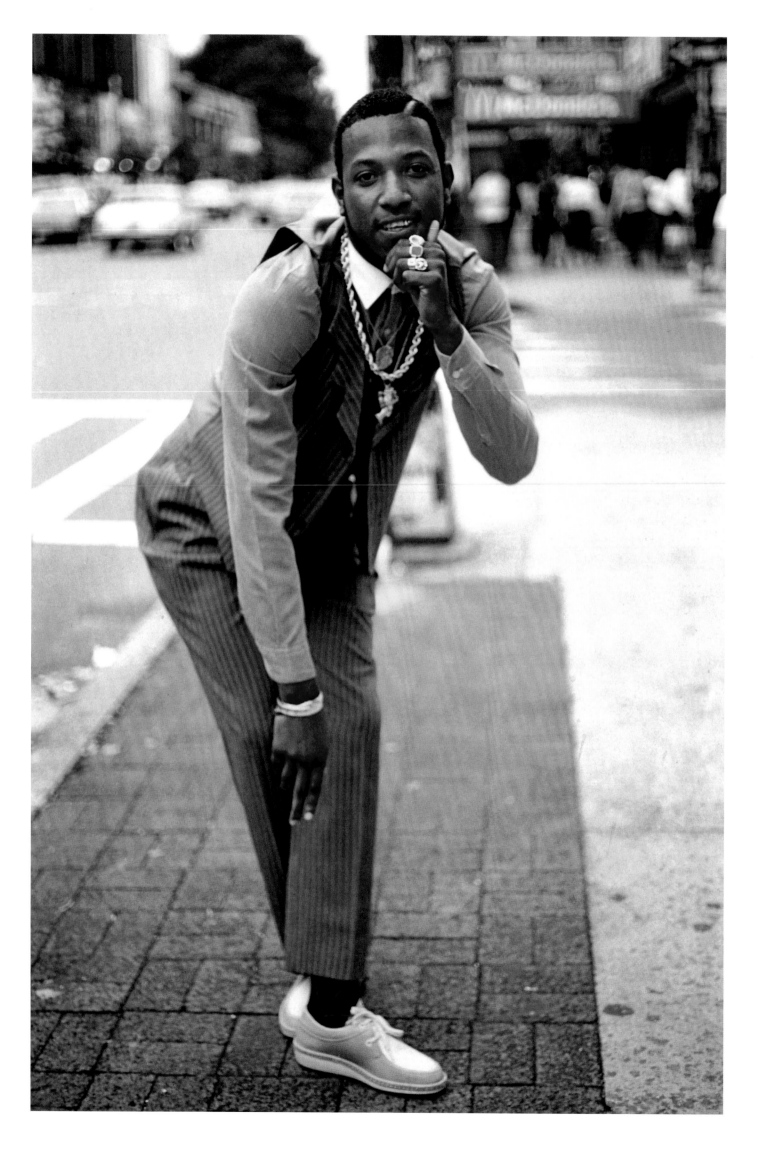

Since the early 1980s, Jamel Shabazz has captured the energy of street life and hip-hop culture in New York. During quarantine, he organized his vast archive, uncovering indelible images of joy, style, and community.

The Alchemist

Tanisha C. Ford

New York is a ghost town. The COVID-19 pandemic has brought the metropolis to a standstill. Many are scared to even leave their apartments to buy groceries. The globe-trotting photographer Jamel Shabazz is tucked away in his Long Island home, his "sanctuary." Shabazz's world is rocked daily by yet another phone call announcing the death of a loved one. It is a calendar of loss with which he is intimately familiar. He survived the 1980s crack era and the AIDS crisis, when so many friends from his Brooklyn neighborhoods— Red Hook and then East Flatbush—did not.

Every morning, while living under quarantine, Shabazz saunters into one of the several closets in his home and picks up a heavy archive box. Hundreds of identical boxes line every available space in his home. They are organized chronologically and then subdivided by type: black and white, color, medium format, and so forth. One box, just like the others, holds bits of time frozen on negatives, slides, and photographic prints. It is an archive so vast (which even contains the negatives belonging to his father, who was also a photographer) that when asked about the quantity, Shabazz replies, "I just can't give a count." He carries the box into the center of his work-space floor. This is a new routine that has become the only consistent thing in uncertain times. Shabazz will spend the next

eight hours meticulously sifting through the box, rediscovering faces and city landscapes that he had forgotten even photographing. He scans some of his faves. Then he posts them on his Instagram, sometimes with an accompanying music track, sometimes not. Within seconds, likes and comments from his one-hundred-thousand-plus followers of all ages, from around the world, start flooding in. Those frozen bits of time still elicit the same delight, pride, and awe as they did in the '80s and '90s.

"I think I'm an alchemist," Shabazz tells me. "I freeze time and motion." It is as if this moniker were a new revelation, the result of now having the time and space to reflect on his odyssey into professional photography. When examined as a whole, Shabazz's brand of portraiture cannot, and perhaps should not, be characterized simply as street photography or fashion photography. He says he is an alchemist. I believe him.

In the early '70s, the Shabazz home in Red Hook was alive and buzzing with the funky sounds of Marvin Gaye, the Jackson 5, and Earth, Wind & Fire. And books. There were tons of books. Books on politics, photography, and culture were neatly organized on a massive wall of shelves. "My father had a really vast library of books, and I would go through every single book he had in the house," he

Page 36:
Rude Boy, East Flatbush,
Brooklyn, 1982

This page:
Rolling Partners,
Downtown Brooklyn,
1982; opposite: *Styling
& Profiling*, Flatbush,
Brooklyn, 1980

remembers. "*National Geographic*, *Life* magazine—all those publications informed me." Shabazz, who had developed a serious speech impediment when he was quite young, discovered that while he struggled to communicate verbally, he could get lost in the worlds of his father's books and album covers. Leonard Freed's *Black in White America* (1968) was among Shabazz's favorites. He flipped through it so often during his adolescent years that the book had fallen apart by the time Shabazz reached high school.

To escape the brewing trouble that was ensnaring many Black boys in Brooklyn in the waning years of the Black Power movement, Shabazz made the decision to enlist in the army as soon as he could. In 1977, a seventeen-year-old Jamel Shabazz was assigned to a post just outside Stuttgart, Germany. He followed the lead of an older Black soldier who carried his camera with him everywhere he went. "For practically everybody who was in the military, a camera was the biggest thing to have. Because for them, they were getting away for the very first time. So it's through that experience that they brought home photographs." Shabazz's Canon AE-1 became his closest companion. He snapped pictures of everything he saw and tasted as he moved through Germany. He became something of an ethnographer, translating the subversive spirit of the Black poets he was discovering—Sonia Sanchez, Nikki Giovanni, and Amiri Baraka—as he manipulated the camera's aperture and shutter settings.

After one tour in the army, Shabazz returned home to Brooklyn, in 1980, a changed man. "I came home a revolutionary," he recalls. No longer enticed by the lures of street life, Shabazz wanted to create real change in his community. The 35mm camera that he had learned to use in the army would be key to his revolutionary arts ministry. Shabazz proclaims, "My journey has never been about wanting to be a photographer. The primary vision was to save our people." His mission was to mobilize those the Black Panthers referred to as the "lumpen proletariat"—gangsters,

After one tour in the army, Shabazz returned home to Brooklyn, in 1980, a changed man. "I came home a revolutionary."

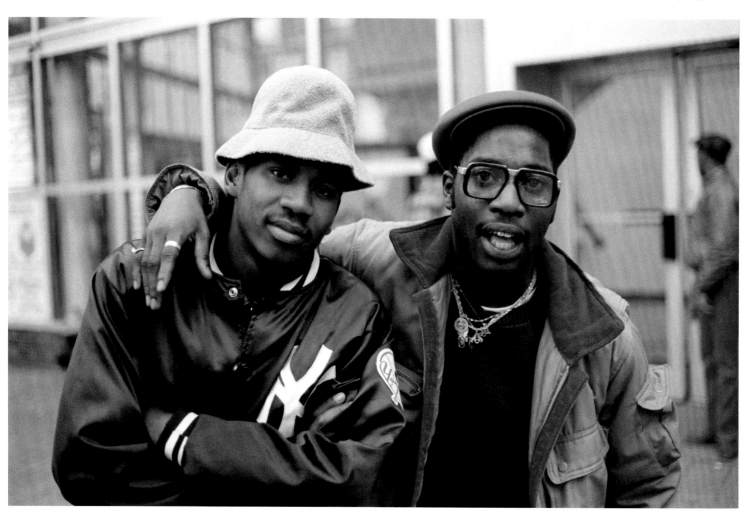

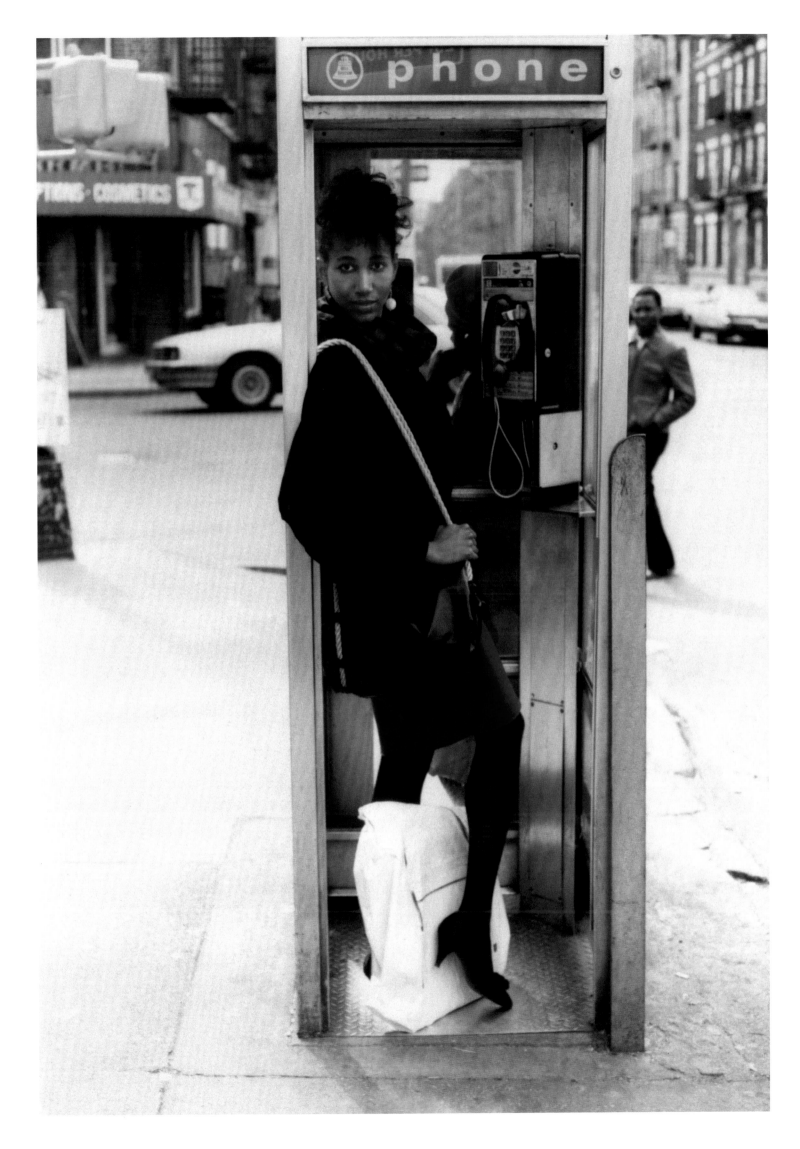

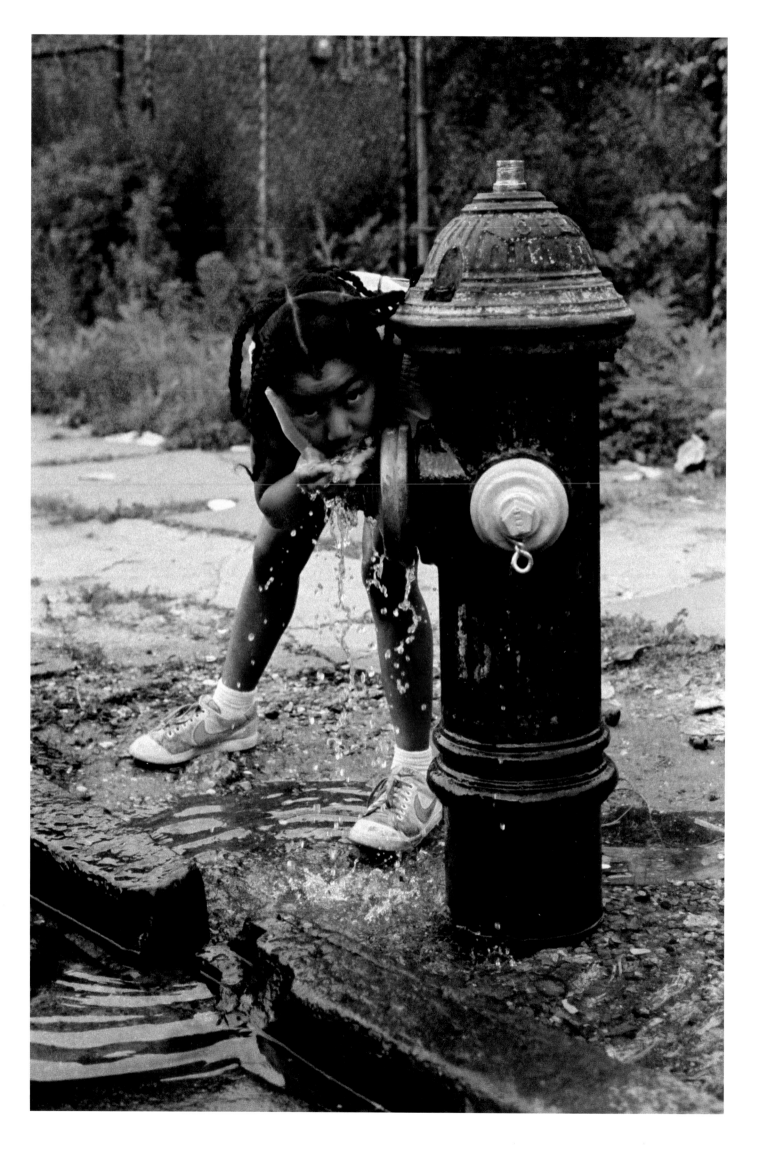

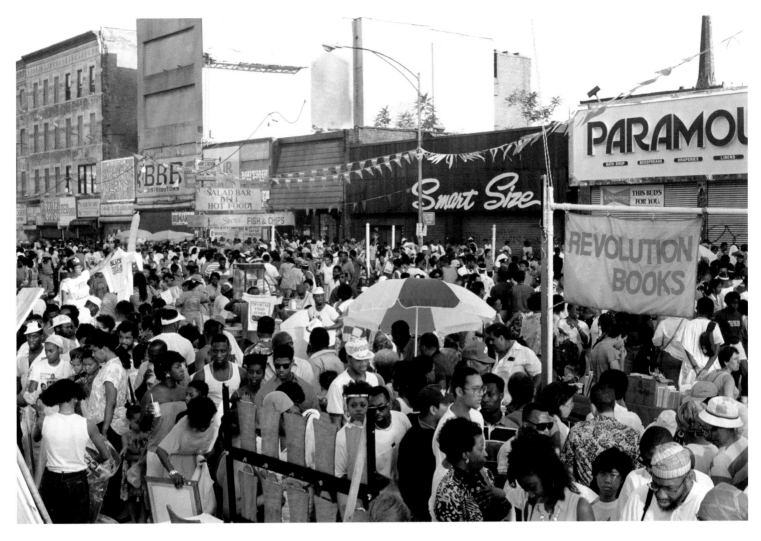

Opposite:
A Time of Innocence,
Red Hook, Brooklyn, 1980

This page:
Harlem Week, Harlem,
1988

Shabazz was channeling James VanDerZee's ability to capture pure human emotion and Gordon Parks's versatility.

pimps, and sex workers—who were most vulnerable to labor exploitation, drug addiction, and homelessness. Many of Shabazz's childhood friends made up this underground economy. And now, the man who had once struggled to speak was committed to using his camera to initiate conversations with these old friends, and even strangers, across Brooklyn and Manhattan.

Those early years were less about following some industry craft standards and more about using the special relationship between photographer and subject to establish a deeper spiritual connection. Shabazz was channeling James VanDerZee's ability to capture pure human emotion and Gordon Parks's versatility, allowing him to blend different genres of photography. He quickly learned that one could not approach Black Americans, particularly the street-oriented folks he wanted to reach, dressed like a slouch. "I think that some might view me as sort of dapper," he says. "And it made people more open to me when they saw me." They could instantly see that Shabazz understood the style economy of the block, that he spoke a common language. He was an insider. This insider status granted Shabazz access to their inner selves—an intimacy reflected in his subjects' body postures and poses—and gave him a chance to lovingly prophesy alternative possibilities for their futures.

Photography was also saving Shabazz's life, especially once he was hired, in 1983, as a corrections officer at the infamous Rikers Island prison. Long shifts "witnessing the inhumanity that men would inflict on other men," as he describes it, were a daily part of this job. Shabazz says of his frequent after-work photoshoots, "I had to go out on the streets and gain my balance by tapping joy, tapping into brotherhood and unity." He would photograph around East Flatbush, often using his 28mm wide-angle lens. Then maybe he would head to the Lower East Side, where he would switch to his 50mm lens while chatting with and photographing sex workers dressed in their '80s fly-girl fashions: gold bangles and bamboo

This page:
Lovers, Crown Heights,
Brooklyn, 1980

Opposite:
Too Fly, Downtown
Brooklyn, 1982

He photographed Black and Latinx youth in a way that allowed them to shape how they wanted to be seen.

earrings, leggings and heels. Other times, he might spend a Sunday in Harlem, catching the Masons, Eastern Stars, and church-going folk in their finery, before heading to Central Park, to Midtown, then Delancey Street. "I would cover a lot of areas. I'd even get on the train and just look at neighborhoods that were interesting, and get off, and go photograph them." He walked so much that he repeatedly wore holes in the soles of his designer shoes. The more he photographed, the more he could distance himself from the horrors of the prison.

The subtle shift from dance music to something that sounded and looked much grittier might have been imperceptible if Shabazz had not been there to record it on film. "Can I capture your legacy?" Shabazz's simple prompt would offer later viewers of his work a window into the burgeoning hip-hop culture of the early '80s. To live on film was a promise of immortality that the tumultuous street life could not guarantee. One of his most iconic photographs of that era, *Rude Boy* (1982), is symbolic of this early hip-hop style ethos. "Kerral was a hustler," Shabazz says of the photograph's subject. "He was a really smooth, debonair guy who I thought had a lot of potential." Decked out in his pinstripe suit and tons of gold jewelry, Kerral slyly posed for Shabazz's camera—bent over slightly, hand on chin. Kerral was murdered only a couple of years after that photograph was taken. But his legacy lives on in the National Museum of African American History and Culture and on social media. That image also represents Shabazz's pioneering approach to street-style photography. It was not about stealthily capturing a candid portrait of an unknowing subject; it was about collaborating with the person. Shabazz wanted to photograph Black and Latinx youth in a way that allowed them to shape how they wanted to be seen and understood by posterity.

In the late '90s, Shabazz's pictures, which had been circulating around the hood and in prisons for nearly two decades, started

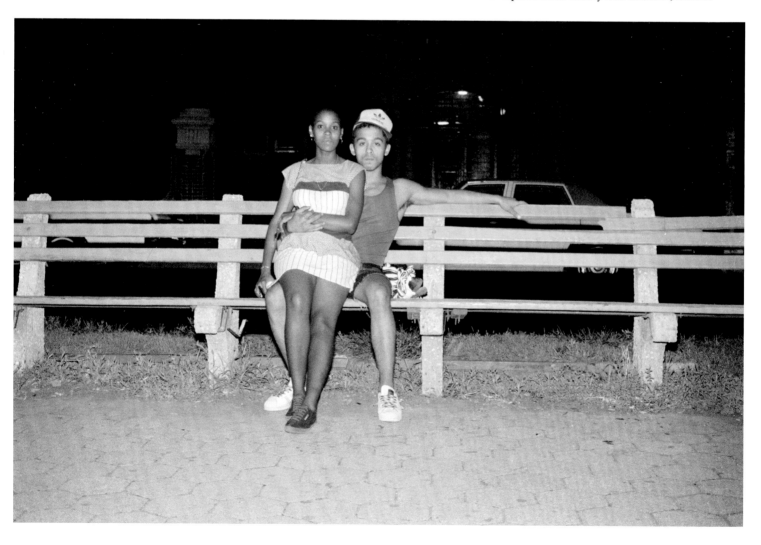

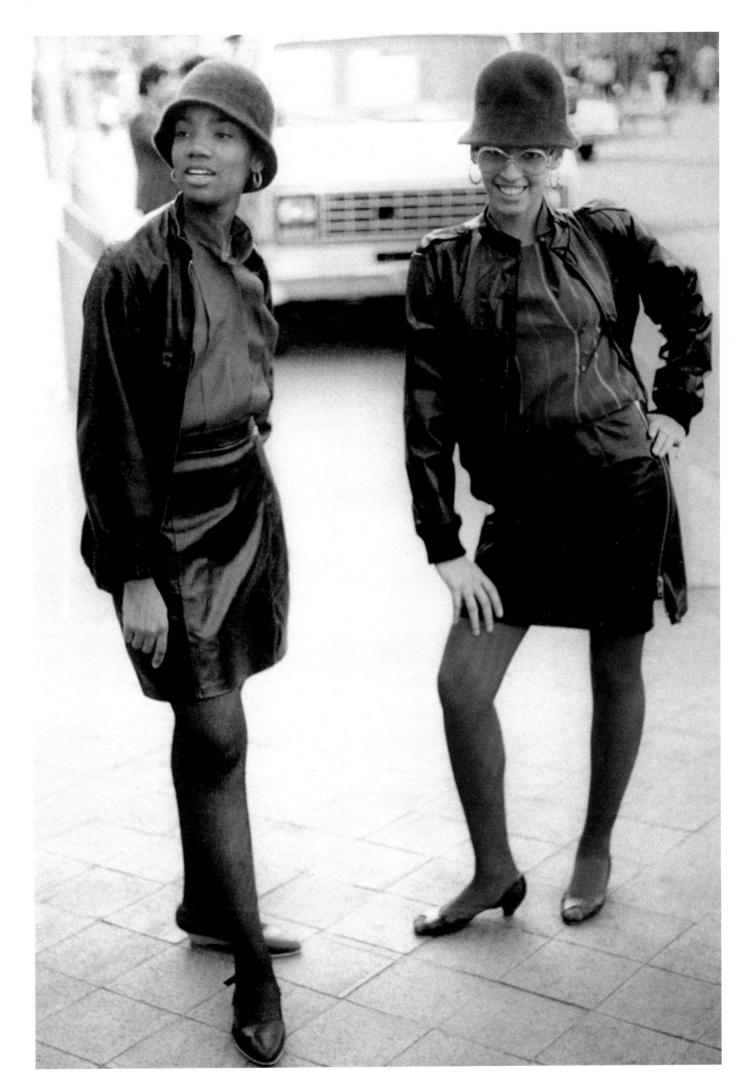

This page:
Fresh on the Scene,
Flatbush, Brooklyn, 1988

Opposite:
The X Men, West Village,
1985
All photographs courtesy
the artist

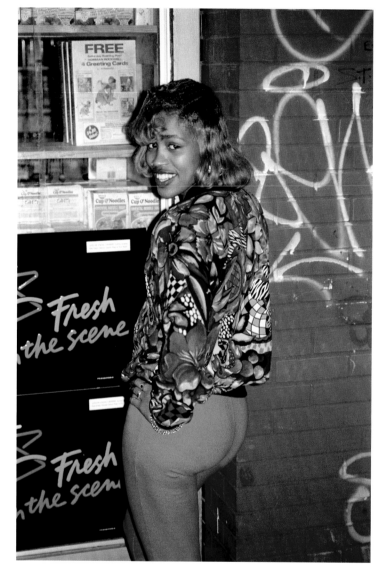

catching the eye of hip-hop magazine editors. *Vibe, The Source,* and *Trace* were helping to translate hip-hop culture for a global audience. Their staffs of writers, editors, and creative directors—most of whom were under thirty—were always looking for something that screamed "fresh," "authentic," "of the culture." During his lunch breaks, Shabazz—then on the cusp of forty and working in Lower Manhattan—would make his way over to the magazines' nearby offices to show editors his portfolio. By then, he had upgraded his equipment to a Nikon N6006 SLR. But the editors especially loved the photographs taken in the '80s, on his old Canon. "He captured a pureness, an essence of hip-hop culture at its rawest and its best. One that was not at all negotiating its relationship to the mainstream or the white gaze," says Joan Morgan, the program director of New York University's Center for Black Visual Culture, who was a *Vibe* staff writer in the mid-'90s. *The Source* ran a multipage spread of Shabazz's photography in its 1998 anniversary issue featuring the greatest moments of hip-hop. "That put me on the map, and that started my fan base," Shabazz remembers.

Seemingly overnight, Shabazz went from a modest-wage-earning city employee to a recognized professional photographer. "I started to make a transition from working in a very negative, hateful atmosphere to now doing solo art shows." Antwaun Sargent, an art critic and the author of *The New Black Vanguard: Photography between Art and Fashion* (Aperture, 2019), believes Shabazz's images connect viewers to a familiar Black vernacular in ways that redefine portraiture: the street slang, the body postures, the sartorial politics, the photographs hanging on grandma's wall. "The way that we think about Black portraiture comes through the vernacular, the local. It comes through the neighborhood photographer," says Sargent. Some of Shabazz's biggest influences were the family photo-albums in his childhood home, which had been passed down from generation to generation: "Those personal, intimate photo-albums really allowed me to see the power of photography." Shabazz has exhibited this homegrown approach to Black portraiture everywhere from the Studio Museum in Harlem to the J. Paul Getty Museum in Los Angeles, from the Victoria and Albert Museum in London to the Addis Foto Fest in Addis Ababa, Ethiopia. Three of his books published by powerHouse—*Back in the Days* (2001), *The Last Sunday in June* (2003), and *A Time Before Crack* (2005)—are considered classics for their articulation of a Black visual vernacular.

Despite now being heralded as a king of the culture by folks in the know, Shabazz has never received the same acclaim as lauded photographers who chronicled New York's vibrant street life. "I don't think there has been a real reckoning with these images," says Sargent, although he believes we would not have Tyler Mitchell, Stephen Tayo, Tommy Ton, or Scott Schuman without Shabazz's pioneering work. The truth is Shabazz was never into it for the fame and institutional recognition. It was always about building community. "You see me through my subjects. Through the eyes of my subjects, you're seeing me," Shabazz says. For years, he could not completely explain why he sought to establish a connective bond with the people he photographed. But now, as a veteran photographer—an alchemist—he is able to powerfully voice just how frozen bits of time can transform a community.

Tanisha C. Ford is the author of *Dressed in Dreams: A Black Girl's Love Letter to the Power of Fashion* (2019) and *Kwame Brathwaite: Black Is Beautiful* (Aperture, 2019). She is a professor of history at the Graduate Center, CUNY.

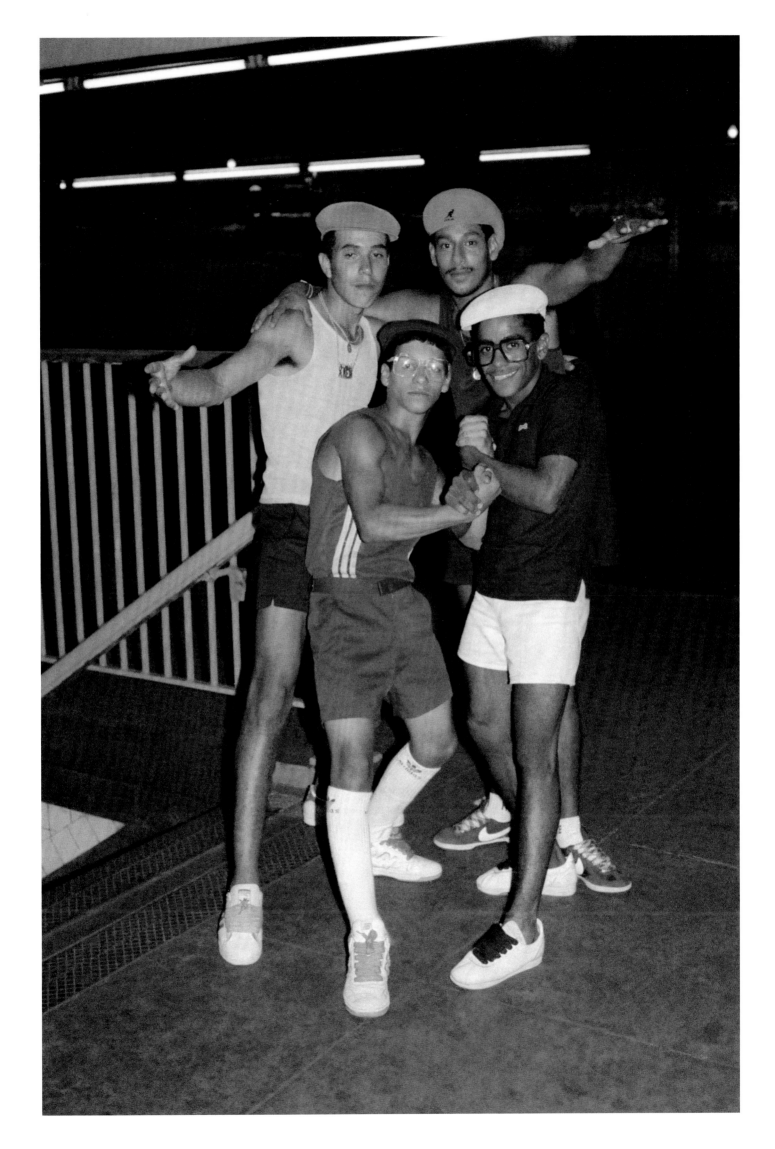

Michael Schulman
The Audience

The last Broadway show I saw was on March 8, 2020, a revival of *West Side Story* directed by the Belgian stage auteur Ivo van Hove. The musical was the talk of the season, and Van Hove's production was heavy on video. (Didn't he know that video would soon be all we had?) Even then, a trip to the theater felt dicey. Was it safe to take the A train to Midtown? Was that someone coughing a few rows back? Should we go out to dinner afterward or skip it? Within a week, amid reports that an usher at *Who's Afraid of Virginia Woolf?* had tested positive for coronavirus, Broadway, unthinkably, shut down—an unprecedented step that, producers hoped, would last only until May.

Instead, it's been a year (and counting) without theater, and without other art forms that give New York its lifeblood. The disappearance of live shows was devastating, both spiritually and financially, to actors, dancers, rockers, opera singers, and jazz trumpeters, not to mention set painters, stagehands, and everyone else involved in the city's precarious artistic economy. Even as schools and museums opened up in fits and starts, live performance remained dormant, anchored to its simple need for people to congregate. Arts organizations went on life support. Many performers, unable to pay their (already punishing) rent, moved back to their hometowns. Who knows if they'll be back?

I'd never realized how much of my identity as a New Yorker was wrapped up in being a member of an audience.

That's not to say that the shutdown hasn't sparked innovation. There have been Zoom plays, socially distanced ballets, drive-in movie premieres. But, oh, how different they are from those noisy nights at the Bitter End or Joe's Pub, watching something come alive onstage. As much as I've missed live performance over the past year, I've felt its absence like a phantom limb, an alternative life I wasn't living but whose seasons I knew well. In the spring, as many of us hunkered down in our apartments, I imagined the rush of Broadway openings before the Tony Awards deadline. In the summer, as we cheered for first responders every night at seven o'clock, I felt the pull of those balmy nights at the Delacorte, home of Shakespeare in the Park. In the fall, I could sense the back-to-school frenzy of season openings at the Metropolitan Opera and the Brooklyn Academy of Music. I'd never realized how much of my identity as a New Yorker was wrapped up in being a member of an audience, whether the bawdy crowd at a cabaret show or the hushed, skeptical throng in a subway car when a busker interrupts

a morning commute. Even the annoyances are missed. It will probably be a long time until we have the pleasure of arguing with a stranger over a velvet armrest.

As much as I've missed theater, I've also missed the serendipitous theater of urban life. One New Yorker who never tired of the city's inherent showmanship—and spectatorship—was Weegee. Born Ascher Fellig, in Austria-Hungary, he immigrated to New York with his family as a child and made his name (which became "Weegee the Famous") selling sensational photographs of crime scenes, late-night fires, and society ladies to newspapers including the *Herald Tribune* and the *Daily News*. A consummate voyeur, Weegee saw New York as a city of watchers, whether movie-goers or bystanders at a murder.

Around 1945, Weegee captured the frisky action in the audience of the Palace Theater, during its decades as an RKO movie house. (*Citizen Kane* premiered there, in 1941.) Before that, in the 1910s and '20s, it was a vaudeville playhouse, and since 1966 it has been a proper Broadway theater, home to musicals such as *Sweet Charity*, *La Cage aux Folles*, and, most recently, the excellent *SpongeBob SquarePants: The Broadway Musical*. Judy Garland, Harry Belafonte, Diana Ross, and Bob Hope have all tread its boards. Weegee, though, turned his camera not on the main attraction but on the audience: two lovers immersed in a kiss, and the people behind them who have become spectators of a new kind of show.

What wouldn't we give to be among them, bodies in close quarters, toes perched on a seat back, scoping out strangers through our 3-D glasses, in the dark? Now it's spring again, and the theater is still in its extended hibernation. But the phantom limb keeps twitching, knowing its cues, ready to return.

Michael Schulman is a staff writer at *The New Yorker*, where he covers arts and culture. He is the author of *Her Again: Becoming Meryl Streep* (2016) and a contributor to *Ethan James Green: Young New York* (Aperture, 2019).

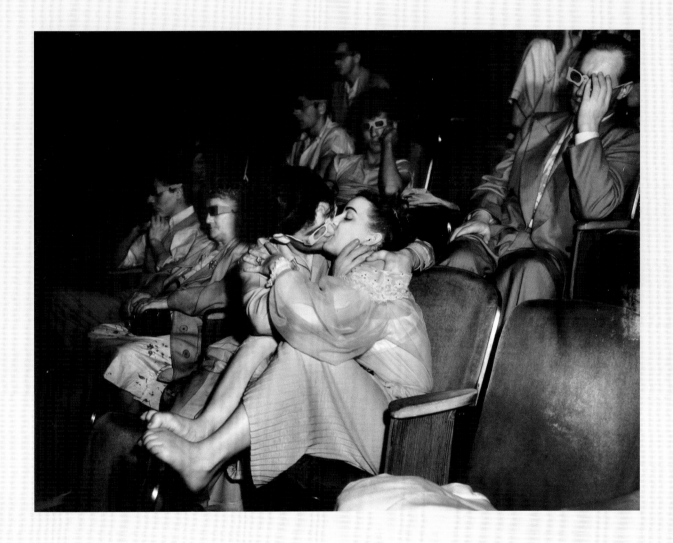

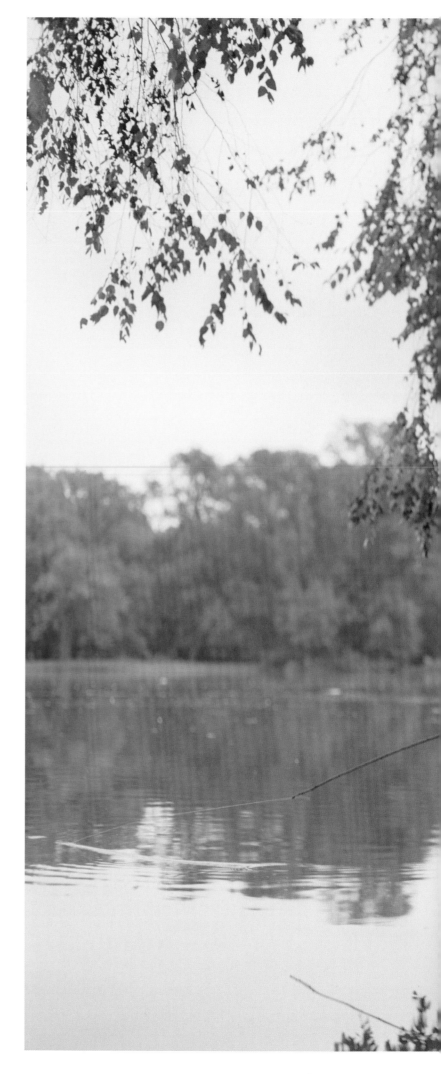

Irina Rozovsky
In Plain Air

Joseph O'Neill

Prospect Park is, of course, a wonderful vast green space in the heart of Brooklyn. It hosts millions of visitors every year. There are playing fields; there are ponds and woods and a ravine with cascades; there are glades and knolls; there are spots for barbecuing and tennis and drumming; there is a bike loop and a bridle path and an ice-skating rink; there is a zoo with sea lions and poison dart frogs; and, at the park's eastern edge, there is a carousel where for more than a hundred years young children—my three sons included—have ridden in circles on wild-eyed wooden horses. Each season changes what's there and what goes on—sledding on Sled Hill in the winter; fishing in the lake in the summer; looking out, in the spring, for the almost invisible American woodcock. Always there is a lot to do and, more pertinently for the photographer, a lot to see.

The spectacular possibilities cannot be understood without a brief ethnology of the place. To the northwest of the park lies Park Slope, a neighborhood of brownstones and, in the main, affluent white families. To the southeast lies Flatbush, the old Dutch country village that these days is densely built-up and densely populated by working-class and middle-class residents, many of whom are of Afro-Caribbean origin. Other neighborhoods,

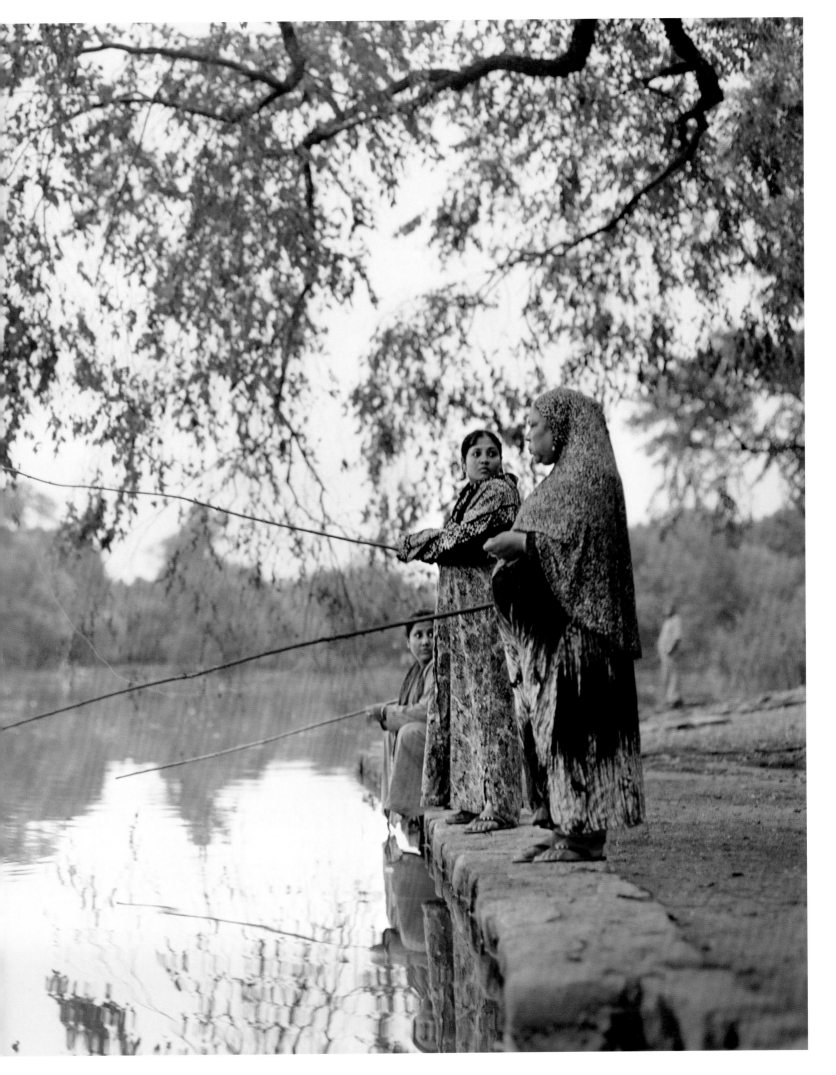

economically and culturally diverse—Windsor Terrace, Prospect Lefferts Gardens, Crown Heights, Kensington, Prospect Heights, Ditmas Park, Borough Park—either adjoin the park or are close by. Hundreds of thousands of human beings of almost every sort and provenance are able to resort to Prospect Park on foot. Subway trains bring in families from more remote parts. If a park may be defined as a specifically urban space, at Prospect Park both elements of this definition—the urban and the spatial—are markedly, perhaps even quintessentially, available to perception. Enter (for *In Plain Air*, a project that spanned 2011 to 2020) the Moscow-born, American-raised photographer Irina Rozovsky.

Note that the photographer finds herself in an unusual position. Photography is precisely one of the recreational activities that Prospect Park users engage in. The formal distance between observed and observer, and the hierarchy implied by this opposition, is, if not erased, then radically modified by a strange mutuality. Going to the park is an act of self-publication. When you step into a space where you observably do as you please, you assert your autonomy. It is an assertion that is particular to the jurisdiction of this special green acreage, beyond the borders of which very different rules and powers apply. The situation of the photographer in the face of this assertion is not dissimilar to the situation of the witness. We all need to be seen in a just light, and Prospect Park can offer such a light, and a photographer can capture it.

At the core of this visibility is, paradoxically, the peculiar privacy that being in the park confers. Privacy, certainly in Western culture, is normally associated with seclusion and secrecy—the closed door and what happens behind it. The privacy of these Brooklyn park-goers is founded on something else: an understanding that the gaze of the other—even if prolonged, even if mediated by a camera and made permanent by a photograph—makes no moral claim on its subject. Rozovsky's images express this social practice. They refuse the curiosity of the sidewalk pedestrian or the tourist or the voyeur. They accept, and proceed from, a certain responsibility. The responsibility in question is the artist's duty of carefulness.

Carefulness, in this artistic sense, is not just a matter of technical diligence or some heightened awareness of the complexity of the subject matter. (Prospect Park, as we have seen, is an extremely complex subject.) Rozovsky's human subjects, as they fish or fool around, are defenseless to the onlooker; and yet her photographs exercise no sway over them. This is the product of a careful eye, which is to say, an eye that is neither seduced by its own power nor subservient to the social constraints in which it partakes. The photographic subject makes his or her claim to self-rule, and the photographer responds to that claim, and transcends it. A unique relation is inaugurated. An ethics of seeing is revealed.

Joseph O'Neill is the author of six books, most recently the novels *Netherland* (2008) and *The Dog* (2014), and the story collection *Good Trouble* (2018).

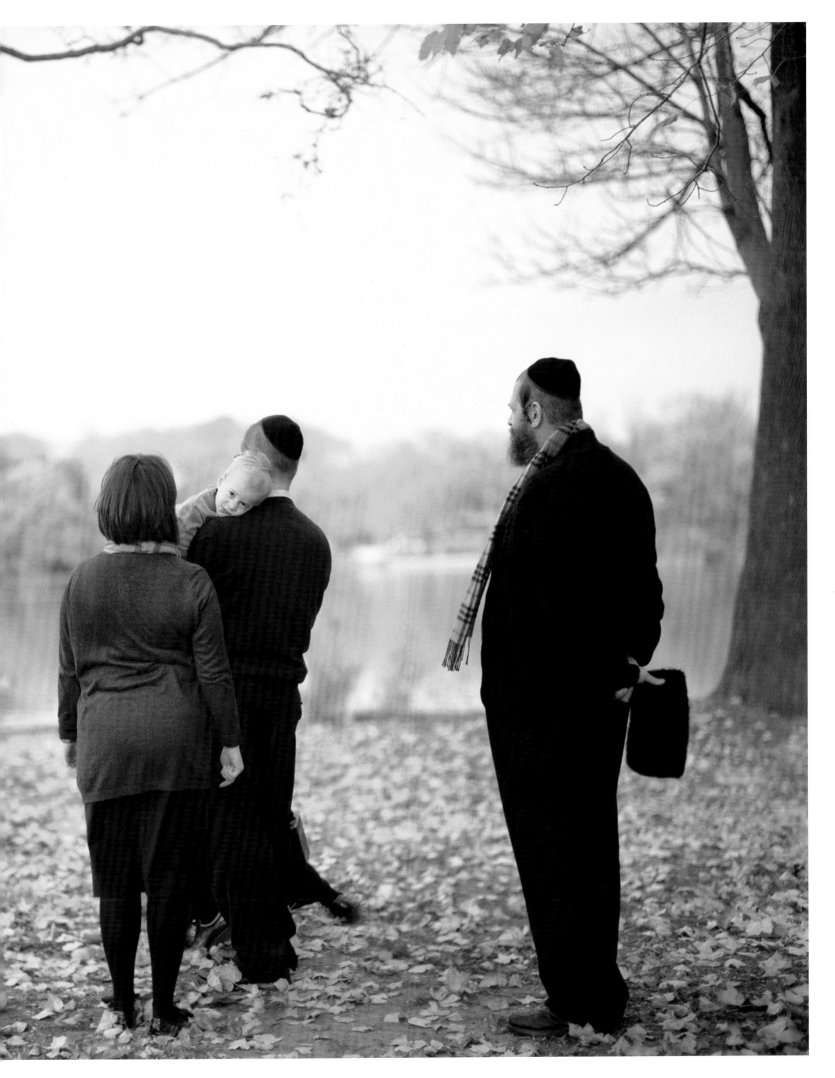

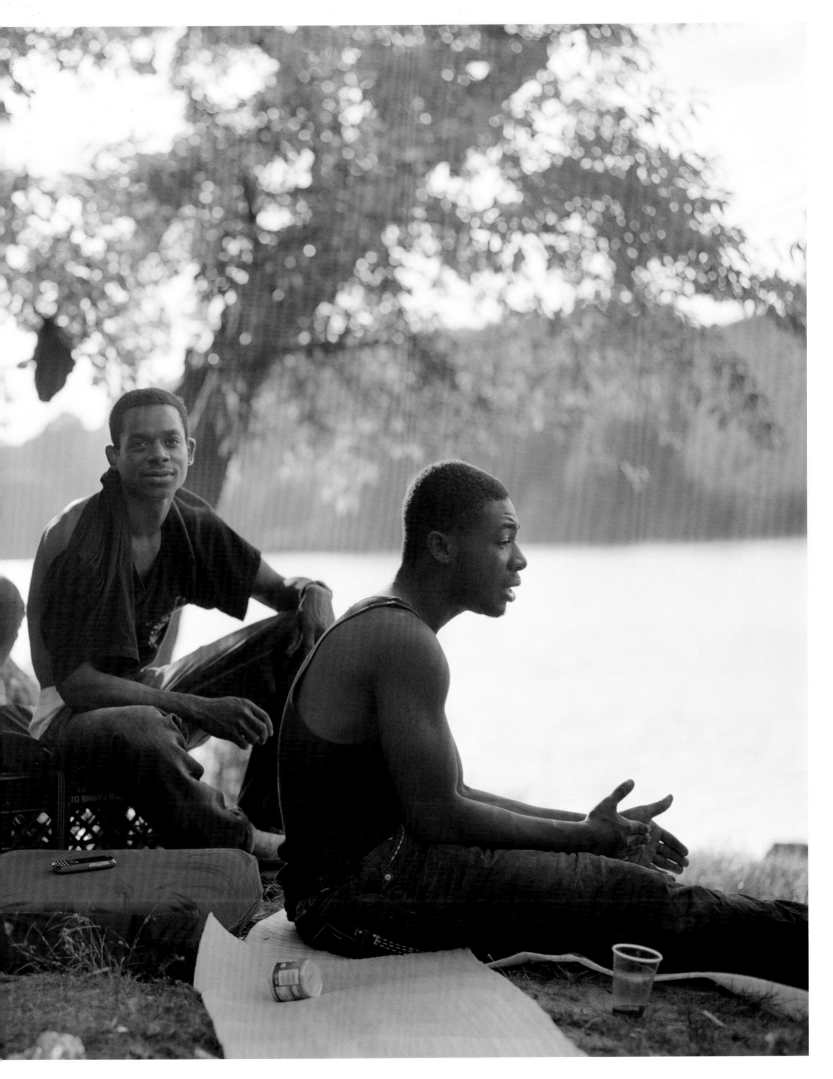

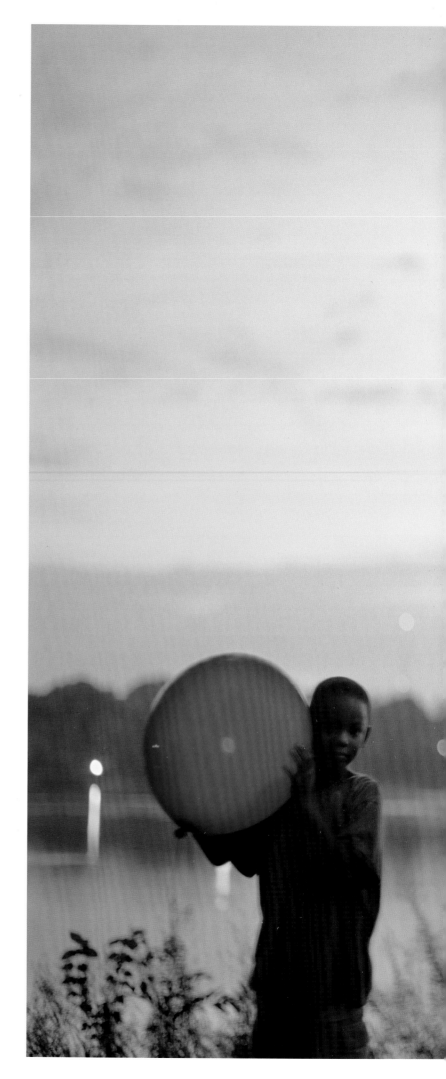

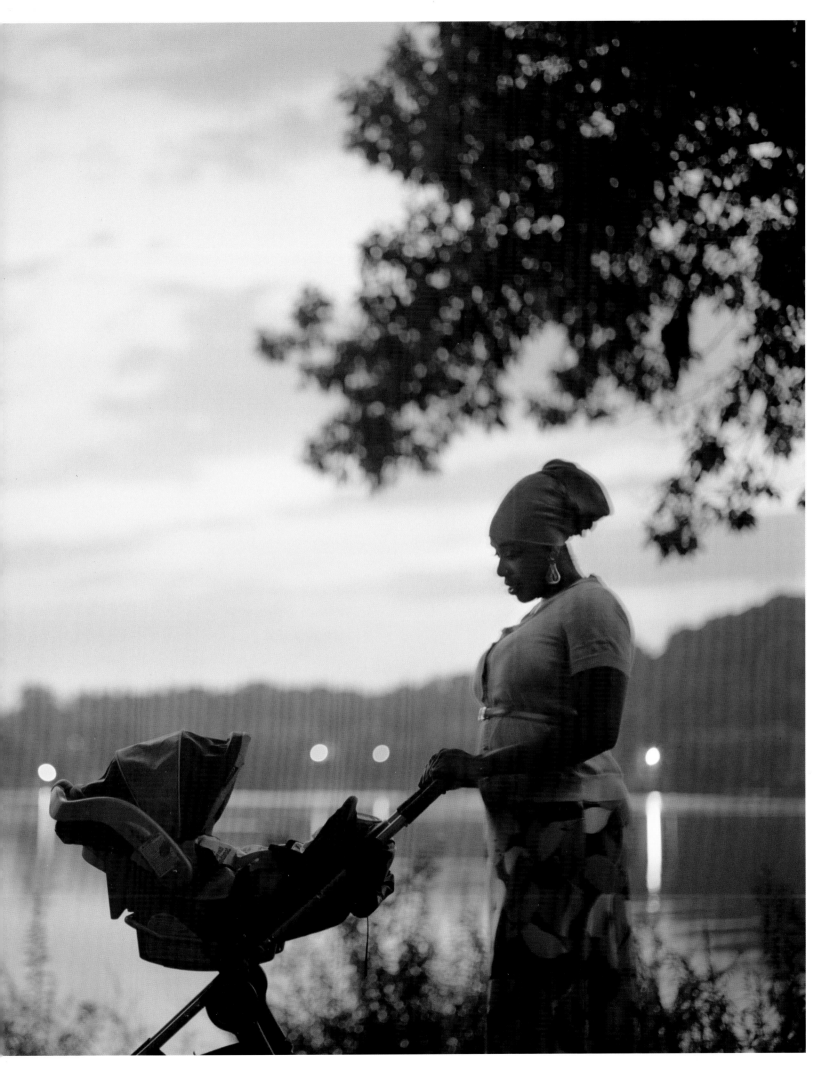

All photographs from the
series *In Plain Air*, Prospect
Park, Brooklyn, 2011–20
Courtesy the artist and
MACK

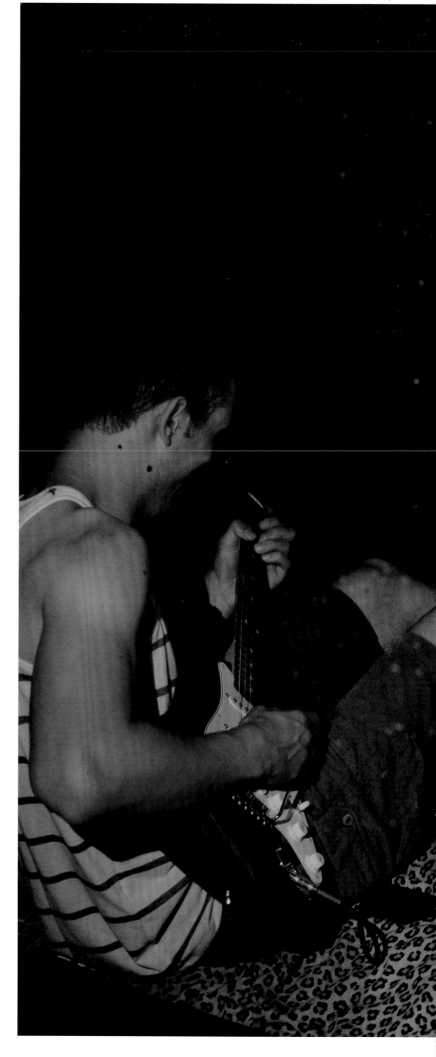

Alan Michelson
Sky Boys

"Social photography" was how Lewis W. Hine advertised his services, but his best pictures, such as this one, capture the social by means of a radiant artistry and a remarkable grit, enough to lug a heavy 4-by-5 camera up steep ladders and shoot from an open steel box dangled a quarter mile above the street. Commissioned to document the construction of the Empire State Building, Hine, over the course of a year, produced a stunning portfolio of images extolling the workers who raised the iconic skyscraper, the world's tallest until it was eclipsed by the World Trade Center. Published in 1932 under the title *Men at Work: Photographic Studies of Men and Machines*, it doted on the ironworkers on the job, whom Hine dubbed "sky boys"—the gangs of Newfoundlanders, Scandinavians, Irish, and Mohawks who erected the steel skeleton of the building—lifting, positioning, and riveting its fifty-seven thousand tons of steel columns and beams.

Nameless and faceless, these eight ironworkers, silhouetted against a sprawling, vertiginous Manhattan, are a study in balance and composure, attitude at altitude. Their casual stances belie the Icarian danger of their sky world—the daily duel with gravity, the grapple with girders that can crush, and the avoidance of the abyss. Among the most lethal of labor, ironwork requires nerve, skill, and agility to overcome the inherent fragility of the human frame in such a precarious environment.

My Mohawk ancestors, from their homeland to the north, witnessed Manhattan's transformation into a burgeoning place of colonists.

Elmer Green, my Oneida grandfather, became an ironworker out of necessity. Raised on a farm on the Grand River at Six Nations Reserve in southern Ontario, he came of age during the Depression, a bad time for farming. Following a spell of hunting and selling rabbits to German restaurants in Buffalo, he got into ironwork there, where he raised steel and a family. Elmer occasionally worked in New York, but it was a long drive and too difficult with children. The Mohawk ironworkers on the Empire State Building hailed from Kahnawake (place of the rapids), a Haudenosaunee reserve four hundred miles east of Six Nations, on the Saint Lawrence River near Montreal. "Booming out" was what they called working in the cities, where they would stay during the week, commuting back to the reserve on weekends. The first Kahnawake Mohawks to boom out to New York worked on the Hell Gate Bridge (1916), from which one, John Diabo—called "Indian Joe" by the Irish gangs—plunged to his death, drowned in the river.

It was a decade before gangs from Kahnawake returned, to help build the Art Deco Fred F. French Building, the Graybar Building, and One Fifth Avenue. More followed, and in addition to the Empire State Building, they worked on other now familiar landmarks such as the RCA Building (30 Rock), the Daily News Building, the Cities Service Building (70 Pine Street), the George Washington Bridge, and all the major bridges of the 1930s, including the Triborough, the Whitestone, and the Pulaski Skyway. Subsequent generations helped to erect the World Trade Center and, after 9/11, to dismantle its ruins.

Manhattan was known to my Mohawk ancestors as Ka'non:no (place of pipes). From Kanièn:ke (land of the flint), their homeland to the north, they witnessed Manhattan's transformation into a burgeoning place of colonists, who wrested it from the local Lenape and expelled them, as they later would my ancestors from their original base in the Mohawk Valley. In our creation story, there was an island in the sky inhabited by sky people, and one Sky Woman fell through a hole left by an uprooted tree. The animals of the watery world below prepared a place for her to land, the back of a great turtle, which they covered with mud to form the continent we still call Turtle Island. Like the sky boys in Hine's photograph, her Mohawk children have inhabited the sky world of high steel on this island for over a century and continue to do so today.

Alan Michelson is an artist based in New York.

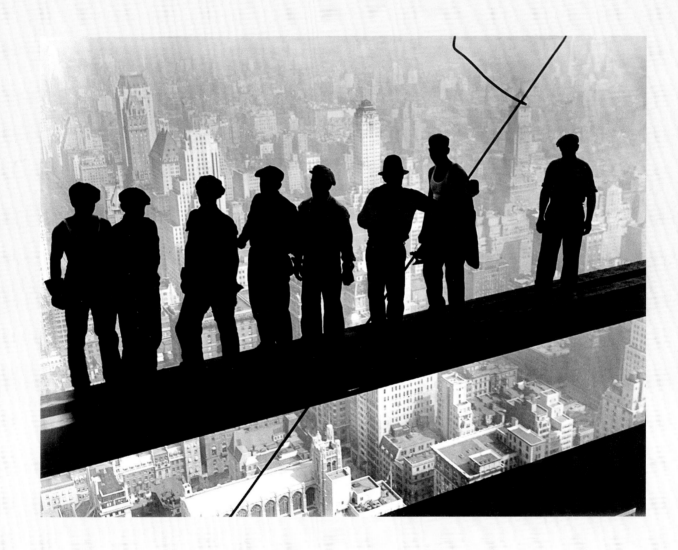

Ari Marcopoulos
Pandemonium

Hilton Als

One thing I find transporting about photography, in general, and these pictures, in particular, is that they are, first and foremost and irrefutably, *images*, which makes them different from language as I practice it, with words. This might seem obvious at first, but it's not, really; we live in an age where all information is treated the same, flattened out, ingested, and discarded, because for all sorts of reasons, language has in recent years been cheapened, exploited, moralized, and it's almost too much to think about. But we must think about it if we are going to say anything of value about pictures, or language, or any aspect of being, let alone aesthetic work, because it's time to bring the specificity of language back if we are to understand what it is and how it defines us, or opens us up.

Looking at Ari Marcopoulos's pictures, I think about his language, and how subliminal and divine and degrading these photographs are, degrading because they remind us of who we are, and what we did and didn't do with all the time we've been given to be, and to move through space, and to think. We live in the air of possibility, always, and I think Marcopoulos's pictures convey that, and possibility is like hope: it can make you feel ecstatic, or a little lonely, sometimes both, since hope lives in the future, and humans, even if it means happiness to come, don't like uncertainty. The future is lonely; who else lives there? We don't know! It's a foreign country with a language no one speaks until they learn that new grammar.

The line "Life is but a dream," from the famous nursery rhyme, "Row, Row, Row Your Boat," cheered me and scared me when I was a kid: If we were living in a dream, or were just a dream, did that mean life wasn't real? That I wasn't—horrors!— a real little boy, or person? Was I a dream? Were you? I think the surrealism at the heart of all photography is just that: in this picture or that, life appears to be a dream, or an aspect of one, and sometimes with the best pictures I like being in that dream, even if it scares me. Once committed, my eye travels beyond the frame, and then I wonder where life took the photographer, let alone his subject, once the moment of love or hatred or isolation of a great swelling wave passed and became something else.

As we move through months of a collective isolation, hope becomes part of fear: Dare we hope? Dare we hope that the vaccine will work, or that we can kiss one another again without suspicion? Or is hope now inextricably tied to our fear? Some, if not all, of the pictures collected here were taken during the pandemic, a time of anguish and loneliness even if you weren't lonely and riding it out with your beloved. We didn't know who we were/are during this period, and so, therefore, who or what we might be. We are relearning touch, even if only in our minds.

Marcopoulos's pictures are from that kind of mind, the work of someone who wonders who we are or what we might be in this period of distress where tenderness still rears its beautiful head. There is a great deal of love and melancholy in these pictures, and also standing on the threshold of intimacy such as the picture of the two women embracing, and that's part and parcel of being a photographer: You are and are not part of the intimacy you're recording, but aren't we all doing the same thing in this current climate? Standing on the threshold of intimacy, waiting to be let in?

Hilton Als is a staff writer at *The New Yorker* and the author of *White Girls* (2014). He won the Pulitzer Prize for Criticism in 2017.

5.24.20

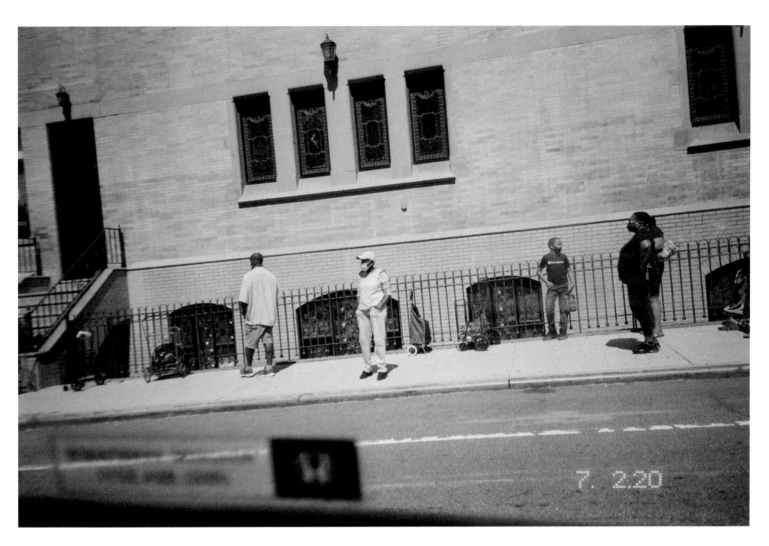

All photographs New York, 2020
Courtesy the artist and
galerie frank elbaz

Darryl Pinckney
Home to Harlem

Ten years ago, my partner, the English poet James Fenton, and I acquired a derelict corner property across from Mount Morris Park, now known as Marcus Garvey Park, at West 123rd Street. It had been built in 1890 as a family home by John Dwight, the cofounder of the Arm & Hammer baking soda company. He also built the brownstone next door two years earlier for his daughter. These were the days when the grid had been laid out and was not fully occupied. Uptown Manhattan in old photographs can bring to mind Oklahoma City in the days of the land grab, mostly empty, but staked out.

Our house, designed by the architect Frank Hill Smith, supposedly the first person whom Oscar Wilde called on when he arrived in Boston, attracted James immediately, because it features a stack of oval rooms. There are bay windows from the piano nobile to the top floor. This house would not be allowed today. Its five floors are now considered by city regulation to be too tall for the narrow footprint.

Constructed of thin Roman brick, our house is not a brownstone, there are no steps rising above a garden-apartment entrance. We are set back—a doorway, a wide step, and then the sidewalk. James once explained to me that Smith was influenced by Stanford White's entrance at Judson Memorial Church. Today, the pillars on either side of the front door and the iron railings that travel along the sandstone-and-brick facade give a sense of privacy.

Uptown Manhattan in old pictures can bring to mind Oklahoma City in the days of the land grab, mostly empty, but staked out.

This structure is older than the subway line that created Harlem as a part of town to which black people could be pushed. It has looked out on social history. The sound of a rolling suitcase on pavement used to come from a tourist. Now it belongs to the unhoused. We are lucky, in our great shelter, in our tired, old, unfinished Trojan fortress.

When has it not been for us a work in progress? James got a contractor, Mike Casey, and an architect, Sam White, a great-grandson of Stanford White, and they set about to retrieve a wonderful home. James and his collaborators were much helped by the descendants of John Dwight, among them the documentary filmmaker Joey Casey and his wife, Lauren Fajardo, a fashion designer and cofounder of Dador in Havana. The large Dwight family lived in this house from 1890 until 1925. Electricity was installed in 1915. The elder Dwight had died by then.

The Dwight descendants shared with us a letter written by a family member in 1939, urging them not to sell the house to "negroes." Mount Morris Park had been a neighborhood of Jewish doctors. Black physicians had begun to take over the practices in the neighborhood as black Harlem spread out in the years after World War II. An elderly gentleman who'd lived in our neighborhood for decades told me he remembered Juilliard students being driven to the house in 1946, he insisted, but I have never checked the school's records.

We think that after the Dwight family sold the house in 1946, it went downhill pretty quickly, becoming a building offering single-room occupancy. It was the typical fate of many buildings in New York back then. Dwight's billiard room on the ground floor, for instance, was cut up into three one-room apartments. We found seventeen closet toilets throughout the house; kitchen stoves and refrigerators in bizarre places; a few bathtubs behind sad doors. There were bullet holes in many of the sixty-two windows of the house. Plastic crack vials littered filthy carpet. The bad luck had gone on for years.

In 1962, a sect of black Jews bought the house and converted the second-floor parlor into what must have been a dark synagogue. No natural light. The founder had been a follower of Marcus Garvey. He died in 1973 and some of his grandchildren embarked on a long, sometimes violent, feud with the old congregation. The police precinct knew them well. This homophobic, extortionate faction of the founder's family, alleging that they had been robbed of their temple, attacked us almost daily as the new owners. They protested that Harlem was losing its cultural heritage to gentrification, to white developers. They never referred to black me in their Web propaganda or street leaflets, only to white James.

Photographs proved an invaluable guide, but also a rescue. They connected us to the history of the house before the black Jews. The story of the house was older than their occupancy. James uncovered staircases and fireplaces, ripped out blue wall-to-wall carpets, pews, and the tabernacle that blocked the main windows. He tore down partitions, rebuilt walls, and restored the oval shape of what used to be the dining room on the piano nobile. Then he gave every room a bold color. Art looks best against a painted wall, not a white one, James will tell me.

They don't come anymore since the pandemic, but when tour groups did stop in the street and were instructed to look up at our windows, they perhaps thought they were looking at the beautiful old synagogue. The wounded, lost place it had been is now impossible to imagine. James can stand in the middle of a ruin and see what could be done.

In my research at the Schomburg Center in Harlem, I discovered that this house had, in 1937, been the Harlem Community Art Center. Jacob Lawrence took classes here. The school had so many people to enroll, it had to move around the corner, where Eleanor Roosevelt made an official opening-day visit. The director of the center was Augusta Savage, the sculptor. There are no ghosts here, but I like to think of her going up and down these steps.

Darryl Pinckney's latest book is *Busted in New York and Other Essays* (2019).

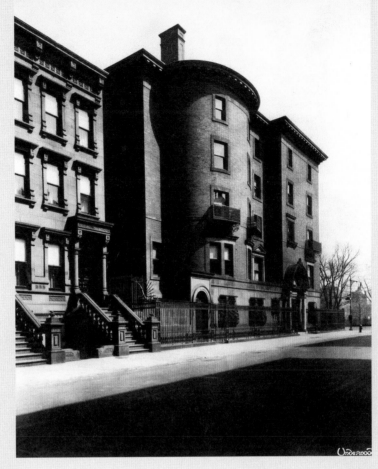

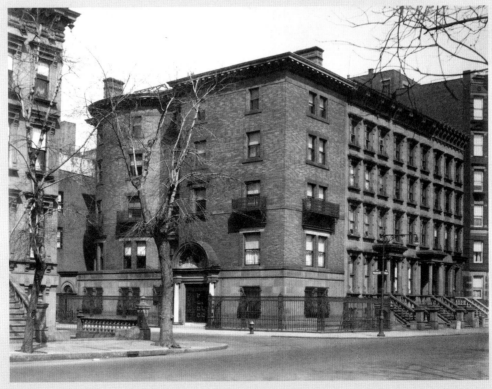

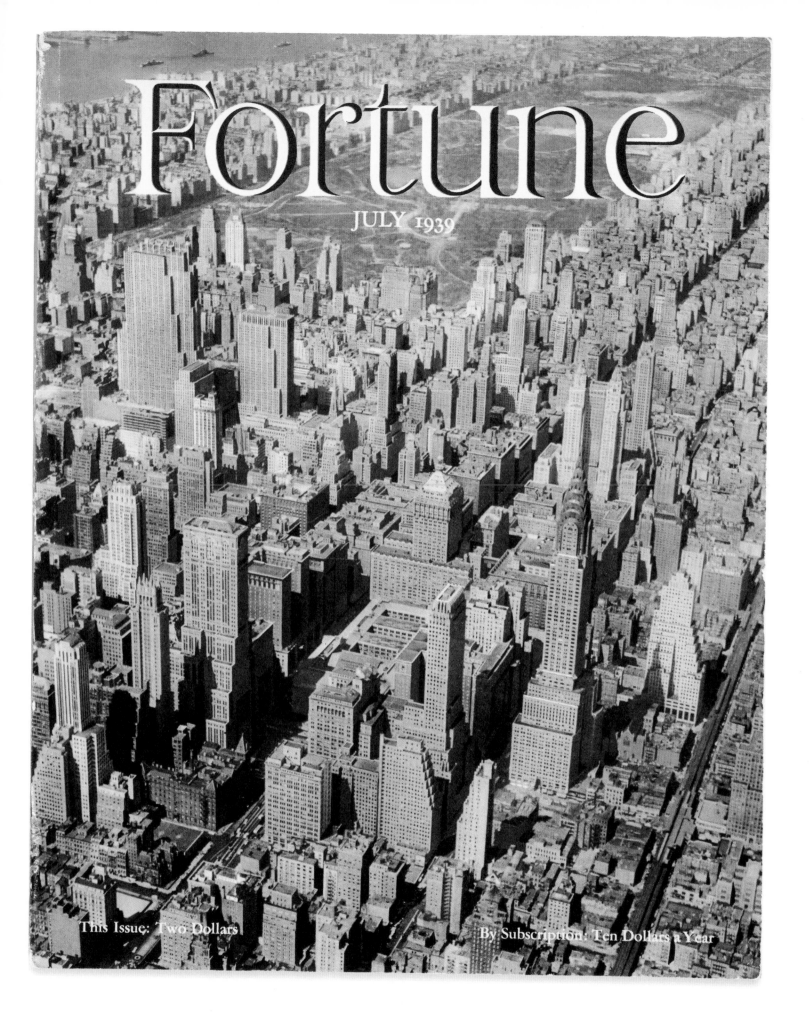

Fortune

JULY 1939

This Issue: Two Dollars

By Subscription: Ten Dollars a Year

The "New York issue" is a publishing tradition. By assembling visionary designers, photographers, and writers, magazines have sought to convey—and pay tribute to—the city's kinetic creativity.

On the Town

Vince Aletti

I didn't move to New York until 1968, but I'd been imagining what it would be like to live here for as long as I can remember. Movies fueled my fantasies, of course, and nearly all of the novels I read (Salinger, Capote, Kerouac, *The Great Gatsby*, *Auntie Mame*), but it was magazines that really enticed me. Because all but a few of the major U.S. magazines were based in New York, the city dominated their coverage of culture and commerce. Every museum, restaurant, art gallery, theater, publisher, bookstore, hairdresser, performance space, dive bar, nightclub, discotheque, and art-house cinema, it seemed, was here somewhere.

To anyone reading *Esquire*, *Town & Country*, or *Harper's Bazaar* in the 1950s and '60s, New York was apparently the center of the known world: the place to be. I came as soon as I could, lugging a stack of those magazines along with me. I've since accumulated many more, including a number that don't just touch on New York in passing but make the city their primary focus.

The five New York issues presented here, from the July 1939 issue of *Fortune* to the February 22 and March 1, 1999, issue of *The New Yorker*, are hardly the only magazines to make the city their subject in those sixty years, but when it comes to photography, they're among the best. For much of that period, U.S. magazines were big, nervy, ambitious, and flush with advertising; even after television took off in the '50s, they continued to define

Page 70 and this page:
Cover and spread from
Fortune, July 1939, with
photographs by Berenice
Abbott and Lewis W. Hine

To anyone reading these magazines in the 1950s and '60s, New York was apparently the center of the known world: the place to be.

mass media. If a publication had a sense of mission, it usually involved some combination of intelligent writing, sophisticated design, and fine photography—the sort of images that museums were just beginning to collect. Even before *Fortune* brought Walker Evans on as a staff photographer in 1945, the magazine had that formula down. Its July 1939 issue took its peg from that year's world's fair, which had opened out in Flushing Meadows–Corona Park in April. Mayor Fiorello La Guardia called the city "one exhibit I hope all visitors will note," and *Fortune* supported his appeal with a series of unsigned articles on everything from Penn Station to Abercrombie & Fitch, Broadway chorus girls to a taxi driver named Harry Farber, nearly all accompanied by photographs.

Although only a few of those photographs are given major play, those that are set the tone. The issue opens with one of Berenice Abbott's sensational aerial nighttime cityscapes, reproduced full-bleed in a process that mimics photogravure. But Abbott's vision of a glittering wonderland is immediately challenged. The image that follows, introducing a piece on "The Melting Pot," is Lewis W. Hine's photograph of a crowd of European immigrants trudging up the stairs at Ellis Island. This capitalist/populist seesaw continues throughout the issue. Along with Evans, other contributors include a who's who of the city's savviest working photographers: Margaret Bourke-White, Aaron Siskind, Anton Bruehl, Genevieve Naylor, Helen Levitt, Eliot Elisofon. Even if much of their work is ganged together on hectic, scrapbook-like spreads, its accumulated impact is substantial, and the attention the photographers focus on social issues helps balance the magazine's business slant. When the two come together, *Fortune* can be remarkably clear-eyed. In an article on "the lack of economic *raison d'etre*" in the "Negro" ghetto uptown, it notes, "Eighty-five times in a hundred, when a Harlem cash register rings, the finger on the key is white."

That is not the sort of thing likely to come up in the pages of *Vogue* in those years. Its New York issue, dated July 1948, tends to

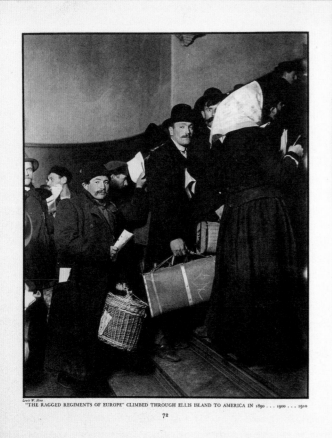

Lewis W. Hine
"THE RAGGED REGIMENTS OF EUROPE" CLIMBED THROUGH ELLIS ISLAND TO AMERICA IN 1890 . . . 1900 . . . 1910

72

The Melting Pot

New York, being five-sevenths Italian, Jewish, German, Irish, and otherwise foreign, is not America. New Yorkers are Americans nevertheless.

NEW YORK CITY may be taken as a symbol, or it may be taken as a fact. As a symbol, it is the symbol of America; its noisy, exuberant, incalculable towers rise up out of the water like man's aspirations to freedom. As a symbol it is the Gateway, the Promise, the materialization of a New World. It throws its long and slender shadow across the Atlantic to the capitals of Europe, to stir their embroiled millions with longing for the New World, even though the New World is itself getting old.

But taken as a fact, New York is less Dantesque. And most Americans take it as a fact. To most Americans the fact is that "New York is not America." It is un-American in lots of ways. The concentration of power that exists among these spires is itself un-American; and so are the tumultuous, vowel-twisting inhabitants who throng the sidewalks and push their way into the subways. In comparison with the Back Bay Brahmin, the Georgia cracker, the Akron hundred-per-center, or the Los Angeles Iowan, New Yorkers are not Americans at all.

New Yorkers are queer largely because of their names, which are *predominantly* such names as Rubinsky and Marinelli and O'Toole and Czernowitz and Schmidt. To the real Americans there is one New York statistic that incontrovertibly isolates the city from the rest of the country: immigrants and the sons and daughters of immigrants, who make up 31 per cent of the population of the U.S., make up 73 per cent of the population of New York City. In Back Bay, Georgia, Los Angeles, and northwest Akron such people are thought of as foreigners. Without them, however, and without its 440,000 Negroes, New York, instead of being the second most populous city in the world (6,930,000 as of 1930*) would be a city of 1,500,000 people, slightly smaller than Detroit. It would be smaller by 1,070,000 people of Italian birth or parentage, by 945,000 of Russian, by 613,000 of Irish, by 600,000 of German, by 458,000 of Polish, by 288,000 of Austrian, by 178,000 of English, by 115,000 of Hungarian, by 93,000 of Rumanian, by 72,000 of Czech and Slovakian. It would be smaller by 800,000 whose parents were born in one of forty other foreign countries, these groups ranging in numbers from the 71,000 Scotch and the 77,000 Canadians to the 240 Hindus, the 136 Icelanders and the one (1) Siamese. If these "foreigners" were removed, whole cities within New York—including most of its slums—would be deserted. At least twenty-five foreign tongues—and most of the city's music—would fall silent. Nearly two hundred foreign-language newspapers and magazines—and most of the city's flowers—would vanish from the streets. Along with the mayor no less than five million people, dropping the tools with which most of the city's work is done,

emptying the shops and offices in which much of its money is made, and carrying off the children with whom nine-tenths of its playgrounds swarm and squeal, would disappear.

Are these queer New Yorkers Americans or not? They are Americans in a legal sense—most Americans were born here, more than a million because they have been naturalized, and something less than 670,000 because, although not citizens, they live in New York and cannot legally be thrown out. Are they Americans in any broader sense? The Englishwoman I. A. R. Wylie, who has lived in America for twenty years, in a recent *Saturday Evening Post* gave her reason for not having been naturalized in that period. It was a sense of her own unworthiness. "No one can become an American except by God's grace," wrote she, expressing resentment of those technical citizens who "periodically pack Madison Square Garden with their grotesque and alien isms" and who "may or may not speak with a foreign accent" but "obviously think with one." In the face of such exacting views of what constitutes an American, it is difficult to formulate a definition that will not do violence to the spirit of our laws. Perhaps he can be called an American who, a legal resident, feels himself to be one. Such a

In this article figures of the 1930 census are used because it makes a distinction between native white and foreign white stocks, the latter including immigrants and all native-born, one or both of whose parents were immigrants. Elsewhere in this issue the population of New York is taken at its estimated total for 1939, 7,300,000.

AND SOME ARE STILL IN THE EAST SIDE IN 1939

. . . speaking Yiddish and Sicilian and Russian, pushing pushcarts, fouling tenements, pinching pennies. New York City's oldest slum still represents all they know of America. It is still notable for its poverty, crime, disease, among family loyalties, low prices, argumentativeness and *Gemütlichkeit*. But by far the majority of the "ragged regiments" have moved on to Brooklyn, Queens, the Bronx, Staten Island, and Harlem. Some (notably Italians) have carried their slums with them; others (notably Germans) have left the slum behind them forever. Even the East Side is gradually succumbing to light, air, and American ways. Its population is only half what it was in 1910.

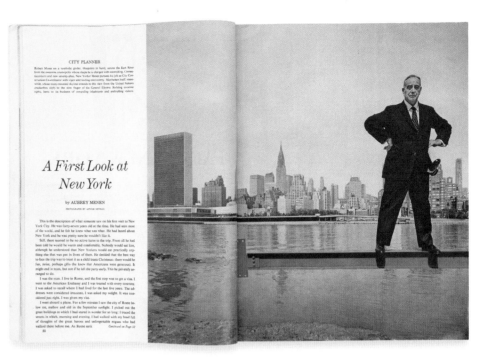

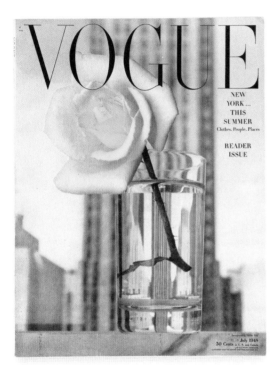

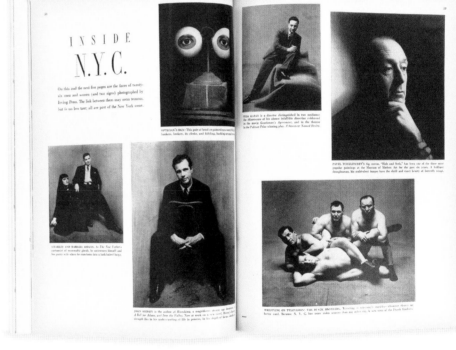

Top:
Cover and spread of
Holiday, October 1959,
with a portrait of Robert
Moses by Arnold Newman;
bottom: cover and spread
from *Vogue*, July 1948,
with photographs by
Irving Penn

gloss over the city's rough spots; with fashion as the underlying force, grit is no match for glamour. Still, there's nothing slight or careless here. With the formidable Edna Woolman Chase as editor in chief and Alexander Liberman as art director, *Vogue* had achieved an ideal blend of style and content. No one conveyed that mix better than Irving Penn, whose striking still-life cover, of a yellow rose in a water glass reflecting a tower at Rockefeller Center, takes a Josef Sudek image on a decidedly cosmopolitan spin. But it's Penn's seven-page "Inside N.Y.C." portfolio of portraits that gives this issue heft, spirit, and a marvelous idiosyncrasy. Even then it must have felt historic. Among the New Yorkers gathered here are Elia Kazan, Joe Louis, Louis Armstrong, Jacob Lawrence, Agnes de Mille, Igor Stravinsky, Isamu Noguchi, and four burly wrestlers known as the Dusek Brothers. All of them were photographed in Penn's studio with few if any props: a rumpled blanket, a bentwood chair, a tight, constructed corner. Working within the conventions of the classic nineteenth-century studio portrait allowed Penn to relax and refresh his portraits for a far more informal age. He didn't necessarily put his subjects at ease, but he did let them be, and the results are not so much performances as statements, both simple and complex.

This page:
Spreads from *Esquire*, July
1960, with photographs
by Diane Arbus (top) and
Saul Leiter (bottom)

Opposite:
Spread from *The New
Yorker*, February 22 and
March 1, 1999, with a portrait
of RZA by Richard Avedon
All magazines courtesy the
collection of Vince Aletti

Penn's supporting cast for this issue includes a number of *Vogue*'s most accomplished regulars—Cecil Beaton, George Platt Lynes, Frances McLaughlin—but Erwin Blumenfeld stands out with a sequence of New York landscapes and street scenes in color that opens the issue on an urbane, artful note, with captions borrowed from Thomas Wolfe.

The New York issue that *Holiday* magazine printed in April 1949 features E. B. White's famous essay "Here Is New York," published later that year in book form and quoted regularly after 9/11, when its dark, premonitory final paragraphs seemed chillingly prescient. The essay still resonates, but there's little else to recommend that issue, and its photography is pedestrian. Things improved considerably by October 1959, when *Holiday* took on New York again in the style it deserved. Although its contributors include the photographers Burt Glinn and Slim Aarons, the illustrator Ludwig Bemelmans, and the graphic designer Herb Lubalin, who created an elegant, sturdy new font for the issue's cover, the magazine belongs to Arnold Newman. An editorial pro with a flair for environmental portraiture, Newman was tasked with photographing the city's movers and shakers, from Helen Hayes, perched on an antique settee in the middle of Times Square, to Philip Johnson, whose newly built Seagram Building (a collaboration with Mies van der Rohe) is seen over his shoulder on Park Avenue. He opens on a knockout spread, with a photograph that epitomizes this approach: the controversial city planner Robert Moses, legs set wide, elbows cocked, looking primed for a fight astride a red girder that juts out over the East River. With the city spread out behind him, landmark after landmark, this is the issue's ideal introduction and one of Newman's most anthologized pictures. Others follow, often stretching across the gutter, always full-bleed, so even subjects you never heard of have an aura of import. And when the subject is Willem de Kooning, seated in the Sidney Janis Gallery surrounded by his own framed canvases, looking wary but resigned, the portrait feels definitive—at once formal and insightful.

Glinn's photographs, kicked off with an arresting shot of the poet Ted Joans reading in a Greenwich Village coffeehouse, accompany a rambling, woozy essay by Jack Kerouac. Assigned to write about Beat nightlife in New York, Kerouac takes us along on a jaunt—"a typical evening among the characters"—that begins in Times Square and, he announces right off, "has nothing to do with night clubs or spending money." Alternately aggravating and inspired, the piece name-checks his buddies (Allen Ginsberg, Gregory Corso, Peter Orlovsky, LeRoi Jones) and touches down at the Cedar Bar, the Five Spot, and other Village hangouts, but Kerouac is too distracted to be a reliable tour guide. "Let's get out of here," he blurts at one point. "It's too literary. Let's go get drunk on the Bowery. . . . Ah! Let's go back to the Village and stand on the corner of Eighth Street and Sixth Avenue and watch the intellectuals go by."

The intellectuals turned out in force the following year for *Esquire*'s July 1960 New York issue. Their names, along with a few choice celebrities, are in lights on the magazine's cover: James Baldwin, Truman Capote, John Cheever, Gay Talese, Mort Sahl, Gerry Mulligan, Salvador Dalí. Diane Arbus, seven years before she was included in the Museum of Modern Art's *New Documents* exhibition, was not among them, but "The Vertical Journey," her six-page portfolio of black-and-white photographs, is the main reason this issue matters. Arbus had hoped for much more from her first big magazine assignment, which she subtitled, cryptically, "Six Movements of a Moment Within the Heart of the City." But even if her original extended captions were trimmed to the bare facts, her pictures survive the cuts and couldn't be more startling in this context. Her first spread was brutal: the grimacing Hezekiah Trambles, a performer known as "The Jungle Creep" in a Times Square sideshow, faces off with Mrs. Dagmar Patino, caught

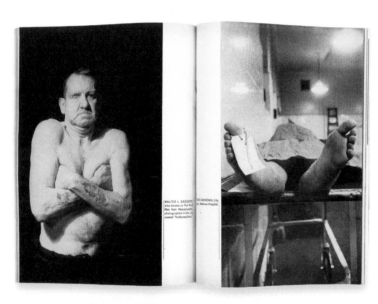

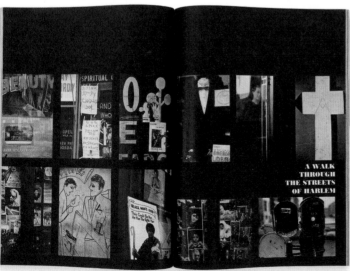

much." In the words of his friend and technical director, Joe Clark, "Joe Volpe rules by terror.... He's good at invisible assassinations when he needs to be."

Neither Clark nor Billinghurst thinks Volpe's style is necessarily bad for the house. Volpe's terror is by design and is extremely effective. And he wants you to know this. He loves to tell the story of how once, on a Met tour in Japan, the soprano Angela Gheorghiu balked at wearing a blond wig to sing Micaela in a Zeffirelli production of "Carmen." Volpe exploded.

"Put the wig on," he told Gheorghiu.

"I won't," she said. "I don't believe in the concept."

"Angela," Volpe told her evenly, "that wig is going on—with you or without you."

Gheorghiu refused. Volpe sent out an understudy.

Next time, she wore the wig.

Often enough, Volpe is charming, if in a studied sort of way. I've seen him endure some hideously tedious chit-chat with wealthy patrons and still hold up his smile. But suddenly he is not so sweet. He sours. When we first met, for dinner at the Grand Tier Restaurant at the opera house before a performance of "La Traviata," we talked amiably for an hour or so, but then he responded to a request for a photo shoot with two so-pranos as if he had been asked to forgo

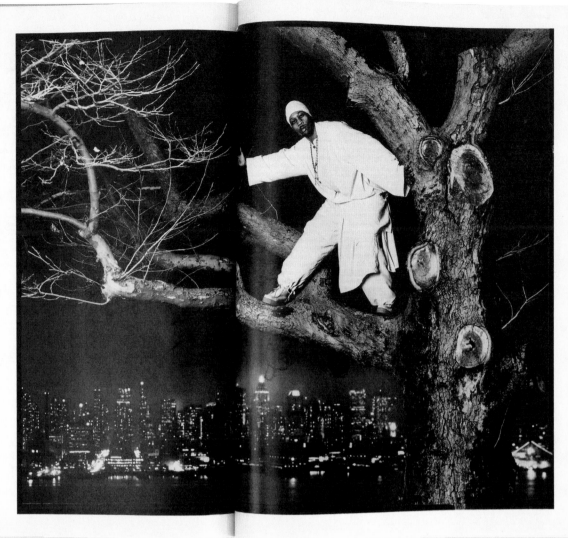

HIGH CLIMBER

Robert Diggs—a.k.a. RZA—the ge-nius behind the fractious nine-piece hip-hop cabal known as Wu-Tang Clan, has become one of pop music's most audacious dealmakers, and his powers of imagination are on con-stant loan: over the past two years, he has produced and/or performed on some twenty CDs, working with such disparate artists as Björk and War-ren Beatty. For all his achievements, though, RZA (pronounced "rizza") may be remembered as the man who put Staten Island on the international map. The woebegone borough once lacked "props," but these days RZA's re-invented version of his home town is known to Wu-Tang fans around the world: it's a phantasmagoric destina-tion called Shaolin, where martial-arts masters battle comic-book heroes.

unaware and distracted at the Grand Opera Ball. Who knows what *Esquire* readers made of the following subjects: a prim matron, identified as the Honorary Regent of the Washington Heights Chapter of the Daughters of the American Revolution; a dwarf actor in his rooming-house bedroom; a shirtless, tattooed mug known as "The Mad Man from Massachusetts"; and a toe-tagged, unidentified corpse at Bellevue Hospital. What now looks like classic Arbus— brilliantly unnerving, at once sensational and matter-of-fact—was radically weird at the time and still burns on the page.

The other reason the July 1960 *Esquire* matters is Baldwin's coruscating essay, "Fifth Avenue, Uptown," included the following year in his book *Nobody Knows My Name* and accompanied here by the photographs Saul Leiter made for his series *A Walk Through the Streets of Harlem*. Describing Harlem housing projects as "a monument to the folly, and the cowardice, of good intentions," Baldwin indicts the system that created them with breathtaking, furious restraint: "A ghetto can be improved in only one way: out of existence." Leiter's color photographs are less commentary than counterpoint. People are rare in his pictures. Typically, he focuses on the urban environment at its most vernacular: storefronts, posters, signs, graffiti. Much of which reads like found collage. Leiter doesn't live in Baldwin's Harlem, but he grounds the reader in an equally vivid and specific space.

A New York issue of *The New Yorker* might seem redundant, but when Richard Avedon is taking every photograph, I'm not complaining. The magazine dedicated its seventy-fourth anniversary issue, dated February 22 and March 1, 1999, to the city in all its brash eccentricity, with contributors including Hilton Als, Susan Orlean, Frank McCourt, and David Remnick (who'd succeeded Tina

Brown as editor the previous year). But Avedon, who never did anything halfway, treats the issue like his idea and totally dominates. Who better to capture the city's character, wit, and range? Among his subjects: Ornette Coleman, Liz Smith, Brice Marden, John Leguizamo, Grace Paley, Richard Foreman, and Joseph Volpe, the general manager of the Metropolitan Opera, surrounded by performers in full cry. In one spread, Mayor Rudolph Giuliani, wielding a street-sweeping broom, finds himself across the page from the soft-porn public-access-cable provocateur Robin Byrd. Both are perched on what appear to be carved stone plinths—cast, like some of the others here, as New York's latest monuments. Not satisfied with being a mere portraitist, Avedon reimagines the city's commemorative statuary, elevating the captain of the Stuyvesant High School math team and the head of an AIDS charity to the same position that Brooke Astor and Philip Johnson enjoy here. In this new democracy of talent and service, Avedon rules.

Vince Aletti is a curator, writer, and photography critic in New York and the author of *Issues: A History of Photography in Fashion Magazines* (2019).

Life and Death in an American City

Philip Montgomery in Conversation with Kathy Ryan

In March 2020, within weeks of the first diagnosed cases of COVID-19 in New York, Philip Montgomery began documenting the health-care workers and staff in nine of the city's hospitals. On his first day, 1,162 new patients had been hospitalized with the disease, and 349 had died. By April 6, his last day, 19,177 people had been hospitalized with the virus in New York, and 3,202 had died. As the story shifted to how New Yorkers would mourn an unimaginable loss, Montgomery chronicled a funeral home in the Bronx, where two undertakers strove to provide services with dignity in a time of isolation. Montgomery hoped his images would "galvanize" the country—and testify to the scale of the tragedy.

One of the most accomplished photojournalists of his generation, Montgomery has covered major U.S. stories from the aftermath of Michael Brown's killing in Ferguson, Missouri, in 2014, to the flooding after Hurricane Harvey in Houston, in 2017. *Faces of an Epidemic*, his account of the devastating effects of the opioid-addiction crisis in Ohio, earned a 2018 National Magazine Award. Last fall, Montgomery spoke with Kathy Ryan about covering New York as the city became the global epicenter of the coronavirus pandemic, publishing powerful photographic essays in *The New Yorker* and *The New York Times Magazine*, where Ryan is the director of photography. As Montgomery recalls, "It was like a movie being played out in front of me in real life."

A passenger on an uptown
F train wears a makeshift
mask, New York, March
2020, for *The New Yorker*

Kathy Ryan: What was it like to be in the epicenter of the pandemic, photographing in New York's hospitals during this crisis? How do you prepare for something like that?

Philip Montgomery: I'm not sure there was a way to really prepare. I wasn't necessarily in panic mode, but it was a feeling of all-hands-on-deck in thinking about how we were going to cover this in the city. You and I had discussed it: "Well, let's do ride-alongs with paramedics." "Let's look at the USNS *Comfort*." But I think we both knew that this story was best told inside the hospitals. That was priority number one.

KR: **Yes.**

PM: When we ended up getting access to nine of the eleven of New York's public hospitals, which was a breakthrough moment, I don't think we really knew what to expect. We were following the statistics, but you have no way of knowing how that's going to look. So in terms of preparation, I didn't really know what to prepare for, emotionally or visually. On the safety front, we were so terrified that we went above and beyond with the PPE, and I'm happy we did, but thinking back on it, maybe some things were a little bit unnecessary.

But what we weren't prepared for was the sheer volume of patients at the peak of the pandemic in New York. As I talk to you now, I have the contact sheet of the shoot at Queens Hospital Center in front of me, and I'm looking through the images, frame by frame, of walking in there, from the first picture to the middle of the take. I remember feeling completely overwhelmed by what we were seeing. I remember feeling really emotional and, at times, was even in tears.

KR: **Why did you choose to use a handheld strobe to illuminate the scenes you were documenting?**

PM: It was pretty immediately clear that was what needed to be done. The light within hospitals is really clinical and flat, and there is so much going on in the space, so the way that I used the light was to enable me to isolate certain scenes and moments. I had to set up parameters within the hospital. HIPAA law dictates that only individuals who had consented to photography could be photographed. And using that light actually helped me to isolate those individuals and frame out the other elements that weren't supposed to be seen in the photographs—unconsenting patients, or patients who were on ventilators, or patients who were being admitted into the ER.

KR: **The light is obviously part of your signature. In our editing, we also spent a lot of time dealing with privacy issues. It was an overwhelming part of this particular project. It's so unusual to have that kind of access in a hospital, and we wanted to be respectful of patient privacy.**
At one point, you photographed fire department paramedics who were resuscitating a coronavirus patient who had gone into cardiac arrest when he stopped breathing. What was that like for you? There you are, you're making pictures, and now you're seeing a life-and-death moment.

PM: It was like a movie being played out in front of me in real life. There were beds and beds and beds. There was barely any walking space within the emergency department at that time, and the room was already high-intensity. Much like you'd see in a television show like *ER*, these paramedics rushed in with the gurney and didn't really have time to station a man in a specific spot, and they were working to save his life in the middle of the unit. It had to be done

right there. I watched the two paramedics taking turns, administering chest compressions to the point where I'm pretty sure they had broken the man's chest plate. It was this profound, cinematic moment—you just couldn't believe it was really happening. But for those working in the ER, this sort of thing happened all day, especially in the time of COVID.

KR: **What was your interaction like with the health-care workers? How do you communicate when there's that kind of chaos unfolding?**

PM: I would try to read the room. Everybody was in N95 masks and face shields. I could see through the shield, and so if someone's eyes locked on me, I could nod. I could sense how they were feeling, and how busy they were. A lot of the time, I was just trying to stay the hell out of the way.

The set of questions I always asked was: "What do you want us to see? What is important for the public to see?" Given the moment with COVID, a lot of doctors were pretty clear about what they wanted to convey to the world, and they largely wanted to reinforce how serious the situation was.

I wasn't in panic mode, but it was a feeling of all-hands-on-deck in thinking about how we were going to cover this.

KR: **In addition to documenting the news and capturing the first visual draft of history unfolding, many photojournalists hope and think and believe that the work they do will provoke some kind of change. What were you hoping the photographs in the hospitals would do in terms of provoking change?**

PM: After all that I had seen, I was hoping they would terrify and galvanize the public into taking preventive measures recommended by scientists, namely social distancing and mask wearing. I was hoping the photographs would spark a collective show of respect for

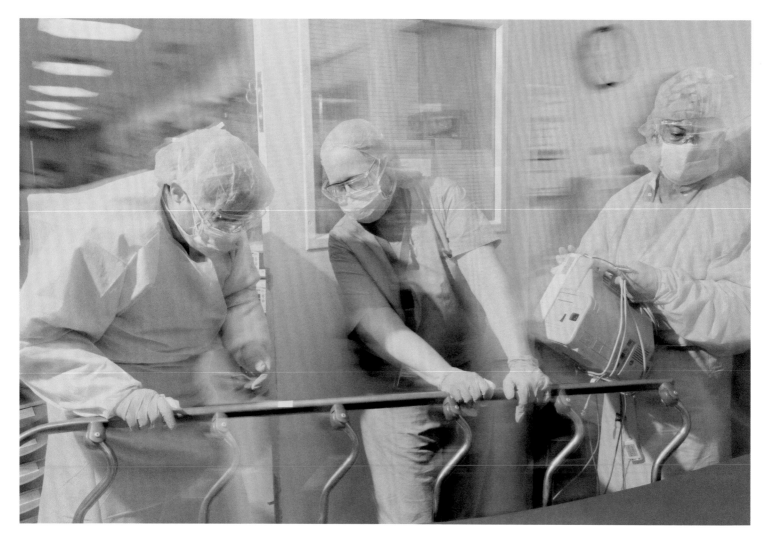

Dr. Sherry Melton (center) moves a gurney after transferring a COVID-19 patient from the emergency department to the intensive care unit, Lincoln Medical Center, Bronx, New York, April, 2020, for *The New York Times Magazine*

A lot of doctors were clear about what they wanted to convey to the world, to reinforce how serious the situation was.

the severity of the disease and the sacrifices by the frontline workers combating it.

How did you feel, as the director of photography at the magazine, receiving those pictures?

KR: **I was shocked. When the pictures came in, it was worse than I could even have imagined—the amount of people crowded into the rooms in the hospital, and the number of health-care workers who were there. It was literally like nothing I'd seen. The project was so emotionally wrenching, partly because of what we were seeing in the hospitals, the speed we were working at, the risks you were taking, and the fact that it was in our own city. Honestly, that *did* make it different.**

We had all just left our lives as we knew them. We've vacated our offices. We're working from home. And we're producing this photo-essay that's going to be extremely important, and hopefully have exactly the impact you were hoping for—which would be to get people to change their behavior and wear masks. This was in March, when there was still a lot of trying to convince people how serious COVID was and how important it was to wear masks and social distance. I felt acutely the unusual experience of producing and editing the photographs while, at the same time, living through this heartrending moment in our city's history. When this issue came out, the response was huge. It was the first, I think, really major moment when a photo-essay kind of showed what it was like, showed everything.

As you were working in the hospitals, it sadly became clear that the next part of your coverage of the pandemic in New York would be to photograph how New Yorkers

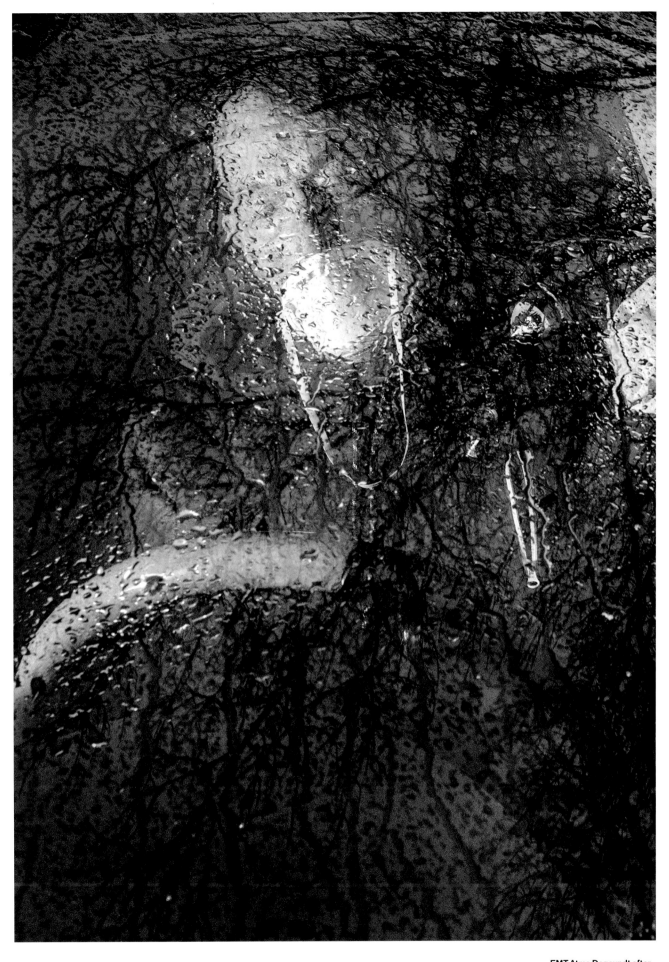

EMT Atma Degeyndt after treating a patient who was suffering from symptoms of COVID-19 in an apartment complex in Bedford-Stuyvesant, Brooklyn, March 2020, for *The New York Times Magazine*

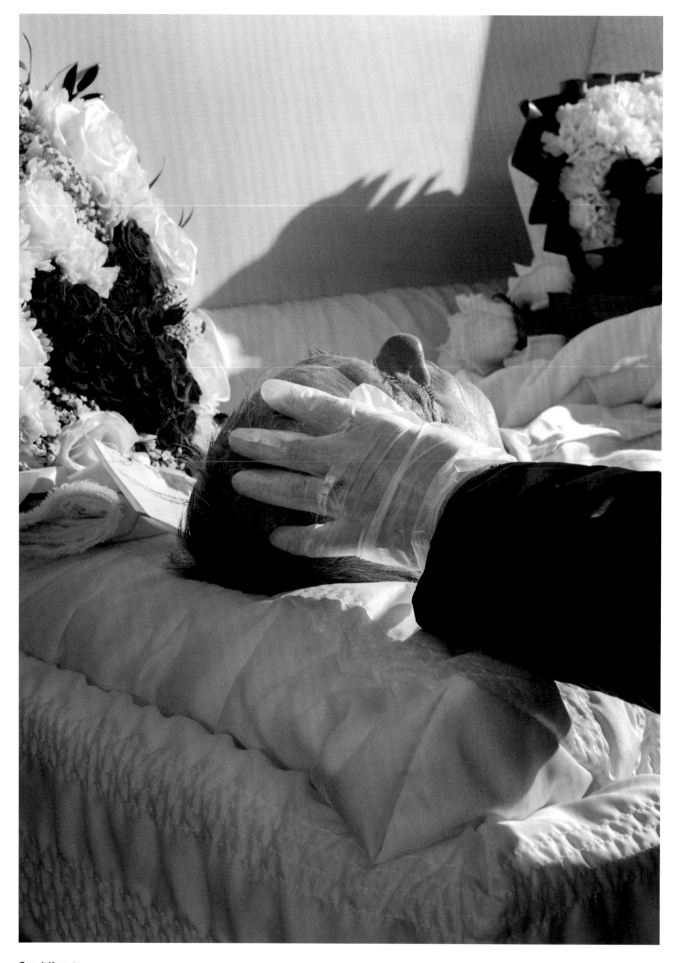

Gurmit Kaur at a
viewing for her husband,
Paramjit Singh Purewal,
Farenga Brothers
Funeral Home, Bronx,
New York, April 2020,
for *The New York Times
Magazine*

are mourning their dead. In April, we arranged for you to spend time at the Farenga Brothers Funeral Home in the Bronx. The idea was that you would photograph the Farenga brothers as they guided families through the mourning process, and you would photograph the families mourning their lost loved ones. One of the first things you did was photograph Nick Farenga retrieving one of those bodies out of a trailer outside a hospital. How did you find the strength to make pictures witnessing that?

PM: I never quite know how to answer that question. The responsibility of the task at hand far outweighs any sort of internal conflict I may have. When I'm working on stories of this significance, there's not much consideration for myself. There's no question of, Can I do this or can I not? I absolutely must.

When I was photographing in the hospitals, the refrigerated trucks being used as temporary morgues were a dark reality, but they were also a mystery. In order to convey the urgency of the pandemic, the public needed to see inside these hidden places. So when we gained access to a funeral home, I thought it was an imperative piece of the story.

The scene inside the funeral home was the evidence. There were bodies stacked on top of bodies. Nick, one of the funeral directors, had to retrieve a body for a family, and he had to move multiple bodies from the shelves to do so. It was completely surreal. He was professional, and at that point he'd done this countless times. For him, it was just work. For me, being there was work as well, but it required another level of focus and sensitivity.

KR: I felt you showed a tenderness on the part of Nick and Sal Farenga. That is difficult, harsh stuff, lifting a body bag off the shelf. The moment that you captured, there's a tenderness to the way that he's holding it, and his head is bent down. I only wanted to mention that because you've got to make pictures that people can bear to look at.

At the time, New York was becoming totally unbearable for everyone—for the people who were losing people, for the people who were trying desperately to save lives. It was just a difficult, difficult time. And you want people to be able to look at this picture. And a lot of people think, Oh, I can't look at that picture inside that trailer, with all the bodies stacked up on the shelves. We never would have thought we'd see something like that in the city.

I felt something similar in your photograph of Sal preparing a body for the embalming procedure, a close-up of his gloved hand as he's washing the hand of the body. There's something about it that feels almost religious. What is your memory of that one?

PM: Sal and Nick are tough men. But when they were doing their work, they implemented a sensitivity that was really surprising and beautiful. I say surprising just because of their demeanors. They're from the Bronx. They're a little rough around the edges. So that juxtaposition was striking.

In the photograph that you're describing, while Sal's embalming a body, he's carrying on a conversation with one of his staff members, and it's like how you or I would talk to a colleague in the office, but he's also still, at the same time, displaying this great respect for the process. I think that's why the picture presented itself to me. His hands were so delicate in handling the hands of the deceased.

I'm sure, in your job at the magazine, you have to ask, How do you show bodies of the deceased? Does that change if they are Americans or foreigners? You must have had this conversation many times throughout your career. It's harder for an American readership to see stories close to home. What were the internal discussions around that, especially considering this story was in our backyard?

KR: We approached it with tremendous care, and every step of the way we were extremely careful to protect the privacy of the patients. It was hard to do the story without showing bodies, and we were committed to making sure that with every picture we showed one could see that the body was being treated with dignity.

The Purewal family agreed to give you full access to document the funeral service of Paramjit Singh Purewal. Mr. Purewal's wife had just recovered from COVID herself and been released from the hospital in time to mourn her husband. For the cover of that issue, we decided to go with the picture of Mr. Purewal lying in the casket, and his wife is stroking his head, and her hand is gloved. So the gloved hand indicates this moment in time, this year of 2020, with COVID, and the fact that she had to wear gloves to touch her deceased husband one of the last times she's going to see his body.

Right up until the end, I was very nervous and concerned and hopeful that the Purewal family would be okay with this decision. We don't seek approval for how we're going to use the pictures in the magazine. It's understood that they know they're being photographed for *The New York Times Magazine* and that, ultimately, we'll decide which images to use. But in this particular photo-essay, I remember wanting to be confident that the family members would feel good about the picture because it was very courageous of the Purewal family to agree to this project. You managed to make brutally honest documentary pictures of the horrendous loss of lives and, at the same time, incredibly honest pictures of tender love, just gentle enough that the people who were pictured in them were accepting of the images.

PM: In each of those scenes, and in other stories I've worked on where I'm meeting someone on arguably the toughest day of their life, whether that's an opioid overdose or a funeral in the wake of COVID, I ask myself, What if that were my father or my mother?

I thought that cover image spoke to how our process of mourning, and our process of engaging death in the time of COVID, has dramatically changed, and how traumatic that could be for a family, from New York, where the funeral homes were completely overwhelmed, funerals were limited and socially distanced, and a lot of New Yorkers were begging funeral homes to help them retrieve loved ones whose bodies had been stored in these trailers for days or weeks.

KR: Being denied the chance to even attend the funerals of their loved ones.

PM: Exactly.

KR: I also think the cover image, because of the light that you brought to it, gave it a little bit of a celestial feel. Without that deft lighting, the picture might not have transcended to the degree that it does, where it feels spiritual.

PM: At the magazine, news moves at a different cadence. But when you have these moments, 9/11, or the peak of the pandemic in New York, where does your mind go as a photography director, when a

Being up there at Rockefeller Center, I began to unpack the profound transformation both our city and our nation had experienced.

story is dominating the whole world? What was your headspace at the beginning of the pandemic?

KR: **I would say it all started with Jake Silverstein, the editor in chief of** *The New York Times Magazine*, **literally on the night before we vacated the** *New York Times* **building for what's now turned out to be at least a year. Who knew? We thought we'd be back in weeks. The COVID crisis was huge at that point in Italy, and it was really just starting to become the issue that it became in New York. Jake said that the story was going to be huge, and be with us for months, and that he wanted to cover it in a big way photographically.**

So I knew what I needed to do. I said we should put you on assignment for a month. When I first reached out to you, we didn't even know what we were going to be covering. The likelihood was it would be the hospitals. Clearly that was at the top of the list. But at that point, we didn't have an actual assignment, to say, "We'd like you to go to the hospitals tomorrow and the day after." We weren't there yet. But it was very clear that major things were happening, and happening in our city, and I desperately wanted us to be able to document it.

Your pictures make people slow down. They make me think of the sort of golden era of *Life* **magazine, when people really stared at a picture. It's so hard now, with everybody looking on their phones, and pictures go by so quickly. Before the COVID crisis took hold, the last assignment you had done for us, in January, was to go into the studio on a big theatrical shoot. We were doing a cover story coming up on the remake of** *West Side Story* **on Broadway, and literally the weekend before it was due to go into previews, we got**

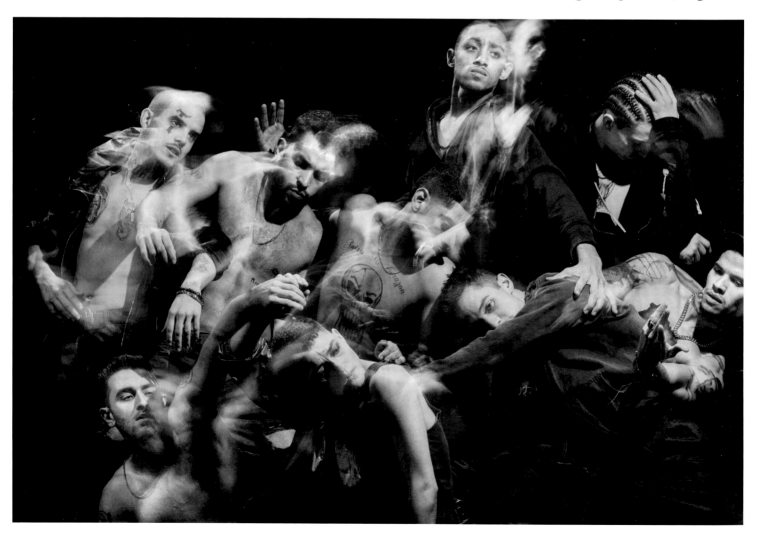

permission and access for you to photograph the whole cast of dancers and singers in the studio. The producer of *West Side Story* arranged for them to go there on a Sunday, and they spent a long day with you.

You got them dancing, singing, reenacting scenes from the musical, doing their own thing—a little bit of everything. It was an extraordinarily joyous day. The youthful energy and enthusiasm and excitement was bouncing off the walls, because for the majority, I think about thirty of these actors, it was their first Broadway role. It just was magical.

In a way, it's almost like I still cannot believe that none of us that day, none of us, could have anticipated that within two months all Broadway shows would be shut down, theaters would go dark. These poor actors are out of a job. This iconic picture of them, which I thought just defined youth and vitality, ends up being ancient history within two months.

PM: I don't know about you, but that was the last time I had fun with the craft of photography. The last photographs I made before the pandemic were during a studio shoot with Matthew McConaughey in LA. Since then, I've photographed New York's empty streets, COVID testing sites, Wall Street as the stock market crashed, John F. Kennedy Airport as it shuttered. Last year, two days before Thanksgiving, I photographed the Rainbow Room on top of Rockefeller Center. The initial excitement at seeing the skyline quickly gave way to sadness. Being up there, I began to unpack the profound transformation both our city and our nation had experienced.

KR: The first couple of months of the pandemic, when I would look at this picture of the *West Side Story* cast, so happy and full of excitement about their future, it would make me sad.

Now, I look at it and have a different reaction—it's a picture about faith. You've got to have faith in New York.

PM: Absolutely. What I'm so proud of in this city is the collective understanding of what we all experience as one. Since those photoshoots, I've traveled a bit throughout the country, and nowhere else is operating like New York in terms of being cautious and considering thy neighbor. That gives me optimism in our path forward. At the beginning, we would see people flee the city—at the first sign of trouble, folks were out. For you and me, people who are over-the-top in our love for New York, it's like, What? Are you crazy? We go down with the ship.

Kathy Ryan is the director of photography at *The New York Times Magazine.*

Brian Wallis
False Comfort

In naval warfare, a false flag operation is a deliberately deceptive maneuver in which a ship engages an enemy vessel while flying the enemy's flag. This tactic was historically used by pirates to approach unsuspecting merchant ships before seizing them and their cargoes. More recently, the term has been used by right-wing commentators to dismiss everything from 9/11 to mass shootings as liberal false flag operations designed to assert governmental authority and curtail individual rights. Amid such conspiracy theories, widely purveyed on social media, the coronavirus pandemic itself has often been decried as a hoax or a false flag.

The photographer An-My Lê has long studied the issues of deception and simulation, particularly as they involve the military. In her early black-and-white series *Small Wars* (1999–2002), for example, she photographed Vietnam War reenactors staging mock combat in the faux jungles of Virginia. And later, in her project *29 Palms* (2003–4), she documented elaborately simulated U.S. military exercises in a Southern California desert intended to resemble a Middle Eastern environment. From 2005 to 2014, she traveled globally on a variety of missions with the U.S. Navy for her series *Events Ashore*, which depicts naval personnel engaged in training for conflicts that never occurred. Lê even photographed the hospital ship USNS *Comfort*, in 2010, on a largely symbolic voyage to bring aid to the earthquake-stricken island of Haiti.

Lê's photograph of the *Comfort* arriving serves as a mute indictment of Trump's hollow response to the pandemic.

The *Comfort* appeared again in one of Lê's photographs last year. In an image taken on March 30, the massive ship, with its prominent red crosses, passes under the Verrazzano-Narrows Bridge, gliding into New York's perfect harbor. The picture reminds us that the city's waterways, a staple of commercial transportation, have also provided solace for immigrants and refugees and easily navigable approach routes for military enemies. And, as in other waterfront cities, these waterways have made New York vulnerable to the increasing threat of climate change, as evidenced by the extensive destruction caused by Hurricane Sandy in 2012.

For New Yorkers ravaged by the raging COVID-19 pandemic in early 2020 and hunkering down in isolation, the *Comfort* symbolized a seaborne rescue, a ship bringing relief or at least some measure of hope. A *Newsweek* headline reported, "Large Crowds Ignore Social Distancing Guidelines to Watch Navy Hospital Ship Dock in NYC Amid Coronavirus Pandemic." On the day the *Comfort* docked in Manhattan, New York Governor Andrew Cuomo reported nearly 7,000 new confirmed cases of COVID-19 in the state since the previous day, increasing the total figure by then to almost 66,500 cases, with 36,221 in New York City alone. State-wide, there were 1,218 dead.

During the first wave of the pandemic, in the winter of 2020, President Donald J. Trump had sought to downplay the highly contagious coronavirus and to dismiss it as scarcely worse than the flu for weeks. Then, at a press conference on March 18, he abruptly shifted gears and adopted a vigorous and defiant new media strategy, predicated on the military. He declared himself a "wartime president" in combat against an "invisible enemy." Seeking visible representations of war, Trump elected to engage the portrayals afforded by the U.S. Navy, and he authorized the dispatch of two hospital ships, USNS *Mercy* and USNS *Comfort*, on missions to California and New York. To underscore this propaganda effort, on March 28, Trump left the White House, where he had been sequestered, to travel to Norfolk, Virginia, for an elaborate photo op to launch the *Comfort* on its voyage. "We are marshalling the full power of the American nation—economic, scientific, medical, and military—to vanquish the virus," Trump said. "This great ship behind me is a 70,000-ton message of hope and solidarity to the incredible people of New York."

After arriving in New York, the one-thousand-bed *Comfort*, a forty-four-year-old converted oil tanker, was assigned to serve as a potential overflow facility for non-COVID-19 patients from the city's beleaguered hospitals. In the days immediately following the ship's arrival, social media spread horrifying images of refrigerator trucks functioning as temporary morgues outside Queens hospitals and giant trenches being gouged for mass burials of hundreds of unclaimed victims in bare wooden coffins on Hart Island. These searing pictures confirmed the severity of the health emergency. Later, the *Comfort* was allowed to receive actual COVID-19 patients, but it was still vastly underutilized. During the thirty-one days the hospital ship was deployed in New York, it served only 182 cases. One hospital administrator dismissed it flat out as a joke. The giant red crosses emblazoned on the sides of the ship, which seemed to be signs of comfort, were in fact an empty promise, a false flag.

In all of her works concerning the military, Lê's goal, it seems, has been to explore the potential role of the fictional in very deliberately invented setups. This is not a post-truth blurring of facts or an argument for the endless ambiguity of simulations, but the opposite: a sensitive and often politically pointed consideration of the deliberate play of imagination across a very tangible landscape. Lê's beautiful color photograph of the *Comfort* arriving as a symbol of hope for New York, an island threatened by plague, serves as a mute indictment of Trump's hollow response to the COVID-19 pandemic, which, with millions infected and hundreds of thousands of Americans dead, stands as the worst health crisis the nation has faced in over a century.

Brian Wallis is a writer and editor based in New York.

Adam Pape
The Roses

Arthur Lubow

In physics, redshift occurs when a heavenly body is rapidly rushing away. Adam Pape's recent photographs, which view New York through a scrim of red and pink roses, convey a similar sensation of life receding at the very moment it is being experienced.

This series, from 2017 through summer 2020, took off from a group of pictures that Pape made of rosebushes growing by a police station in the Bushwick section of Brooklyn, where he was living at the time. From there, the project evolved into a kind of scavenger hunt, with Pape roaming the city on a horticultural search for flowers that could occupy the foreground while, like a mannerist painter, he zeroed his camera in on what was occurring in the middle distance.

Usually, the roses are out of focus, steaming up like toxic vapor or blossoming like gunshot wounds. In the redolent phrase of Charles Baudelaire, that supreme poet of the modern city, they are "flowers of evil." They look both beautiful and dangerous. Pape melds hyperrealistic detail and impressionistic blur. With saturated colors, he conjures an urban setting that is strange even when it features a familiar landmark. A neoclassical office building in Lower Manhattan looms mysteriously behind roses that have dissolved into a lavender mist, but the red traffic lights and incandescent-white streetlamps provide sharp punctuation in the crepuscular scene. A subway entrance glows golden at its depths, like the cave of the Nibelungs in Richard Wagner's *Das Rheingold*, framed top and bottom by light-dissolved pale-pink blooms and green leaves.

Pape is best known for a previous collection of black-and-white photographs, *Dyckman Haze* (2018), which he made in northern Manhattan at night. For that series, he enlisted people to reenact scenes he had previously seen them engaged in. Here, too, he sometimes approached his subjects and asked them to collaborate by holding a pose. He kept his eye out for figures whose clothing incorporated pink or red. If red was absent, though, he readily provided it. The face of a woman in a gray-and-white-striped jacket is obscured by the crimson petals and green sepals of a blurred rose; while in a portrait of a shirtless, sweaty young man, illuminated by flash, the roses have denatured into nothing more than a flush on his bare chest.

Lurid and moody, exaggerated yet naturalistic, these photographs, which Pape often shot at twilight, evoke a cityscape that is both fantastic and recognizable. It is as if the artist had stared hard at what was around him, shut his eyes, and allowed the afterimage, distilled and heightened, to register on his consciousness and then, as if in a darkroom, develop slowly and inexorably into being.

Arthur Lubow is a writer based in New York and a regular contributor to the *New York Times*. He is the author of *Diane Arbus: Portrait of a Photographer* (2016).

Paul Moakley
Ocean Breeze

Late last year, I knocked on the door of the only house left at the corner of Naughton and Oceanside Avenues in Staten Island. A man in a blue bathrobe answered and after brief introductions—masked and from a safe distance—I asked him about a photograph made there in in 1983. He immediately recognized his sister Christine Ann Gibson, who had moved away years ago. He kindly gave me Gibson's number, and the next day we spoke on the phone.

"In that beach community, everybody knew everyone else," Gibson said when I asked if she recalled the day the photographer Christine Osinski made this picture. "It was just a normal thing back then. The guys in the neighborhood would drive by and beep, make noise, to try to get your attention. I would be like, Oh, really." Osinski set up her 4-by-5-inch camera. "I just didn't think anything of her. I was trying to get my task done, and it was just like one of the boys bugging you."

On that day, Gibson remembers the heat but also struggling as a young, single mother. "I was living next door to my widowed mom. She helped me with my two-year-old son while I was working three jobs. I was trying to scrape by to pay the bills."

When most photographers looked to the crowds in Manhattan for inspiration, Osinski captured the quieter lives of Staten Island's working class.

Osinski's photograph captures that feeling—a tough attitude, an athletic frame, Gibson taking out her aggression on an overgrown patch of grass. A row of beach bungalows, lush trees, and old cars fill out the background. Today the only house left standing in this scene is 726 Naughton Avenue, the one in the middle of the frame. This small neighborhood, Ocean Breeze, is on Staten Island's South Shore, sunk between the larger Midland and South Beaches. It's known as "the bowl" to some residents, one of the lowest areas and prone to flooding.

Ocean Breeze has felt desolate since Hurricane Sandy, in 2012, the remaining homes seeming misplaced and alien, surrounded by grassland. Red, spray-painted numbers mark the plots where houses once stood, and new signage outlines plans for the Mid-Island Bluebelt, an ecologically rich drainage area designed to absorb floodwater from future storms. Two blocks north, wild turkeys roam around nearby medical facilities, where military tents cover a COVID-19 testing site run by the National Guard. Directly across the boulevard, a beach stretch borders everything with an uninter-rupted view out to the Atlantic. Since the 1880s, this area was a summer destination; more than a century later, it still provides a place to escape.

Raised by a father who was Lithuanian and a mother with Irish and German roots, and the youngest of six children, Gibson recalls when her parents bought the house in Ocean Breeze. In its heyday, South Beach Boardwalk had been home to an amusement park and a resort until their closings in the 1950s. "There used to be a casino in Midland Beach, and it was a place to be," Gibson says. "My parents bought that property, and others, under that premise. They liked the area so much that they winterized the homes and stayed there. They saw a great profit; my father flipped homes back in those days. He was a visionary." Gibson's father used to mow the lawn, but he died when she was nineteen.

Osinski moved to Staten Island after being priced out of Manhattan in the early 1980s, around the same time she made the photograph of Gibson. Osinski was drawn closer to the working-class people she grew up around in Chicago. A massive expansion followed the opening of the Verrazzano-Narrows Bridge, in 1964, with thousands migrating from Brooklyn and other parts of the city. The island drew one of the largest Italian American communities in the country. Osinski's photobook *Summer Days Staten Island* (2016), with images made in 1983 and 1984, records the rise of new housing developments and shopping centers that took hold on the edges of former farms and beachfronts. Yet much of the island's natural space has been preserved to this day, making it the borough with the largest area of green space. When most photographers looked to the crowds in Manhattan for inspiration, Osinski captured the quieter lives of the working class and the city's expansion on a new frontier.

For Gibson, Osinski's photograph opens a box of memories that touches on many issues from that time—the struggle to fit in, the racial tensions, and her own path as a student and later a mother. "I thought, I can do it all. I was superwoman. I wasn't going to let anything get me down." She noted her Stevie Nicks look (she was into rock 'n' roll then) and a telephone pole in the background painted for the bicentennial.

"I loved growing up on Staten Island," Gibson says. "It was quiet and peaceful." At thirty-eight, she moved away, and now lives in Florida, where she works in clinical research. Back at home on Staten Island, they call her "the glue." She misses her family, but remains close to them. "You remember a lot of love with that many kids growing up in the family. I remember the ocean breeze rolling in around two each day. My dad always said, 'All good things come from the sea.'"

Paul Moakley is a documentary photographer and editor at large for special projects at *TIME*. He lives on Staten Island as the caretaker and curator of the Alice Austen House.

Christine Osinski,
Woman Cutting Grass,
Staten Island, 1983
Courtesy the artist and
Joseph Bellows Gallery,
La Jolla, California

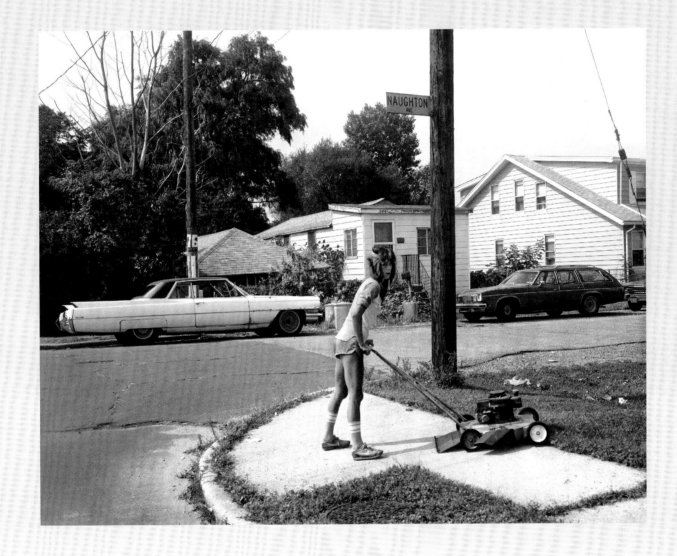

Seeing In Black

A Roundtable with Antwaun Sargent

At the height of the racial justice protests in the wake of George Floyd's, Breonna Taylor's, and Tony McDade's deaths by law enforcement in 2020, a group of six young Black photographers organized themselves into the collective See In Black. Spearheaded by the New York–based image makers Micaiah Carter and Joshua Kissi, the mission was simple: use art to affirm that Black life, disproportionately affected by the coronavirus and state-sanctioned violence, matters beyond moments of crisis.

"See In Black formed as a collective of Black photographers to dismantle white supremacy and systemic oppression," the coalition's statement of solidarity reads. "Our intention is to replenish those we've been nourished by." Their first action was to establish a print sale titled Vol. 001 Black In America, which included snapshots, street scenes, self-portraits, still lifes, and editorial images of Blackness by nearly eighty photographers. Collectively, these intimate portrayals present community as an act of hope. Image by image, you see Black America honestly gazed at from within the circle of lived experience. At a time of deep despair, their photographs were a testament that Black narratives will not be devalued. The print sale raised over $500,000, which they donated to five homelessness, youth, queer, political, and legal organizations.

A number of the photographers call New York home. The city, battered badly over the past year, has allowed these artists to establish themselves creatively and to attune their eyes to construct counternarratives that squarely capture what the collective calls "Black prosperity." Here, I speak with seven of the photographers about how art meets activism in New York.

AS: How does New York inform your practice as an image maker?

JK: Being of West African descent, in a place in the Bronx that has a lot of West Africans, people from Ghana and Nigeria and Guinea and Senegal, made me think about what this vibrancy looked like within my work. I always thought, What do color and tone look like? How do I make this photo feel like you're really in Little Senegal, or on the west side of the Bronx?

AS: You see the multiplicity in Blackness in your images. There are differences in the way that skin color needs to be shot from neighborhood to neighborhood to make sure that you capture the richness and the specificity of that identity.

JK: Yeah, absolutely.

AS: Our city experienced this pandemic like no other at the beginning, and then we went into racial protest. You and Micaiah decided to launch See In Black.

JK: We were just thinking, like, Will we be able to live the same type of lives that we were living before? We knew that we weren't the type of photographers to necessarily go out and photograph protests. That's really an emotional thing. We love and support the people who do. But, what else can we do that isn't necessarily on the front lines but is on the front lines? It isn't necessarily just about a trend. It's about, How do we solidify our perspective when it comes to image makers who are Black?

Everybody put their head down and just got to work. Getting the photographers together. Trying to organize, getting logos and websites and photos. We were really in it. But we didn't

JK: We know a lot of photographers in New York and LA, but there are so many multitudes and layers of Blackness. So it was important to have as much representation as possible within the Black community. We wanted other photographers to be like, "My personal work may not be in there. But I see my lens, I see my understanding, I see my practice." The main point was if you see your work within this selection, the job is done. You could continue to add on to that narrative. You can continue to shape that story.

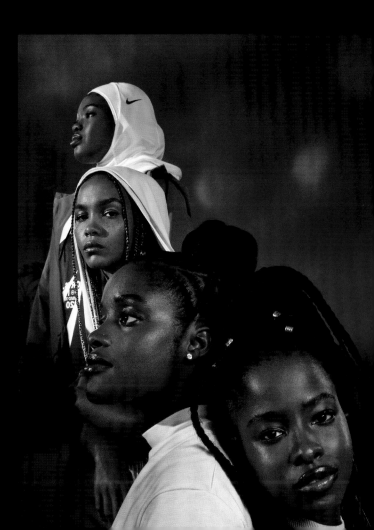

AS: Why did you and Joshua start See In Black?

MC: We wanted to have a response. As Black photographers, how can we give back to our own communities, not only based in New York but across the country? We wanted to have a plethora of people that we could reach out to for the first round of what See In Black was, and to raise money and help people in need.

AS: One of the first actions was a print sale—and they weren't necessarily all images of activism. It really was about a real deep look at Black life. Why was that important to you?

MC: Black trauma is something that is expected. There always has to be some type of struggle. We wanted to show that's not always the case. There are moments of happiness. There are moments of mundaneness.

AS: Your photography often takes moments from our rich past as Black people and remixes them in these contemporary images.

MC: I think that's consistent from when I first started. Even now, when I'm home, I look back at my dad's photographs. That's still a big inspiration for how I view photography, the family album as a whole.

AS: How did you develop that style?

MC: I think it's just my perspective on how I am as a person reflecting on other people. I am inspired by certain people. So, for example, like with Megan Thee Stallion, when I shot her, I wanted her to be in her style element. I wanted this softness that you don't really see with her.

AS: What do you want the future of See In Black to be?

MC: Almost like a boys and girls club—to have, from different pockets of America and the world, accessibility to Black photography. Black tools. Like, say there's

a Black photographer who really wants to start. They can go into See In Black, know just how they want to network, and from there build to where they want to go. It's not an agency; it's more like a mecca for knowledge and a mecca for community.

AS: And history. Right?

MC: Yeah, and history.

As Black photographers, how we can give back to our own communities?

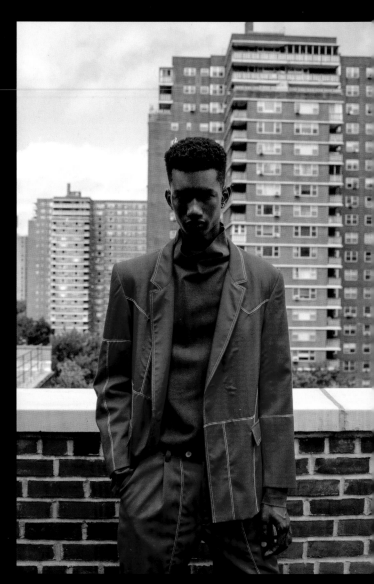

Micaiah Carter,
Highsnobiety, **2019**
Courtesy the artist

**Micaiah Carter is a photographer based in Brooklyn
and Los Angeles.**

Florian Koenigsberger

AS: **You grew up in the city, right?**

FK: Born and raised here.

AS: **How has being a native New Yorker informed the development of your photo practice?**

FK: Growing up here makes you unafraid of approaching strangers. I remember when I got my first camera in late middle school, early high school days, the big story for me was having a chance to walk around New York and ask questions to people that I didn't know, and to make their pictures.

AS: **Why did you want to use your images in service of the mission of See In Black?**

FK: Many of us were fearful that what was happening in the aftermath of Mr. Floyd's death was going to be a moment and not a movement. How do you carry this forward? For us, it was: If you can live with this representation of Blackness in your space, and this becomes something that you interact with daily, it really fundamentally challenges the racism and bias that many people are operating with daily. The other side was we wanted the community to have work. It shouldn't just be people who are used to buying this work that can have their ideas challenged in their space.

corporation can now be repurposed to directly serve the community. No frills. No middleman. To me, that was the greatest honor. To spend all of this time learning all of these skills and to finally be able to bring them back into the community in a way that really directly and immediately serves its needs was incredible. And there was never a question for me that that wasn't the thing to immediately dive all the way into.

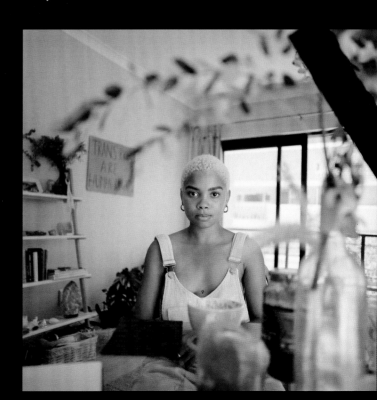

AS: **How did New York help you develop as an image maker?**

TI: My first experience of community was being involved in nightlife. It taught me so much about the different ways we can take care of each other within the work that we want to do. When we were curating parties, like Alien or like Roxy Cottontail or like Good Peoples with Katie Longmyer, at least the crew that I was with, we'd come together and just ask, like, "Who are the folk that need support right now? Maybe we can hire them for the door."

AS: **One of the things that emerges in your work is this mosaic of young creative New York. Why was this communal portrait making important?**

TI: Everyone contributes to a space in some way. You have the door person. You have the host. The DJ. The bartender. The person who cleans up at the end of the night. I took that idea and extended that to the everyday. I want to photograph everybody that will allow me to photograph them. And that felt important to how I was establishing an archive. Everyone is valuable. Everyone deserves a visual space.

AS: **Why was it important for you to show up in the way that you did by joining See In Black and offering to the community your images?**

TI: It was a way to give back. I'm not a big protester. Not everyone can be a part of a protest for five hours. So, it was just a way to remind people that they do have access to artwork during this time. I've known Joshua for a while now, and I trusted that Joshua would hold this space, along with Micaiah. It really felt important to also be a part of something that was established by Black people and for Black people.

I treat my friends. I think See In Black is part of that, showing up for community and showing up for each other, even if not all of us are familiar with one another. We're coming together and just trying to figure out how we can make our work more accessible to the community, and then also how we can raise funds and donate them to a plethora of Black organizations and collectives.

AS: **Do you think of your archive making as a form of activism?**

TI: I do. I'm just trying to turn away from these traditional structures of how people believe photography should be valued, and what it means to be photographed, and what it means to step into that space, and how it can be a space for everyone, every single person. It doesn't matter if you are a janitor or if you are a gardener. You are still contributing to this world, and you deserve that space.

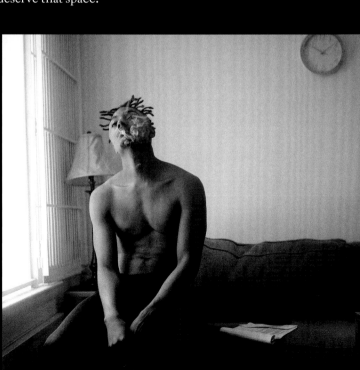

Kreshonna Keane

AS: **How has New York informed your work?**

KK: A lot of people strive to move to New York because it seems like the greatest place on earth. I think, being from here, I started to hate it and resent it. Then, moving to Atlanta and coming back, I grew a larger appreciation for New York and, more specifically, for the Bronx, which is where I was born and raised.

AS: **What are you trying to capture about the Bronx in your images?**

KK: Originally, it started out as the life and culture. I was shooting our local restaurants, my friends in front of them, and things like that. Then I kind of wanted to start a deeper meaning, maybe by shooting the people who own these places and things like that. The part of the Bronx that I live in, the culture there, a lot of the things that we focus on are, like, food and the mom-and-pop shops that are owned there. It's heavily Caribbean-based and Caribbean-owned.

But then it kind of grew into something larger for me. I took these overlooked places, like New York City public housing. We see these project buildings every day when we walk past, and they have these negative connotations attached to them. I tried to turn it into something more beautiful by giving it an editorial spin and putting a model that you wouldn't see there.

AS: **When you joined See In Black, why did you feel like your photography could be used in a way to help the city?**

KK: I was actually shocked that I was asked to join it. Looking at the list, I was like, Wow, I don't really see my work as comparable to all the other artists up there. But I realized that I should be a part of this, that maybe my work could be something for people. It felt good to be part of a larger collective and to make a difference, and I knew the impact that we could make.

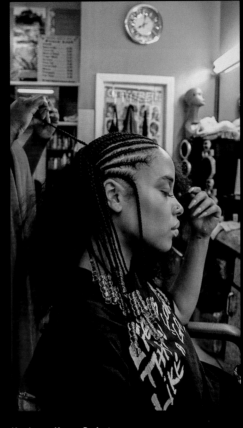

Kreshonna Keane, *Project Princess*, Bronx, 2019
Courtesy the artist

It's always been important to me to show that there's beauty in the Bronx.

AS: **The brilliant thing about what you did with See In Black was to share images of the breadth and depth of Black life. Why is it important to you that the Bronx is a character in your images?**

KK: Because it's so overlooked. There's always this talk about boroughs. Everybody always says, "Oh, my borough is the best—the Bronx is the best," or "Brooklyn is the best," or "Queens is the best." Ever since I was younger, I always used to hate it. I would hate being from the Bronx. I would hate what I saw when I walked around the Bronx. I was experiencing things walking around the Bronx. It's always been a place to be feared, and a place to be looked down on, and a place to be frowned upon when you tell people you're from there. So it's always been important to me to show that there's beauty here; regardless of the struggle or not, there's beauty in it.

AS: **And with your camera, you're showing it.**

KK: Exactly.

Kreshonna Keane is a photographer, creative director, and visual artist based in New York.

AS: **How has New York shaped you as an artist?**

FN: It's pretty much the whole reason why I think I'm able to approach the world of photography the way I do. From a young age, I've always been outgoing and talkative and excited about life. It's a vigor that I acquired growing up. I think it would be very different if I was raised in the country or another city.

AS: **Early on, your practice was largely self-portraits at home in Harlem, of you on the roof. How did you frame those images in relationship to the city's landscape?**

FN: People call New York a concrete jungle. The city itself builds up more than we build across. So just even being on a roof was something I was used to, being on a fire escape was something I was used to in the homes that my parents and my family lived in.

AS: **When See In Black was formed, what did it mean to you to use your images in a way that gave back to the community?**

FN: I remember being in high school and being a fan of what Josh was doing with Street Etiquette. I loved that so much because it was this awesome representation of the city and fashion photography and Black men. So, I was honored to be included. To be able to show an image that a lot of people felt was powerful, that a lot of people felt moved to purchase, something that was taken in my home literally a couple of blocks from my house, to me, that's a representation of the community at a

though I've done other work as the years have gone on, that muscle is very sixth-sense, it's very muscle-memory, it's very natural to pop back into the action of it and just be in the moment. You communicate with people. And I love that I can hop back into that kind of work very naturally. It's really a blessing.

To be able to see my work, not just on my social media or on my website, but to see it in people's homes and to have people hit me up, and say, "I want to buy that print"—I'm like, Wow, that's so cool. That moment spoke to you enough that you wanted to bring it home with you and have it forever.

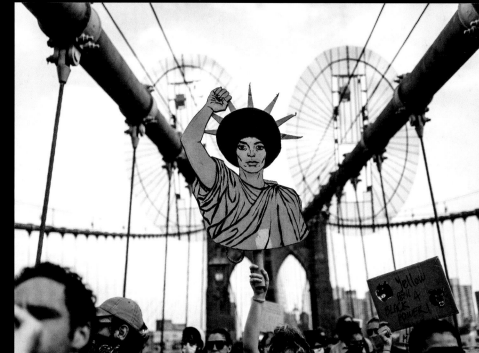

Flo Ngala, *Untitled,*
Brooklyn Bridge, NY, **2020**
Courtesy the artist

Mahaneela

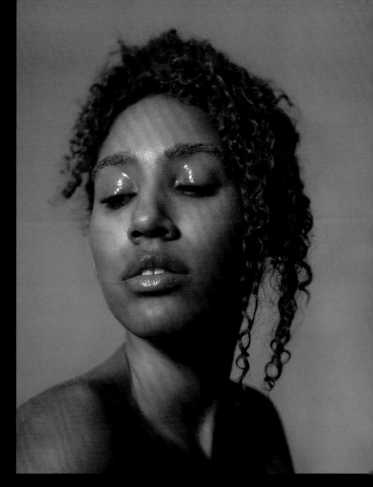

AS: How does New York inform your way of seeing?

M: I should start with how much identity informs my work and my practice, being someone of multiethnic backgrounds. I'm from Jamaica; I'm from West Africa; I'm from India, born and raised in London. My parents are from East Africa, even though they're Indian. I am used to the mix and blend of cultures. So, for me, that's always been a really big part of how I see things, and being in New York is a gold mine of cultural richness.

AS: Has your portrait practice changed from England to New York?

M: Yes, it has, actually. In England a lot of my photography was of people I knew, people within my community; in New York it's shifted. I'm creating a new home for myself—and so I have to go outside of myself, to kind of reach out to people and start these conversations and connections, rather than them already being there.

I've been coming back and forth to New York for years, like since 2014. That's actually when I met Josh. He showed me around New York. We'd never met before; we just knew each other on Instagram. He was the one who took me around and gave me my first insight into the city.

The subject that I shot for See In Black, she is somebody I met in New York. I met her randomly, at a party. Which I felt was such a New York experience. That was the reason I feel I did that image. Because really, that image reminds me of how things come full circle, and how I just met this girl at a random party, I didn't know anyone, we started talking, and then maintained that relationship, and ended up doing this shoot, which was very spontaneous. New York gives me that confidence.

AS: Why was it important to use your images in a social justice movement?

M: I was able to feel like I was actually being an agent for change in a way that was acceptable to me. That period of time between March and June was an extremely scary and unstable time for New Yorkers, especially being that there was such a high concentration of COVID-19. It felt like a moment of powerlessness, coupled with the murder of George Floyd. And it also felt like a time in which we could kind of take matters into our own hands.

See In Black was a way of making a change in a positive way. We are raising money for the Black Youth Empowerment Project, the National Black Justice Coalition, the Black Futures Lab, and also the Bail Project. And we are giving a broad look into what Black photography and what the canon of photography are now. Even just seeing all of our prints there, seeing the diversity of composition and people and characters and subjects that exist within the work, was eye-opening. We are not one homogeneous thing, and yet we still come together for these causes that affect all of us and all our families and all of the communities that we belong to.

We saw close to half a million in sales for See In Black. The demand and the value are there. It goes to show the value of this work and our contributions to the world.

Mahaneela, *Stay Tru*, 2019
Courtesy the artist

Mahaneela is a multidisciplinary artist and DJ from London

Antwaun Sargent is a writer and curator based in New York. He is the author of *The New Black Vanguard: Photography between Art and Fashion* (Aperture, 2019) and the editor of *Young, Gifted and Black: A New Generation of Artists (2020)*

Natasha Stagg
Nightlife

At the moment, I'm near a building in the East Village that in the 1980s used to be the home of a club called the World, where, apparently, a lot of firsts happened, such as Björk performing in the United States. Of course, today everything is different here, but a few things are the same. For example, Björk has to watch for paparazzi and phone cameras now, but I've heard from many New Yorkers that until very recently, she'd often go alone to out-of-the-way bars just to dance—hiding in plain sight.

When we read about the '80s and its parties, there is always mention of an epidemic, the AIDS crisis, and how it set a tone, acting both as deterrent and impetus for going out. Partyers showed bravery, or maybe it was nihilism in the face of certain oblivion, the end of the world, for which this club I'm near was named. People liked to party like it was their last day on earth, like it was 1999, like their lives were in danger, since they were.

A good party requires a sense of urgency, heightened by secrecy, and during recent years, it's been hard to keep anything a secret. Even if parties are illegal or exclusive, they are surveilled by their own guests' social media. Guests whose lives are mostly online develop competitive natures, and soon every exciting event can't not be broadcast to their followers. This structure leads to sponsorship, obviously. The opportunity for organic reach is irresistible to brands. And so the underground nightlife scene gained a moneyed polish. Bars were set with glowing, labeled glasses, and people stopped doing things they wouldn't want to be photographed doing. Each era has its pros and cons. We had free, themed cocktails in the 2010s, at least.

> **A good party requires a sense of urgency, heightened by secrecy, and during recent years, it's been hard to keep anything a secret.**

But in 2020, the coronavirus made nightlife shameful. Social closeness causes spikes in transmission, which crowd the hospitals. No one wants to be seen at parties anymore. This situation has gotten rid of the sponsors, for worse and better. The party hosts are living on unemployment, without a lot of options, but then again, there is potential for that urgency and escapism we always hear about to return. I used to wonder, If underground parties go, or go completely corporate, what will future generations think of us? There were always exceptions. The Spectrum, a queer club in Brooklyn, did everything possible to stay underground despite its popularity. It was always threatening to shut down because it wasn't legal and needed to pay off violations, I assume. Located at first

in a sweaty house in a residential neighborhood, with a bouncer standing on a gated lawn, the Spectrum moved around, its name becoming synonymous with a crowd more than a space. In Wolfgang Tillmans's images of the Spectrum, the parties appear quiet, almost serene, as if the music wasn't drowning out most conversation. When friends tell me about missing the Spectrum, they talk about a sense of intimacy that they weren't able to find anywhere else.

There was, we can appreciate looking back, a unique uncanniness to the phony layers of those sponsored parties. I remember working at a party in the now closed Pacha New York, a massive space on West 46th Street, near Larry Flynt's Hustler Club, famous for its policy of not giving back change if one paid for drinks with cash. The party was real, but it was also staged, as it was being filmed for a Nile Rodgers & Chic music video. The strangeness of being watched while partying was inhibiting but also exhilarating, and the multiple takes of a supermodel getting out of a cab in freezing weather didn't even make it into the video, but we got to be there for it, watching from inside. That's the tension we're chasing at parties, after all—it amounts to otherwise impossible inversions of status, however momentary.

When a space is shut down, it becomes legend, the meeting spot for a cross section of a time period. I often think about Passion Lounge, a Bushwick club with a mirrored staircase leading up to a balcony, before it got renovated and renamed Republic, and later closed. For a short moment, it felt as if everything emergent in New York was being performed there. Then, the dim sign with its silly backward S became an oppressive LED marquee, and I stopped hearing about anyone going.

Probably the most notable permanent closure announced in 2020 was China Chalet, the financial district Chinese restaurant by day and underground venue by night, which had somehow stayed under the radar despite many years of celebrity attention. Now, China Chalet is being called our Studio 54, even though no one called it that a year ago. And, it is that, if only because the idea of this location will stand in for a scene. In photographs of our pre-pandemic places, future students will study nightlife that tried to fight off exposure, before everyone went into hiding again.

Natasha Stagg is the author of Surveys: A Novel (2016) and Sleeveless: Fashion, Image, Media, New York 2011–2019 (2019).

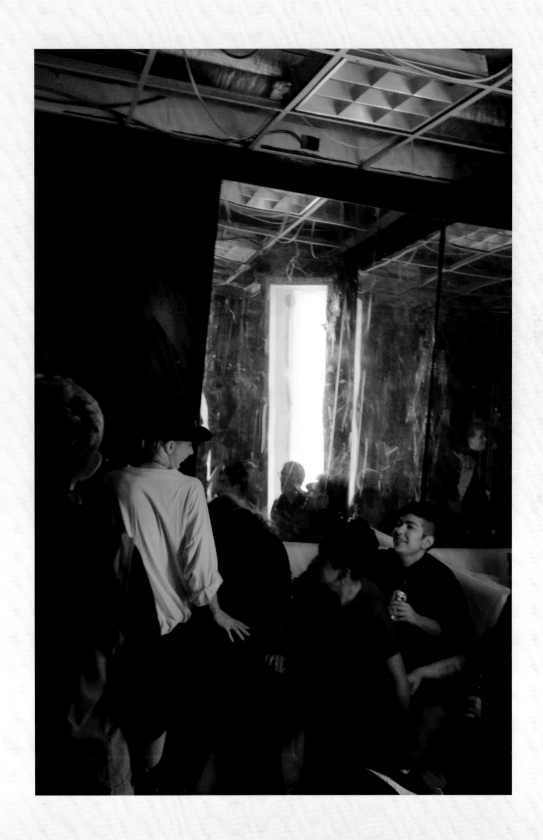

Rafael Rios
Family

Concepción de León

Too much weight is often placed on the value of an outsider's vision, presumed to be clear and unfettered. But what of the insider? He who can witness more intimately what the outsider cannot. That has long been Rafael Rios's prerogative. The New York–based photographer's images center on his extended Puerto Rican family, many of whom have lived in the same Fort Greene house since his aunt and uncle bought it in the early 1980s. Growing up, he and his parents lived on the top floor, his cousins on the second, and his aunt and uncle on the ground floor. His work tells the story of this house as much as it does that of his family members. And both are memorialized in his aptly titled 2018 book, *Family*, which contains images taken over an eight-year period, from 1999 to 2007.

Multigenerational living is common among Latinx and other immigrant families in New York, driven by economic necessity and tight-knit family values. In the mountainside village, in the Dominican Republic, where my family is from, relatives often live in clusters—small, multihued houses built near enough to each other that one can easily pop in for coffee or make lunch a neighborhood affair.

In New York, driven by necessity, my extended family replicated that communal living. We grew up in two- or three-bedroom apartments where every second at home was a shared one, every space communal. My father bought his own home when I was a teenager, and we all moved in there, separated only by wooden beams and drywall. This sort of setup is becoming more common in the United States. A 2016 analysis of census data indicated that 20 percent of the population, or sixty-four million people, were living with multiple generations in a home—particularly in Latinx and Asian households. Rios documents the intimacy of this arrangement in his photographs.

Over the years, Rios has captured his family at play and at rest, braiding one another's hair or lying twisted in an embrace. When his aunt got sick, he took his camera to the hospital and photographed her cackling into a ventilator and later, at home, family members crowding into bed with her. "Families gather for parties, or when something bad is happening," Rios says. He shows his family in various states of gathering, for both quotidian and special occasions. Rios also presents the same people in different contexts, and across time.

Gathering is much more difficult and dangerous now, during the pandemic, and the focus of Rios's camera has necessarily narrowed, homing in on his partner, Jassine, and his daughter, René, who was born in June of 2020. "All of René's life has been in quarantine," Rios tells me. He returned to the family home and took a photograph of his mother standing in front of a framed portrait of herself from *Family*, wearing a mask and sanitizer in hand, seemingly mid-pump. She held René for the first time only recently. In another image, Jassine sits on a park bench with René, a black mask pulled down underneath her chin.

These photographs reflect how the pandemic is forcing us all into isolation, testing our bonds. When I got COVID-19 in late November, many family members dropped medicinal teas and food at my doorstep. One night, my aunt came by. She left tearfully saying, "I love you," and "I can't be with you." As if trying to reconcile the two statements. There is joy in gathering, but perhaps there is a different sort of connection to be found in our new reality, a renegotiation of family love—an air kiss rather than a physical one, a delayed reunion rather than a tragic one.

Concepción de León is a staff writer at the *New York Times*.

Page 109:
Jassine and René, 2020;
opposite, top: *Mom
sanitizing her hands*,
2020; bottom: *René after
her bath*, 2020; this page:
Marcus on Thanksgiving,
2002

Isaac and Jenny, 2000

Mom in her room, 2003

Opposite, top:
The downstairs bathroom,
2004; bottom: *Getting
ready for the party,* 2004;
this page: *Marcus's
stocking cap,* 2004

**All 2020 photographs
for *Aperture***
Courtesy the artist

Since last June, a group has gathered every Thursday on the sidewalk outside the Stonewall Inn, the launching place of the modern gay rights movement. As expected at gay bars, those assembled coagulate in little clots, smoking, chatting, and exchanging hugs. That this has happened during a global pandemic means that they are sporting masks. And that this is but a preamble to a rally and march, aimed at holding space for, drawing attention to, and advocating on behalf of Black trans women, means that it's all done under decidedly different auspices than a night out on the town to pull looks and dance.

"We aren't doing anything crazy," says Qween Jean, who alongside Joel Rivera has been organizing and leading the weekly Stonewall Protests as well as other actions since the reigniting of the cultural conversations around the Black Lives Matter movement. "We are asking for people to love us; we are asking for people to listen to us; we are asking people to protect us."

When the actions began, the remit was simple. Rivera, who had been starting "little riots" since she was in Catholic school campaigning to open a queer alliance club, sought to include the Black trans community in the ongoing calls that Black Lives Matter. She strove to add Nina Pop and Tony McDade to the growing Say Their Names list. So, following other actions last summer, she organized the first Stonewall protest, where she met Jean.

"That was the first time I saw a Black trans woman in leadership," Rivera says of seeing Jean speak and lead those assembled in a series of chants. The pair quickly became close collaborators. "I didn't think of [the protests as] being something that would keep happening until afterward. There was no excuse for people not to be out here fighting for Black queer people."

The Stonewall Protests have begat their own community: Musicians United sends drummers, a sax player, and a horn player that pose as a veritable marching band; a battalion of marshals on bikes blocks the streets to keep marchers safe; a group of banner holders and flag bearers, along with marchers, shouts chants led by Jean; and there's a sizable group of photographers who capture almost every moment of the action.

"When I think of it in terms of the pandemic, Qween is really giving us everything we are missing," says Ryan McGinley, who has photographed the protesters with their consent. McGinley began to get involved in activism in 1992, after his brother was diagnosed with HIV. "Nobody can go out and dance, there are no fashion shows, no bars, no parties. What Qween is essentially doing is making an ecosystem of all the things that we are missing and incorporating them with activism."

One night last November, during Trans Awareness Week, Jean, Rivera, and other organizers made their entrance at the Stonewall gathering in floor-length gowns. Rivera recounted an exchange where a woman told her that the actions (and Rivera's decision to wear gowns and get done up) were for attention. "When I'm here, everyone sees me as beautiful," she said on the mic, explaining that her wardrobe choices are a personal embodiment of that beauty. Others spoke of those gathered as family, the space as one of rejuvenation. And then they read the names of the thirty-seven trans folks who were reportedly killed in 2020, most of them Black trans women.

As the march wound through downtown New York, McGinley and other photographers ran alongside, climbing up onto signs, scaffolding, and fences to get their pictures. Jean led the marchers in a series of chants, screaming "Black trans lives matter," "No justice, no peace," and calling for the abolition of police. At one point, she stopped the entire procession. Music played on loudspeakers and the night turned into a mini-ball, with people walking the runway, voguing, and participating in an impromptu twerking competition.

Jean paused twice for moments during the march that attendees call "Fuck Your Dinner." "I hope you get out of this bubble," she said to a group of diners who were eating inside a plastic dome on the sidewalk of a restaurant. It proved an apt metaphor. "There are people who will never be able to afford a dinner here. We want you to go home and say your evening was disrupted by a group of Black trans and Black queers."

"In case you didn't know, it's Trans Awareness Week!" Jean continued, the marchers huddled outside the bubble, Pride flags, trans flags, and banners held high. "And we are so happy that we could meet you here, at your dinner, and let you know."

"Fuck your dinner."

Ryan McGinley
The Stonewall Protests

Mikelle Street

All photographs from
the series *The Stonewall
Protests*, 2020
Courtesy the artist

Mikelle Street is a writer based in New York
and the digital director of *Out* magazine.

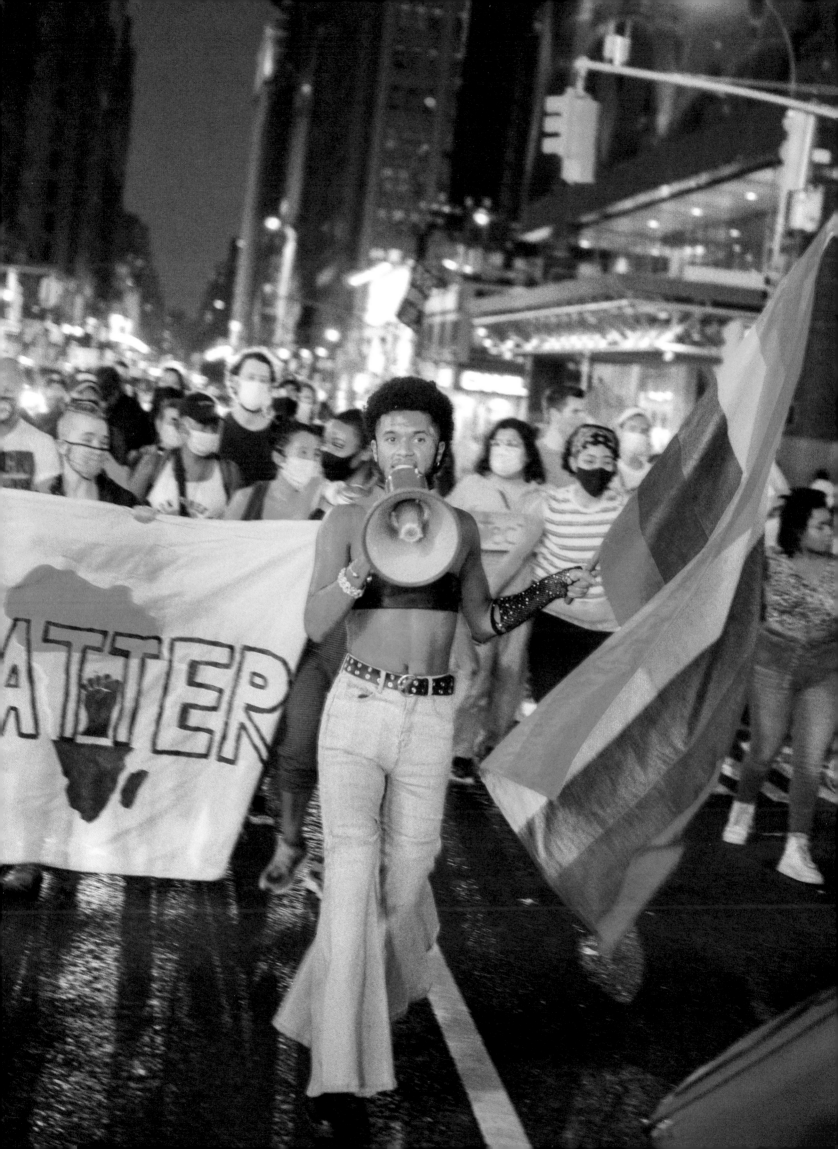

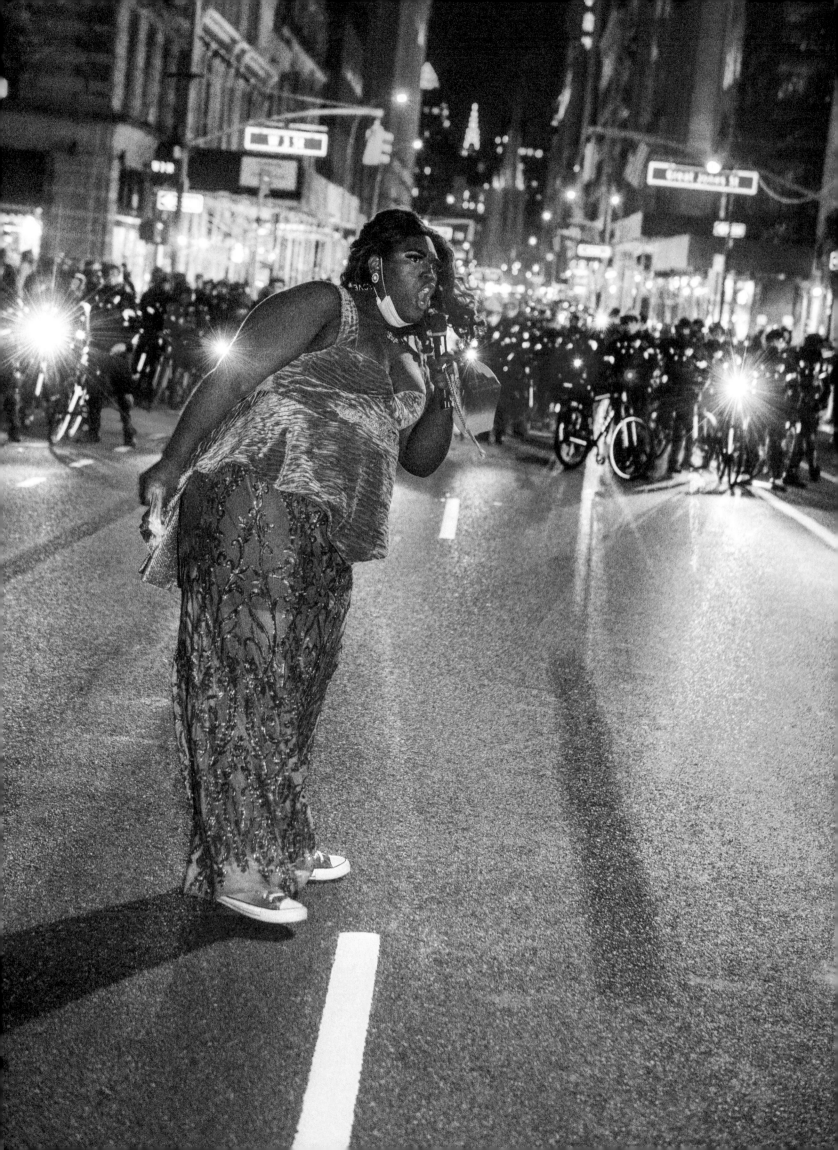

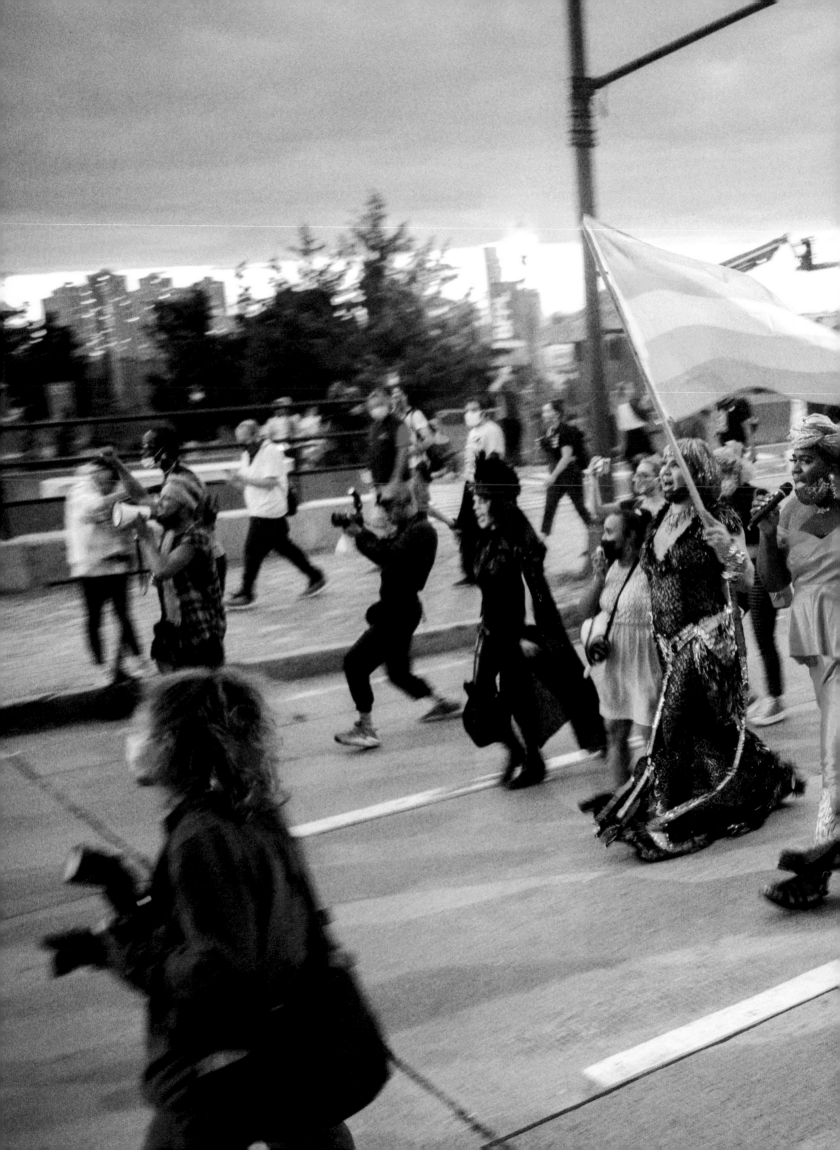

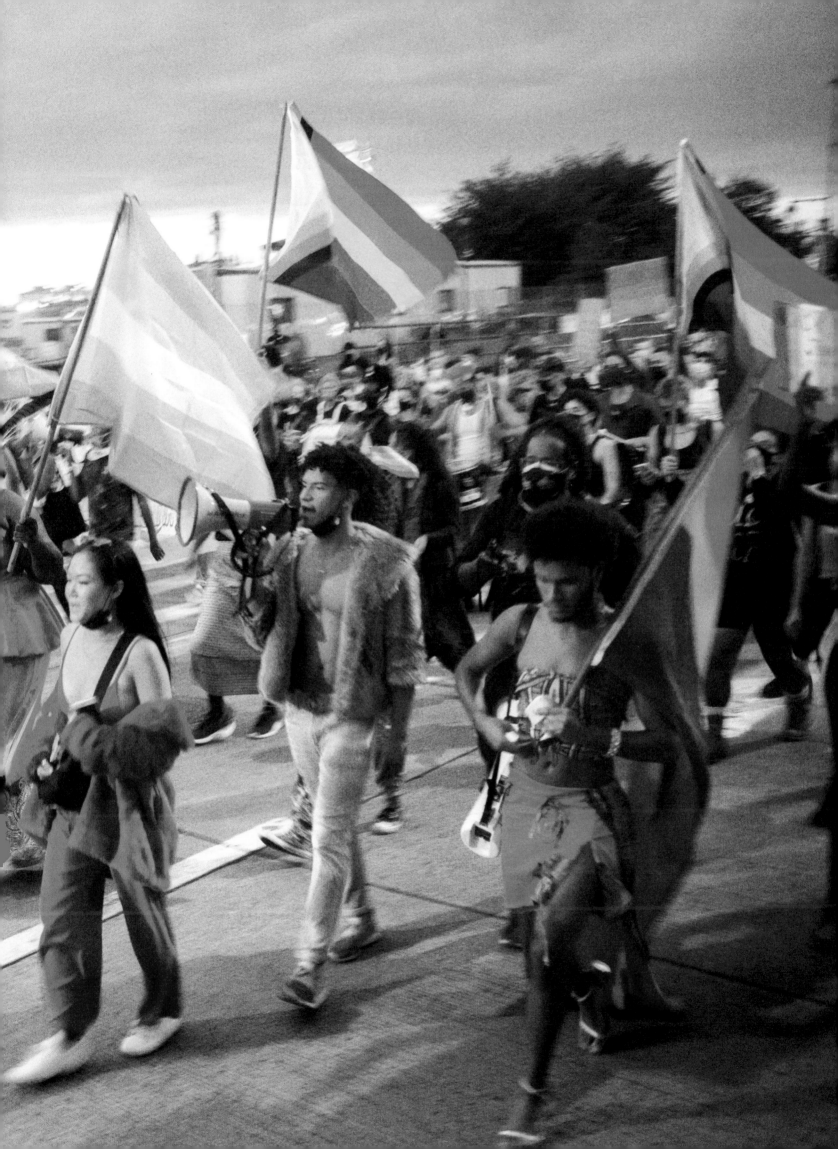

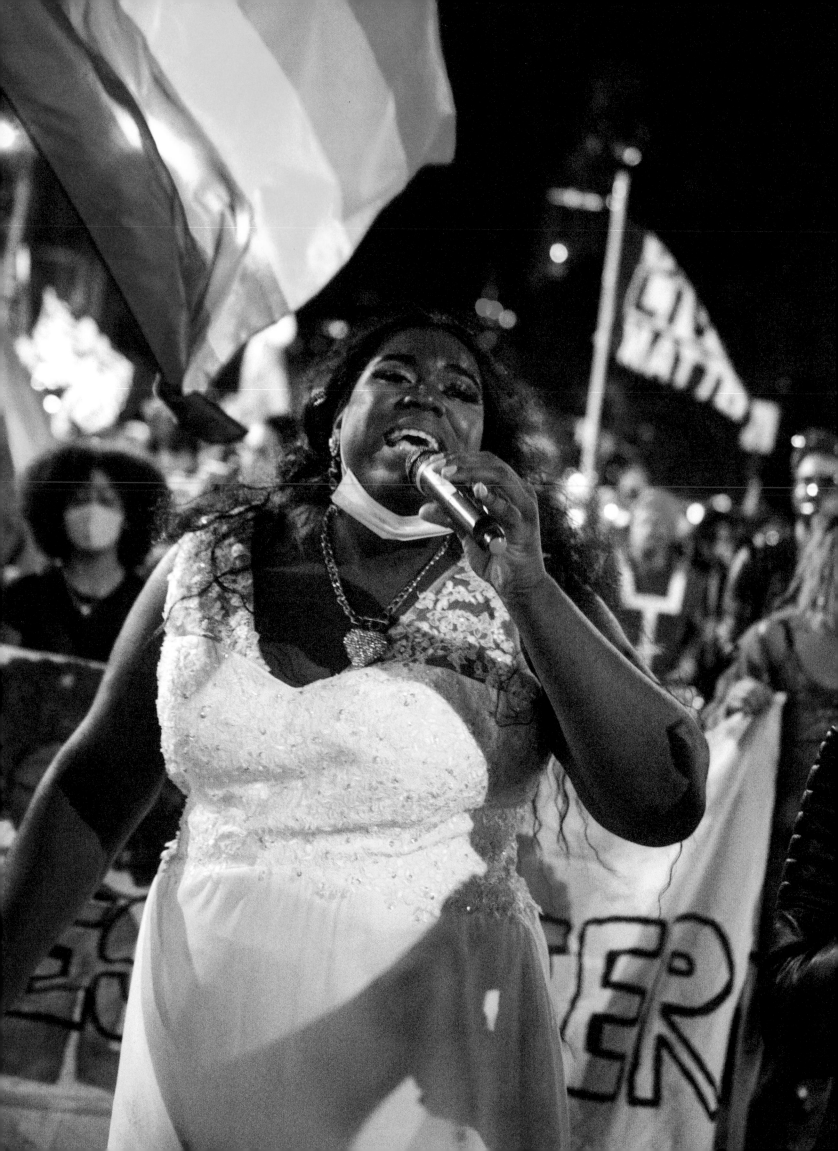

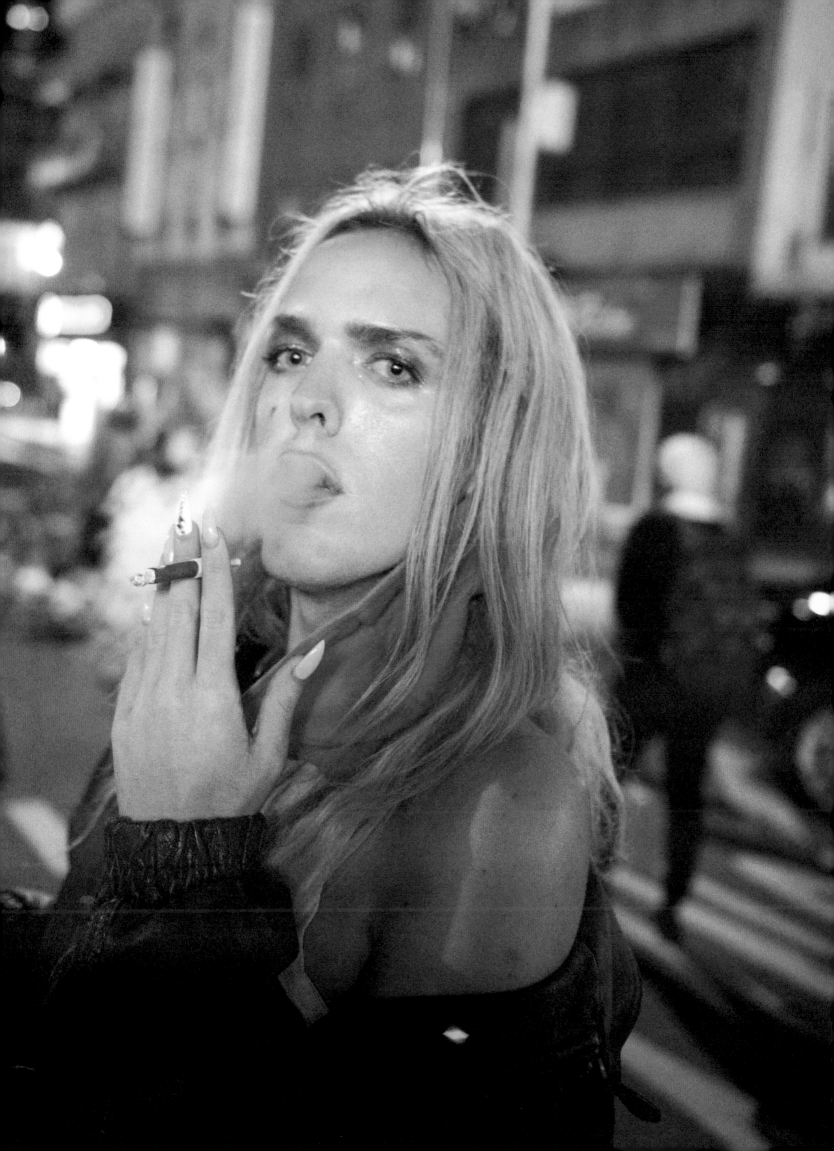

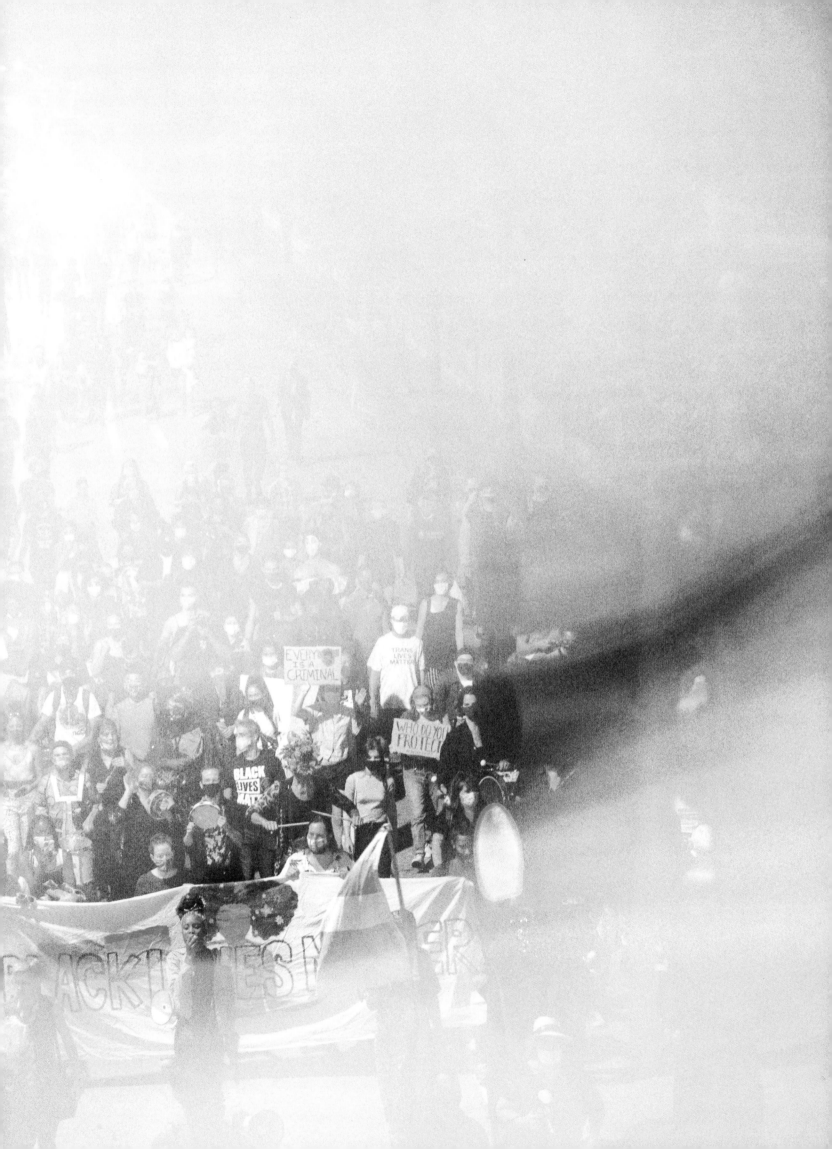

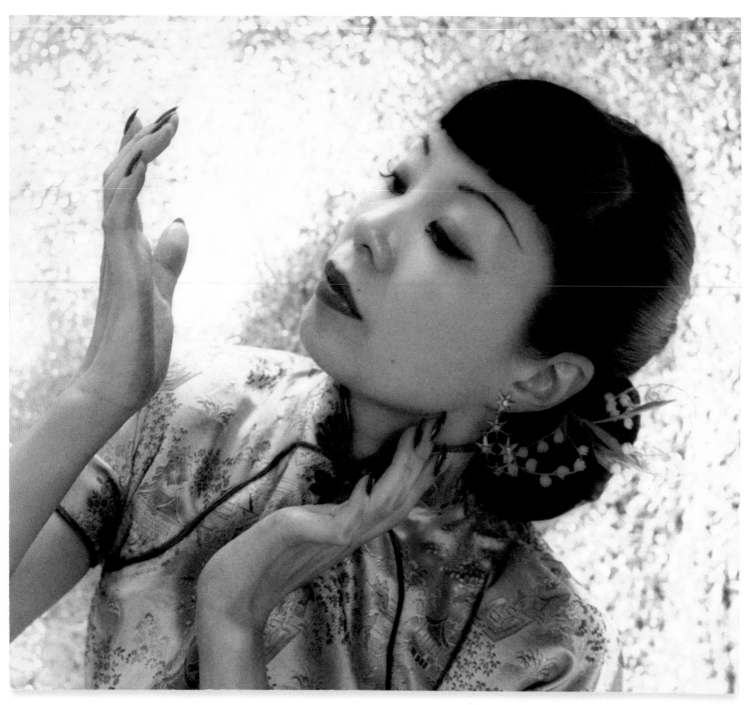

Jadin Wong wearing a qipao, ca. 1939–41
Courtesy Wally Wong

Voices & Memories

When a devastating fire tore through the archives of the Museum of Chinese in America, curators feared for the loss of priceless cultural heritage. What do the surviving photographs say about the Chinese diaspora's resiliency?

Hua Hsu

In late January 2020, as a fire tore through the building at 70 Mulberry Street, in New York's Chinatown, the staff of the Museum of Chinese in America feared the worst. They watched from a park across the street as firefighters worked deep into the night to contain the blaze. This five-story corner building was once a schoolhouse; now it housed a dance center, a senior citizens' center, a vocational training office, an athletics association, and the museum's off-site collections. Luckily, there were no fatalities. By morning, the building was a smoldering husk, and it would be weeks before they would be allowed back inside. Many figured that if the fire hadn't ruined the collection, then all the water surely had.

The museum, located a few blocks away on Centre Street, was started as a salvage operation of sorts. In the late 1970s, Jack Tchen and Charlie Lai began noticing all of the stuff old-timers were leaving out on the streets as junk. Luggage, clothing, personal papers, things that had outlived their usefulness. But Tchen, a historian, and Lai, a community organizer, saw these items as part of a broader history. Perhaps whoever owned this old suitcase or sheaf of menus never perceived themselves that way—as having a history, or participating in a broader story of belonging, let alone an American one. What began as Tchen's and Lai's dumpster diving resulted in a museum that today contains some eighty-five thousand

items. They are random items, yet they collectively articulate the diverse experiences of Chinese in America.

In the months following the fire, curators and archivists were allowed to reenter 70 Mulberry. Somewhat miraculously, the bulk of the collection could be restored and saved—T-shirts, concert posters, hand-painted signs, old passports and immigration documents, paper fans, cigarette cartons. These are items which might be worthless in purely monetary or market-driven terms. Yet they are irreplaceable, indexing immigrant histories, traditions, and practices that have yet to be written. Very few of these objects were meant for archival preservation. Old signage or furniture once served a primary function for the nearby merchants who couldn't understand why a museum would want such things. Instruments were meant to be played. Costumes were for performance. Irons and washboards were merely tools of the laundryman's trade.

Unlike other parts of the collection, the museum's holdings of photographic prints, slides, and negatives communicate a clear desire to leave something behind, despite the lingering possibility that the people on both sides of the camera may have regarded this U.S. chapter of their lives as a temporary, transient one. These images articulate aspirations or desires that the subjects themselves might not have felt brazen enough to speak aloud: the family looking their spiffiest for a holiday portrait; professional headshots for modeling or singing gigs; school children obediently reciting from their workbooks; the tourist measuring himself in front of a statue of some supposedly great American. There is a photograph of the Chinese Musical and Theatrical Association, which opened on Pell Street in 1931. Associations such as this one functioned as community centers and schools, ways of maintaining a tie to centuries-old traditions of storytelling and performance. In this photograph, taken at a fundraiser in 1946, the performers huddle together onstage. Some radiate pride, smiling, sitting up as straight as possible. Others look shy or uncertain; perhaps they'd prefer to

These images articulate aspirations or desires that the subjects themselves might not have felt brazen enough to speak aloud.

Clockwise from top left: Emile Bocian, Marcie (left) and Maureen "Peanut" Louie (right) at the U.S. Open at Forest Hills Stadium, 1977; Kitty Katz, Four performers standing on a stage with costumes, 1993; Miss Qwong Yee Wo in the Miss Chinatown Pageant, October 10, 1971; Kitty Katz, Onlookers at a Lunar New Year Celebration, 1992

Thessaly La Force
Crazy City

There's an out-of-print book called *I Love New York, Crazy City* by the German artist Isa Genzken that is, while not impossible, still somewhat difficult to track down in this age of accessibility. First published in 2006, it sells for at least a hundred dollars on a website owned by Jeff Bezos that I refuse to use out of principle. The New York Public Library has one, but it's located in the Art and Architecture room, which means you can't check it out—a dicey proposition during a pandemic. Other rare- or used-book sellers don't carry it very often. As someone who grew up with the Internet, I sometimes forget that things can exist outside of it. Like many bibliophiles, I relished the book's elusiveness almost more than I did the satisfaction of finally setting eyes on it.

Created between 1995 and 1996, the publication is a scrapbook of sorts, a love letter to a city. Originally printed as three separate entities, it was later turned into an enormous monograph. "They are fragile, funny, crazy," Genzken admits. She called them her "guidebooks," and that's exactly what they are, even if they don't possess any coherent information. Instead, what you find are pages and pages of collages that have been thoughtfully composed using photographs, magazine and newspaper clippings, and various ephemera (business cards, receipts, brochures, programs, playbills)—all artfully layered one on top of the other and held together by strips of tape. At the time that Genzken made them, she had been living in New York for several months. *I Love New*

Genzken captures the energy of the street, the serendipity of wandering someplace you didn't mean to go.

York, Crazy City also includes hotel bills and miscellaneous mementos of hospitality: faxes to and from the New York Hilton, ripped matchbooks from the Pierre, stationery from the Hôtel Plaza Athénée, a "Please Do Not Disturb" sign stolen from the Carlyle. Wherever Genzken was staying, she seemed to be having a grand time.

What's striking, looking now, is how this particular kind of New York doesn't really exist anymore. Or at least not in the same spirit—not like this. Back then, entrées at the Odeon—an establishment that is described as serving "Mediterranean food for the well-groomed"—cost fifteen dollars. Fugazi is playing for one night at Irving Plaza, and CBGB is just an unassuming music venue on the Bowery. Pat Steir is curating an art show. Larry Gagosian's gallery is still located on Wooster Street. There are the Angelika Film Center and Film Forum to see the cinema, as it's called, and

there are yellow cabs and buses to get you there, not Ubers and Lyfts. Lawrence Weiner complains to Genzken that "people started to go to clubs because they were afraid of getting old, but when everybody was young, they weren't afraid of getting old so they went to bars and talked." But who even goes to nightclubs now? The Twin Towers hover in the periphery. You sense them, out of sight. Just in the same way that you sense Rem Koolhaas's theory of Manhattanism and the culture of congestion from his 1978 book *Delirious New York*. Everything in this book epitomizes New York before 9/11. Here are the last few glorious years before it began to seem like America was irrevocably in decline.

Still, *I Love New York, Crazy City* wasn't made to be nostalgic. It's rigorous in its curiosity, born out of a time when Genzken was not making much other art in her studio. Genzken doesn't shy away from repetition. She is most known as a sculptor and large-scale-assemblage artist, and her appreciation for architecture is evident. She enjoys layering photographs of buildings she's repeatedly taken pictures of, and there is something cinematic in the way she confronts their spatiality. Reading this book *feels* like walking through New York. It captures the energy of the street, the serendipity of wandering someplace you didn't mean to go, the pleasure of making your way to the Solomon R. Guggenheim Museum on an autumn day, of sensing the colossal weight of the skyscrapers stacked on top of one another as you cross Midtown. Genzken saw New York as her stage; she delighted in its options, its variability. In her book, the city dazzles with the promise of consumption, of possibility, of more. "That's probably why you're comfortable in New York," Weiner says to her. "There's really no rules other than *please* and *thank you*, because every five years it's a completely different configuration of people in the same city."

Genzken is a shadowy figure these days. At seventy-two years old, she rarely gives interviews. She suffers from bipolar disorder and alcoholism, and because of both she has been tossed out of hotels and restaurants, lost friends and galleries. "You told me that your favorite thing to do was to go somewhere and make a scene," says her friend the artist Daniel McDonald in the final interview of the book. "You told me at one point that after five o'clock you liked to get aggressive." "Not now any more," Genzken replies. "That was my state of mind at that time. I don't want to be aggressive in that way any more. I paid too much for it. I really paid. I paid!—No more!"

Here, the implication goes, the city was so intoxicating, so wild that it could drive Genzken to madness, to crazy love. At the end of the book, Genzken is forthcoming about the fact that Berlin is her antidote, a place where she can return to work, feel settled, find calm. Yet she worries of leaving and losing New York. That it will be gone when she comes back. Now, as we settle into what is hopefully the final stretch of this pandemic—one that has left New York empty and impoverished, shut down and silent—so do we all.

Thessaly La Force is a features director of *T: The New York Times Style Magazine*.

Widline Cadet
Absence Persists

Edwidge Danticat

I happened to be reading Roland Barthes's *A Lover's Discourse* (1977) when these photographs by Widline Cadet landed in my in-box. Although, Cadet's photographs might have a more likely kinship with Barthes's *Camera Lucida: Reflections on Photography* (1980), his highly personal study, in which he writes that "in order to see a photograph well, it is best to look away or close your eyes."

Eyes closed, I tried to re-create my own version of these images, which would remain with me long after they were out of sight. What persisted was their coupling and twinning, what in a mix of Haitian Creole and English (Crenglish) one might call their *marasa*-ness.

In a section on "figures" in *A Lover's Discourse*, Barthes writes, "A figure is established if at least someone can say: *'That's so true! I recognize that scene of language.'*" It is those types of scenes and unspoken languages that keep bringing me back to Cadet's photographs.

Here is an unseen hand offering a blessing to an openly receptive face peacefully receiving it, with eyes closed. The hand might belong to a healer, and the gesture a type of prayer. Here is the elder who's accepting her own blessing, through embrace, while both she and the person embracing her are out in the cold. Here they are, these same two Black women of different generations meeting, or reuniting. Was one lost and is now found? Here are two young women, near mirror images of each other, almost, but not quite, *marasa*, or twins. Are they sisters? Lovers? Friends? Sister friends?

These scenes, made in New York parks and collected in a series Cadet calls *Soft* (2017–20), capture figures who also seem like memories or dreams. Here I can't help but see my mother and me, my daughters and me. Among a series of recollections that these photographs sparked, this particular memory lingers.

When my oldest daughter was six years old, we took my mother to the airport so she could return to her home in Brooklyn, after a long visit with us in Miami. We waited for Manman, as I called her—my daughter called her Grann—to clear security and wave goodbye to us before disappearing into a crowd of other travelers. As an adult, taking Manman to the airport and watching her leave was one of the most recurrently painful moments involving my mother and me. Each time we had to experience this particular ritual, I wanted to scream because these moments reminded me of my first concrete childhood memory, which was of being separated from my mother on the day she left Haiti for the United States when I was four years old. No one had told me that she was leaving without me, and that we would only be reunited in Brooklyn when I was twelve. When it came time for her to walk toward the plane, my body had to be peeled off of hers. Mysteriously, or perhaps not mysteriously, that day, as my six-year-old daughter and I watched my mother merge into the crowd heading toward her gate at the airport in Miami, my daughter screamed, "Manman!" I was too concerned with consoling her to ask her why she let out that particular cry, at that particular moment—years later she does not remember this at all—but it felt as though the part of me that was inside of my daughter had gone back in time to help me scream.

"Absence persists—I must endure it," Barthes writes in *A Lover's Discourse*. This cross-generational absence persisted in my daughter, and persists, too, in these striking and moving photographs by my fellow Haitian, who moved to New York in 2002, when she was ten years old. I felt somewhat vindicated in what seemed like an overreach in imposing my own absences on Cadet's photographs when I read some words she shared in a 2019 interview with Zora J Murff of the Strange Fire artist collective. "My mother's parents, for example, died before I was born and there aren't any pictures of them anywhere that I could

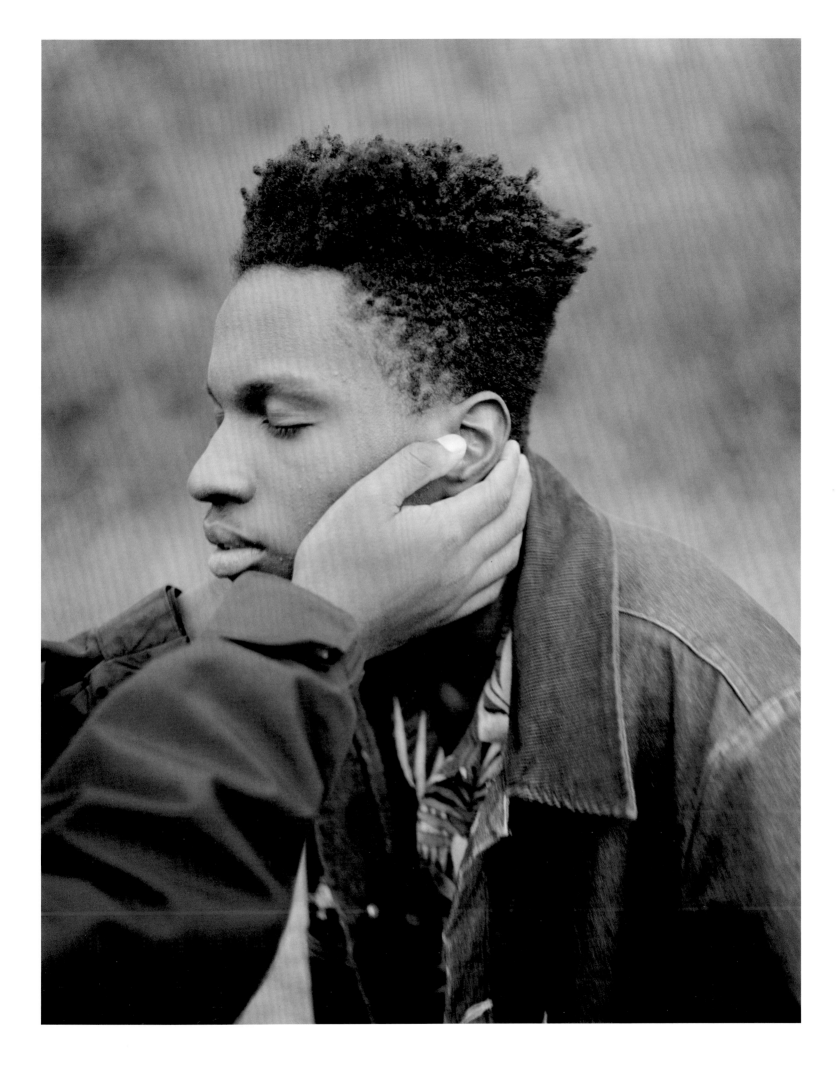

find. The same thing could be said about my siblings and I, of when we were growing up in Haiti," Cadet stated. "I feel more desperate to have an image of them as a point of reference and remembrance when memories start to fail. In addition to that, I honestly just get fed up with the way people produce and distribute images of Black bodies."

Entering Cadet's world makes me long for a type of physical contact and familial intimacy that for now has been put on hold. Here are Black bodies that have not yet become the battlefields of a deadly virus. Here are maskless people lovingly touching one another, intergenerationally. "Here we are," Cadet's subjects seem to be telling us with their tender gazes and gestures. Absence persists, but we will endure. *Nou la toujou*. Each photograph is an amulet and a memorial, and a welcome breath of fresh air.

Edwidge Danticat is a writer based in Miami and the author of numerous books, including the memoir *Brother, I'm Dying* (2007) and the short-story collection *Everything Inside* (2019).

Previous page:
Untitled (Derrick and Tiberius), 2017

This spread:
Untitled (Marsha and Tashae), 2020; overleaf, left: *Untitled (Ebony and Gail)*, 2017; right: *Untitled (Nene and Beryl)*, 2020. All photographs from the series *Soft*
Courtesy the artist

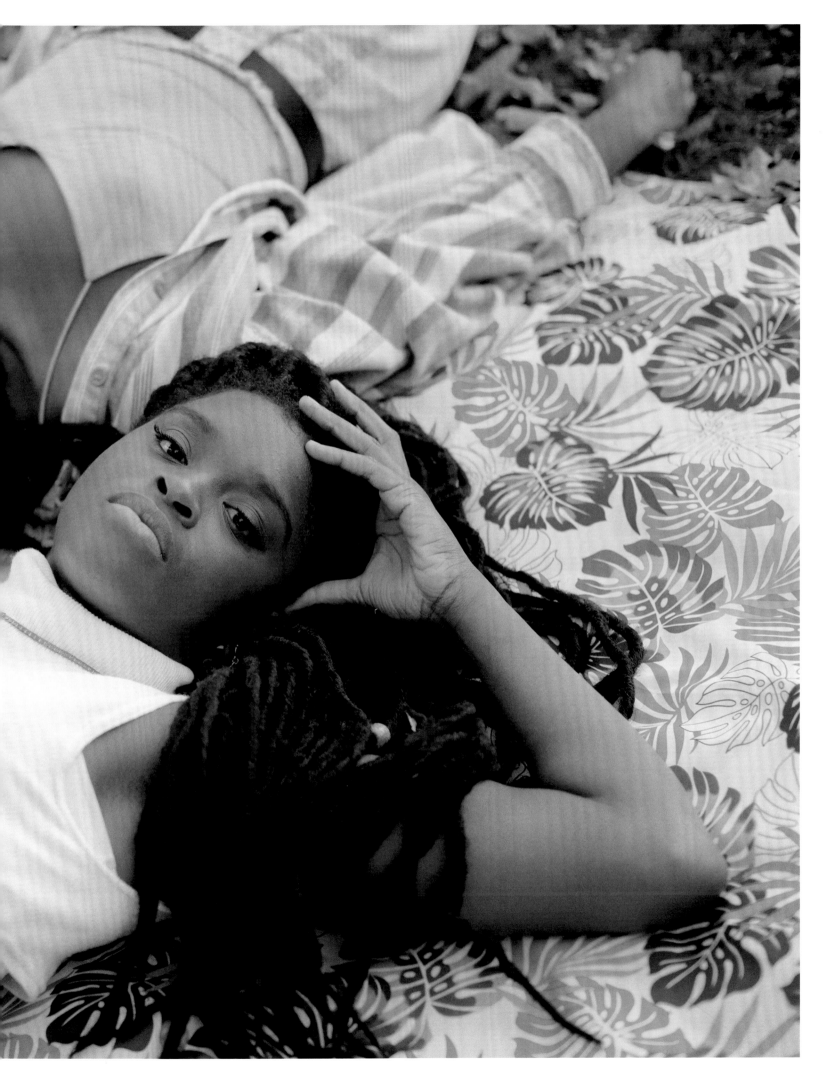

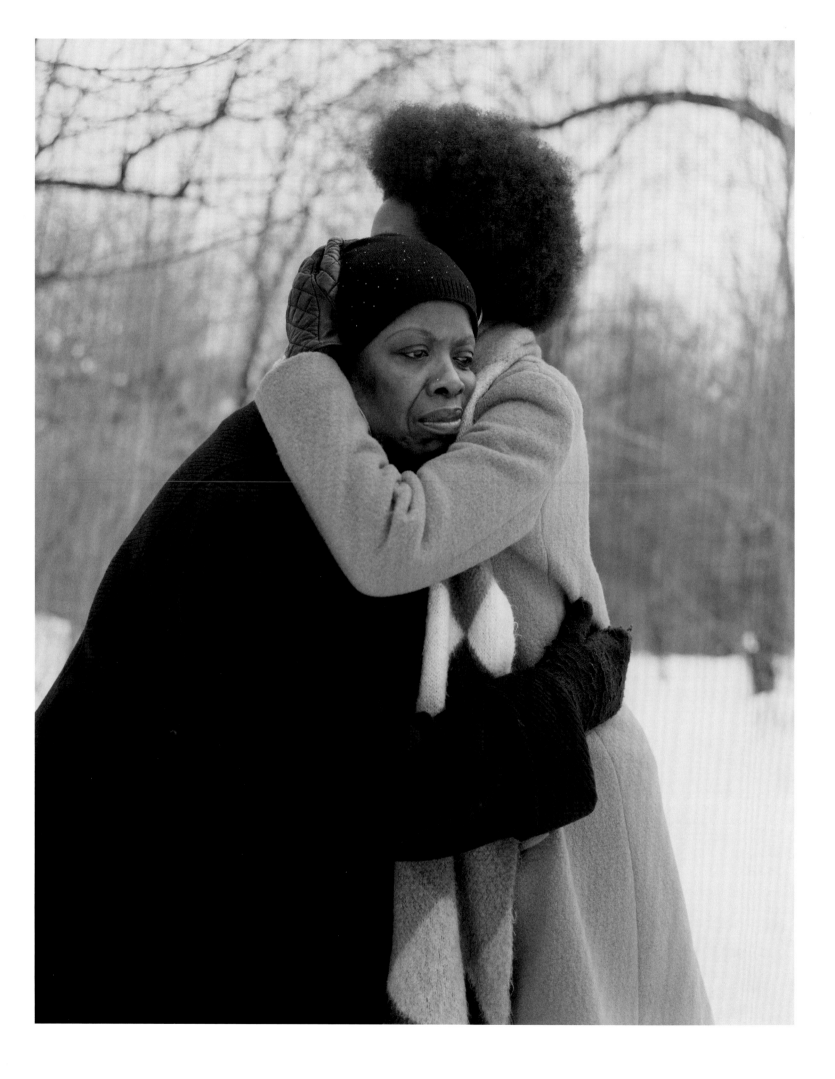

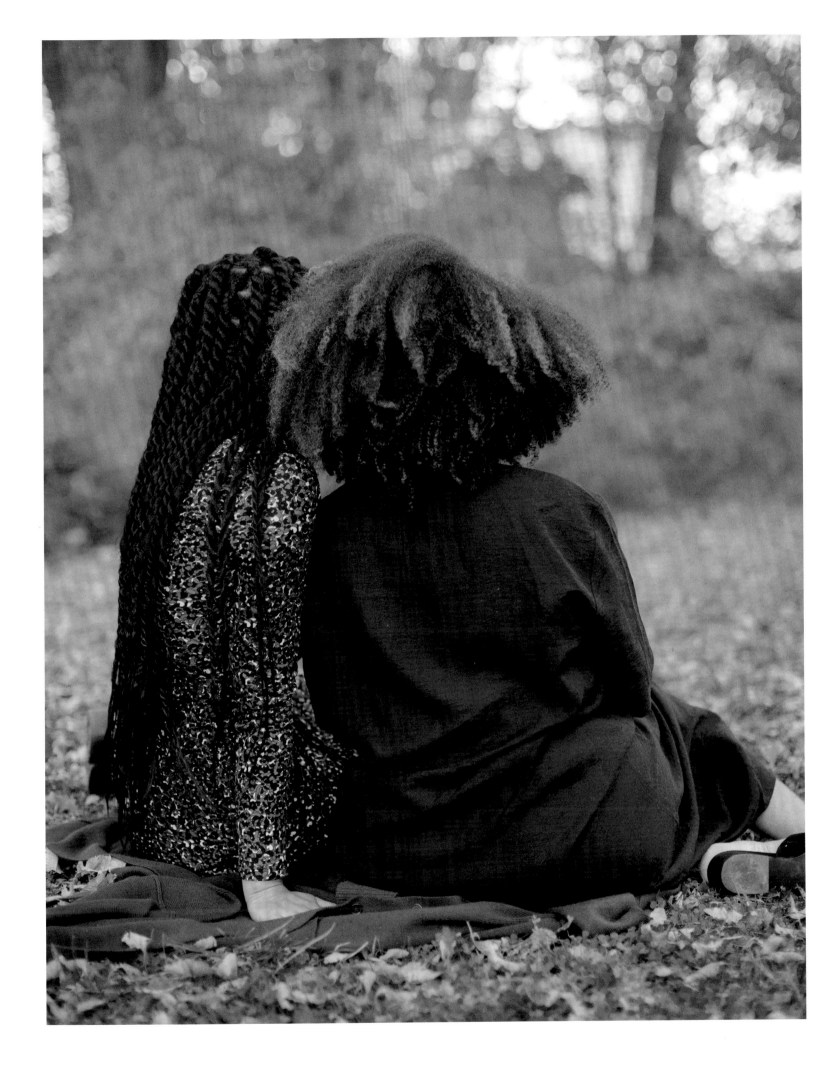

When I first started surfing in Rockaway, I'd get up early and take the A train from my apartment in Brooklyn and transfer to the S train at Broad Channel, a forty-five-minute trip, if I was lucky. I'd change into my wet suit in a shared surf shack, surf for an hour or two, maybe chatting with the photographer Roe Ethridge or other surfers in the lineup. I could be back by noon. Coming into "the city" after a morning surf always felt like I carried a secret—surfing in New York, with dolphins, whales even!—as I wandered through gallery shows in Chelsea or sensed water pockets displace in my ears during faculty meetings at Pratt.

I now live in Rockaway full time, since before Hurricane Sandy, in 2012, which destroyed much of the boardwalk and flooded the peninsula. Rockaway is technically part of Queens, but it's a remote and liminal space. For most New Yorkers, Rockaway is a down-for-the-day experience, and only on a nice day at that.

And the summers in Rockaway are crowded—this past summer particularly so. After many vacation plans of 2020 were tabled due to the pandemic, day trips were all that were left. Summer crowds create a lot of garbage; visitors are unprepared for the strong afternoon onshore winds, and all the shit they carry down for a beach day ends up strewn about the sand and in the ocean. Tragically, in entirely preventable incidents, people die because they venture into the surf after the lifeguards go off duty at 6 p.m. You know when you hear the helicopters and the sirens that there's another body being taken out.

Ethridge's photography is about mixing categories, and his projects on Rockaway likewise capture the whiplash effect of moving between spaces and seasons in New York's uncut gem of a neighborhood. His work confuses the genres of traditional photographic representation, including still life, landscape, and portraiture. Ethridge lavishes the attention of product photography on banal or foul objects such as old fruit and drugstore toys, makes landscapes of "ugly" places, and converts fashion photography into an ersatz mix of these things. In his recent series on Rockaway, where he has a weekend home, these categories get further jumbled. In his 2007 book, *Rockaway, NY*, even the notion of place is upended: some of the images are not even of Rockaway but rather mark the way that, for many, the area is an urban vacation station between

other places in New York, a beach day that begins and ends somewhere else.

Ethridge's new book, *Beach Umbrella* (2020), portrays the jolie laide character of Rockaway. In addition to pictures of broken umbrellas littering the shoreline or stuffed into overfed garbage cans—the detritus of objects becoming landscape—he includes images of a fashion editorial with a red-headed model, paradoxically called "summer in winter," and landscapes of the urban-littoral blender of the peninsula, some from an advertising campaign for the Medea handbag line, most shot in Rockaway, or on the ferry, or off the Belt Parkway en route to the beach.

These images capture the unique and sometimes sublime weirdness of Rockaway, a place I love for its racial and economic diversity, all the while living here in trepidation about its infrastructural vulnerabilities. Rockaway is a hub of contradictions. It's New York's face to the majesty of the open Atlantic Ocean. It's the wildness of Jamaica Bay and Fort Tilden. And, encompassing the "uptown" Rockaway neighborhoods of Belle Harbor and Breezy Point, it's one of the city's most politically conservative sectors. (They adore the Queens boy Donald Trump uptown.) Rockaway Beach is "downtown," a landscape blotted by tightly packed, gambrel-roofed houses clad in vinyl siding, desultory strip malls, blocks of nondescript brick housing towers, and a tremendous amount of telephone poles that in other parts of the city were disappeared but here stand as sentinels of urban grit.

Ethridge's images show all that—bits of beauty spattered with dollops of blight. Along with the somehow still-cheery busted umbrellas and the patterns of trash on the beach, his photographs depict African American glamour among the Blue Lives Matter paraphernalia on Beach 116th Street, the once derelict house on Holland Avenue that has been undergoing a glacially paced reconstruction for about the past eight years, and the earnest and garish Halloween decorations that come out every year, rotated among attic boxes of Saint Patrick's Day, Easter, and Christmas tchotchkes. Rockaway beach-goth eclectic: it's a perfect Empire apple (on this issue's cover) from the local Edgemere Farm market, stem still attached, cupped by the black latex glove of COVID times. Ethridge accomplished the ultimate genre paradox of 2020—a travelogue about his own neighborhood.

Roe Ethridge
Fugitive Sunset

Eva Díaz

Eva Díaz is an associate professor of contemporary art at Pratt Institute.

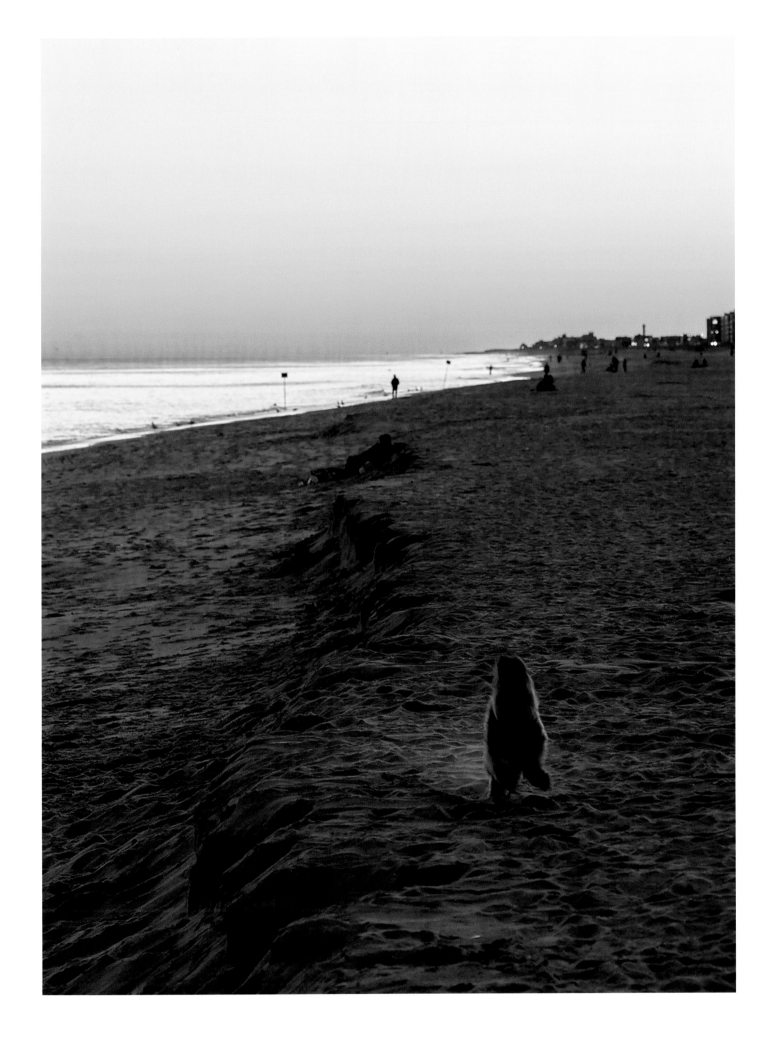

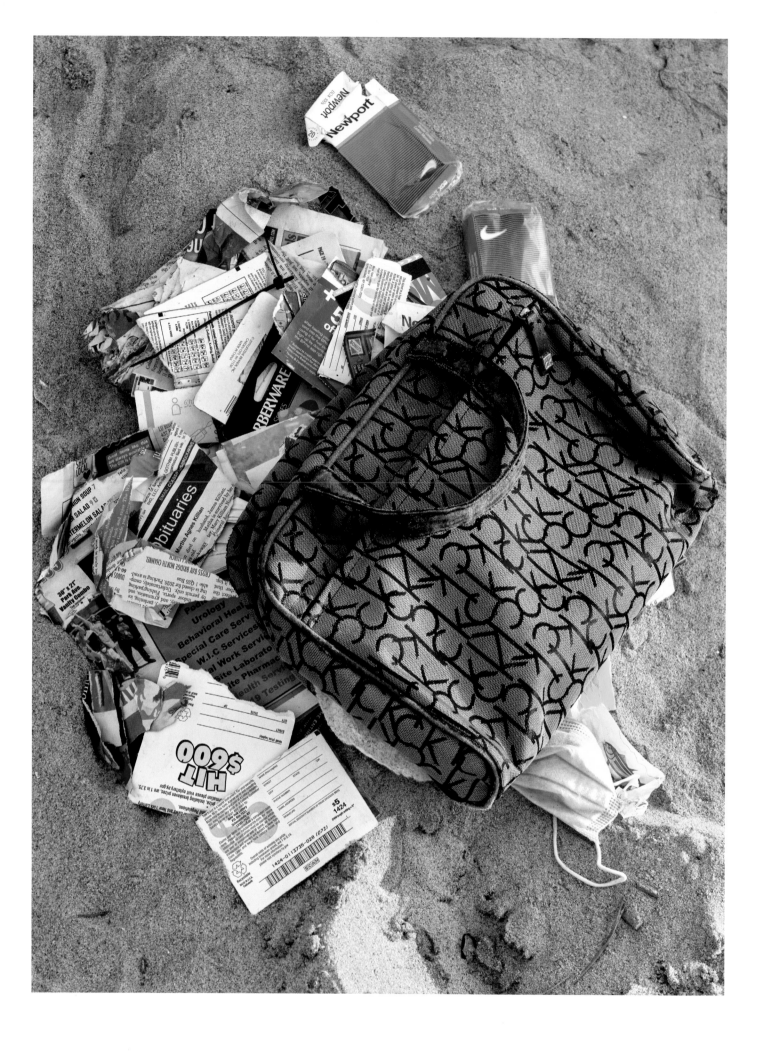

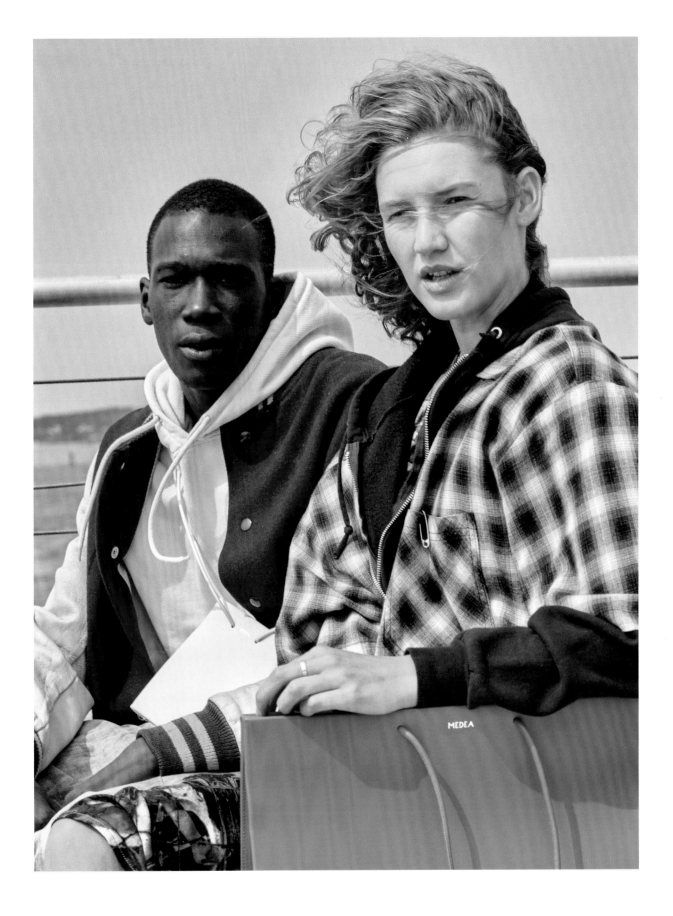

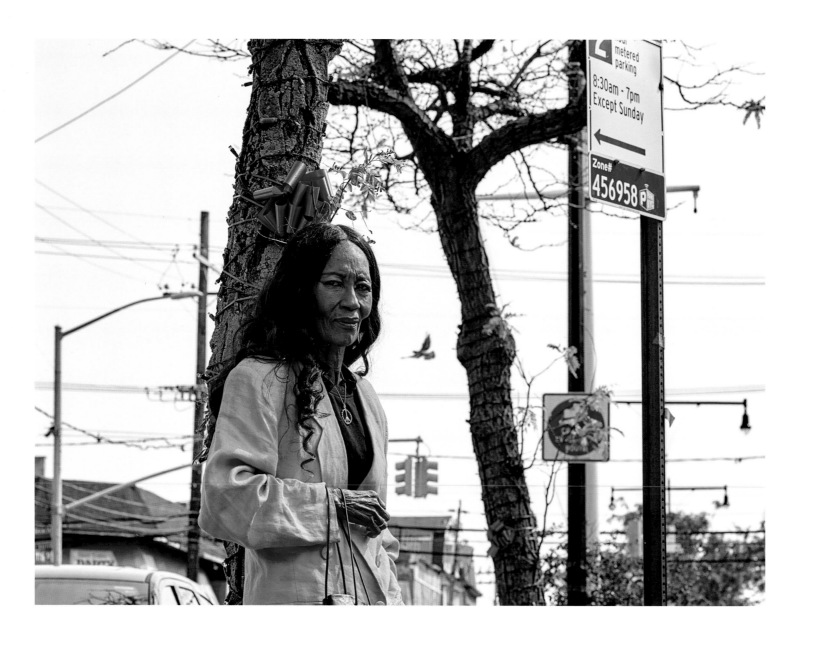

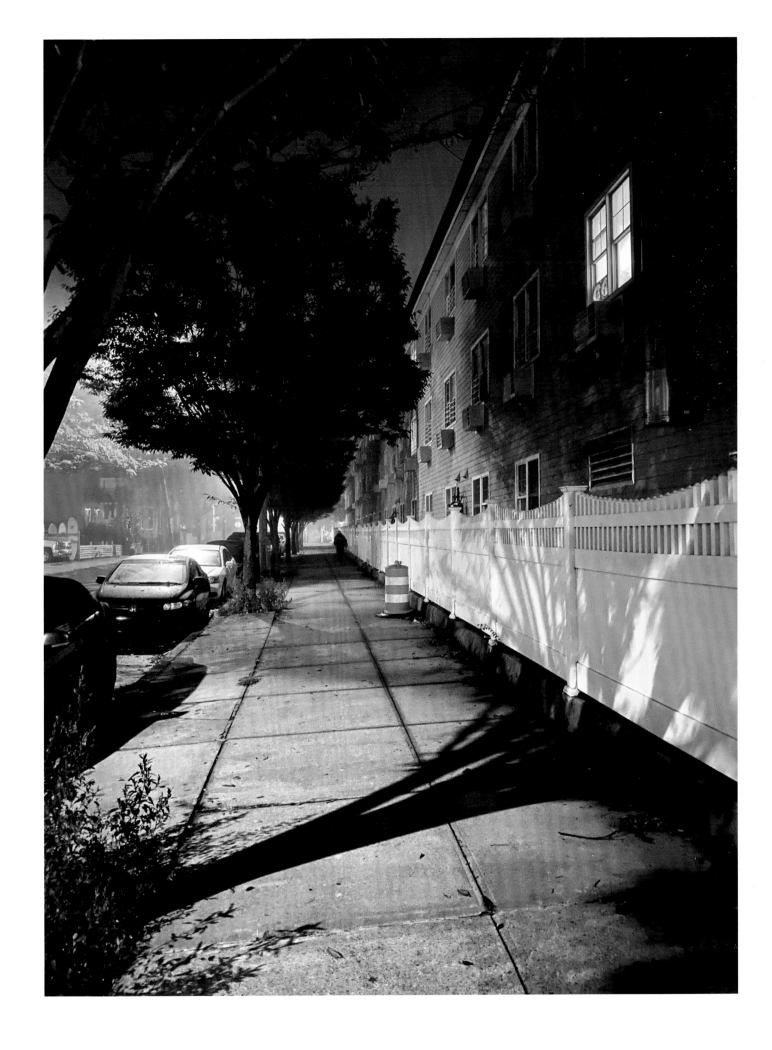

All photographs from
the series *Fugitive Sunset*,
2020, for *Aperture*
Courtesy the artist and
Andrew Kreps Gallery,
New York

M|I|C|A
PHOTOGRAPHY

Nate Larson, *Site of the Former Shoe Company*, De Soto, Missouri, 2017.

Centroid Towns is an anthology documentary project chronicling the twenty-five cities that have been the mean center of population of the United States.

Larson has been a member of MICA's faculty since 2009 and chair of the Photography Department since 2018.

mica.edu/aperture